HOWARD BEN TRÉ

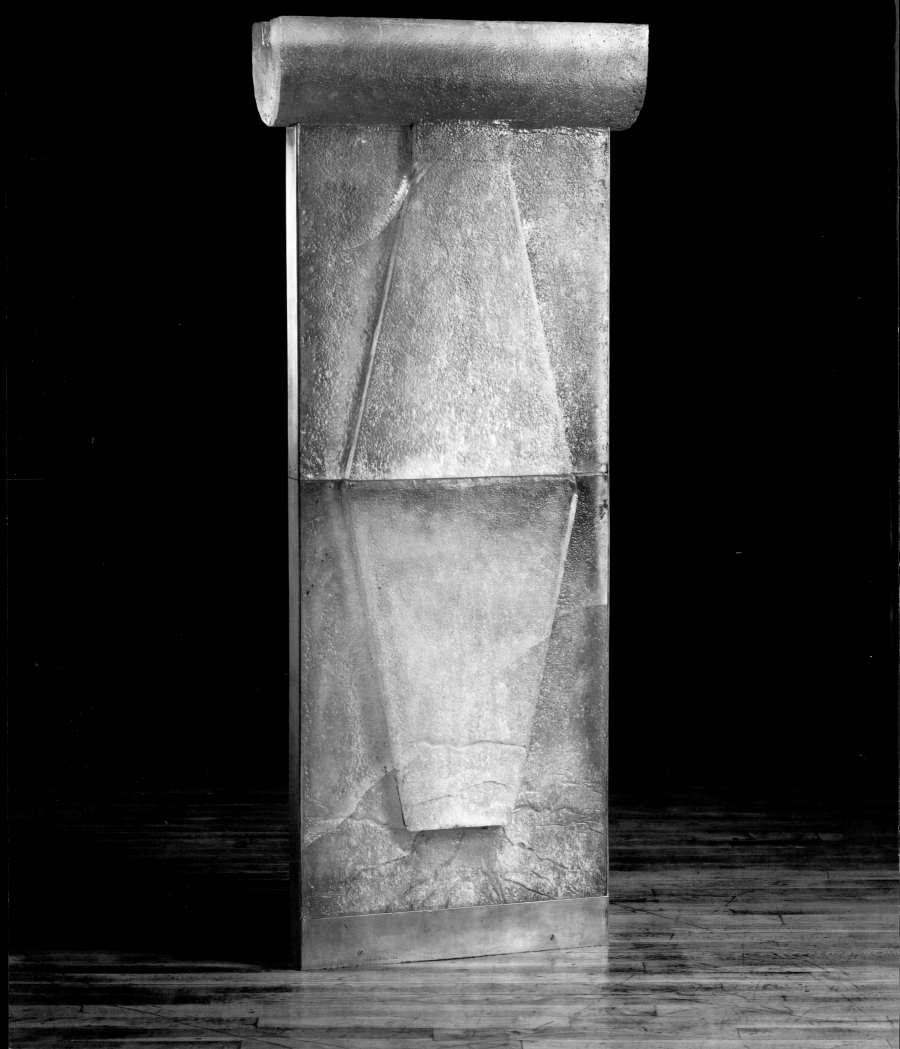

HOWARD BEN TRÉ

Arthur C. Danto

Mary Jane Jacob

Patterson Sims

Hudson Hills Press, New York

in association with the

Scottsdale Museum of Contemporary Art, Arizona

**Howard Ben Tré was published
on the occasion of the exhibition
"Howard Ben Tré: Interior / Exterior"
organized by the Scottsdale Museum
of Contemporary Art, Arizona.**

Palm Springs Desert Museum, California
December 15, 1999 through March 12, 2000

Scottsdale Museum of Contemporary Art, Arizona
April 7 through June 11, 2000

San Jose Museum of Art, California
July 1 through September 30, 2000

Orange County Museum of Art, California
June 1 through August 26, 2001

Published by Hudson Hills Press, Inc.
122 East 25th Street, 5th Floor
New York, New York 10010-2936
Editor and Publisher: Paul Anbinder

Distributed in the United States, its territories
and possessions, and Canada by National
Book Network

Distributed in the United Kingdom, Eire, and
Europe by Art Books International

Manufactured in Japan by
Dai Nippon Printing Company.

Publication coordinated and edited by
Terry Ann R. Neff, t.a.neff associates, inc.
Tucson, Arizona

Designed by Elizabeth Finger Design
Belmont, California

Library of Congress Cataloguing-in-Publication Data
Danto, Arthur Coleman, 1924–
 Howard Ben Tré / Arthur C. Danto, Mary Jane Jacob,
 Patterson Sims.
 p. cm.
 Published on the occasion of the traveling exhibit
 "Howard Ben Tré: interior / exterior" organized by
 Scottsdale Museum of Contemporary Art.
 Includes bibliographical references and index.
 ISBN 1-55595-187-2 (alk. paper).
 I. Ben Tré, Howard, 1949– Exhibitions. I. Ben
 Tré, Howard, 1949– . II. Jacob, Mary Jane.
 III. Sims, Patterson. IV. Scottsdale Museum of
 Contemporary Art. V. Title.
 N6537.B4516A4 1999
 730'.92—dc21 99-36156
 CIP

COVER

Bearing Figure with Ming Vessel, 1997 (detail)
Cast low expansion glass, silver leaf inclusion,
and granite
84 x 37 x 20 inches
Collection of Maxine and Stuart Frankel

FRONTISPIECE

Fourth Figure, 1986
Cast glass, brass, gold leaf, and pigmented waxes
$72\,{}^{1}\!/_{2}$ x $29\,{}^{3}\!/_{4}$ x $9\,{}^{3}\!/_{4}$ inches
Private collection

CONTENTS

I first became aware of the sculpture of Howard Ben Tré while working at the Charles Cowles Gallery in New York's SoHo district. Like slabs of green ice sculpted from a primordial glacier, the artist's monumental cast glass forms captivated me with their sheer physical presence and frosted luminosity. This effect was heightened by the ambiguity of Ben Tré's use of modern industrial aesthetics juxtaposed with ancient architectonic references. Now, some sixteen years later, I am honored that the Scottsdale Museum of Contemporary Art will present a comprehensive exhibition of the sculptures, public art projects, and works on paper of an artist I have long admired.

All art is imbued with the personality, intellect, and belief system of its creator, regardless of the methodology or formal production techniques employed. Tolstoy commented that, "Art is not a handicraft, it is a transmission of feeling which the artist has experienced." To that end, the work of Howard Ben Tré embodies a complex matrix of his formal artistic training, political ideologies, human relationships, and highly personal sense of spirituality. And while his sculptures certainly are aesthetically compelling, they spring from an internal well of philosophical constructs that are separate and distinct from the creation of merely beautiful objects. It is as though they are a continuum of the artist's life and represent poignant commentaries on simply what it is to be human.

Organizing a touring exhibition of eight tons of cast glass requires many years of work and a good deal of logistical finesse. Consisting of thirty large-scale sculptures, eleven works on paper, four proposals for public art commissions, and a comprehensive monograph, this ambitious project has been supported by a coalition of five museums, all of which will present the show at their respective institution. We are most grateful to the following for their participation in this tour: Palm Springs Desert Museum, San Jose Museum of Art, and the Orange County Museum of Art. My sincere appreciation is also extended to the Scottsdale Cultural Council Board of Directors and staff for their continued support of this exhibition and its presentation at the Scottsdale Museum of Contemporary Art.

Our commitment to this exhibition, and its ultimate success, would not have been possible without the ongoing enthusiasm, good humor, and just plain hard

exhibition charts the progression of Ben Tré's work from the early architecturally based pieces through his most recent sculptures, drawings, and public art projects. Included are several examples of work from the mid-1980s that were influenced by a trip to Greece and extended his interest in ancient architecture as a referent. The scale of these works progresses gradually towards the monumental, in large part due to the artist's access to industrial glass factories where a high volume of glass was readily available. *Cast Forms*, *Structures*, and *Columns*, situated directly on the floor, progress in size and stature; bands of patinated copper and gold leaf add color and depth. *Cast Forms* and *Structures* range in size from two to four feet respectively. These truncated pillars call to mind Minoan columns, which were characterized by a plain tapering shaft supporting a large, dense capital. Ben Tré's *Columns* appear to defy gravity in their vertical skyward thrust while affirming a strong spiritual presence. Since over time the artist has become increasingly concerned with synthesizing architectural and figurative references, gradually the proportions of the columnar works have been manipulated to provide a more human context and scale.

Ben Tré's first series of figure-based works, entitled simply *Figures*, were realized after a number of trips abroad. The earliest *Figures*, from 1986, were influenced by ancient burial markers carved to record and commemorate an individual's unique traits, and they manifest a similar spirit. Here Ben Tré's intellectual focus turned inward—both literally and figuratively—as he grappled with metaphors relating to the soul. This shift toward interior forces was especially evident in subsequent work. While the earlier *Columns* involved vertical supporting structures, Ben Tré began to create works that held their contents within. He began to incorporate interior spaces or voids in the figures encased within the glass. The internal cavities suggest a connection to the human body while at the same time alluding to a troubling disconnection between the intellect and spirit.

The *Primary Vessels* and *Basins* series were a distinct evolution of the *Figures*. Primitive and prehistoric cultures are the source for Ben Tré's translations of crude implements and ceremonial objects. In *Primary Vessels* the artist used figurative references in his interpretations of tools and vessellike shapes. Human in proportion, these elemental objects merge male and female forms and symbols; their scale, proportion, and vertical orientation give them an unmistakable humanlike presence. Conversely, the horizontal orientation of the *Basins* suggests a grounding in nature, rather than a defiance of it. Whereas the *Primary Vessels* are containers that take in and enclose what had previously been held outside, the *Basins* open up and offer forth their contents. Ben Tré's *Basins* are reminiscent of prehistoric stone objects such as the *metate* used in Native American culture for grinding grain and Japanese water basins used for ritual cleansing. Many of Ben Tré's *Basin* shapes are patterned after fragments from old stone temples. The hollow openings are lined with

a dark, soft coating of metal powder, suggesting female attributes and the energies that evoke the origins of life.

In *Wrapped* and *Paired Forms*, Ben Tré's figural references become even more abstract, evolving into lingams, which symbolize the regenerative powers of the universe as well as the integration of male/female principles. The sculptures are devoid of ornamentation which would detract from the geometric quality and purity of their sparse architecture. *Bearing Figures* is the synthesis of Ben Tré's exploration of the human figure and the vessel. The series is rich with spiritual and mystical associations. The artist has enveloped the interior vessel form within a protective casing of metal or stone. Internal cavities that earlier indicated a disconnect between the spirit and intellect no longer seem separate. In Ben Tré's *Bearing Figures*, vessel and figure are seamlessly connected; male and female aspects are in perfect balance; interior and exterior are one.

Ben Tré's contemplative work encompasses a vast array of human experience. Over the years he has fashioned a unique vocabulary of archetypal images based on his own political and spiritual beliefs. The artist's journey, from the earliest cast architectural works up to his most recent sculptures and large-scale public commissions, demonstrates an uncommon continuity of purpose. Both the allusive and tactile texture of the objects imbue his art with a sense of deep time, thereby establishing a parallel persistence of meaning, in which the work, rooted in the past, is fully alive in the present.

This publication and the traveling exhibition "Howard Ben Tré: Interior/ Exterior" represent a significant achievement for the newly formed Scottsdale Museum of Contemporary Art. This ambitious endeavor aptly reflects the museum's mission by exploring ideas of our time and advancing appreciation of contemporary art and culture. The project has been partially underwritten by a group of philanthropic and dedicated collectors of Howard Ben Tré's work. My deepest thanks to Maxine and Stuart Frankel, Dorothy and George Saxe, Francine and Benson Pilloff, Mary and Jon Shirley, Vera and Robert Loeffler, and Dr. and Mrs. Joseph A. Chazan for their generous financial support.

I also wish to extend my appreciation to our guest authors: Arthur C. Danto, art critic and professor of philosophy at Columbia University, New York; Mary Jane Jacob, independent curator based in Chicago; and Patterson Sims, deputy director for education and research support, The Museum of Modern Art, New York. This publication has benefited tremendously from their intelligent and discerning analyses of Howard Ben Tré's art. I am also deeply indebted to Terry Ann R. Neff, t.a neff associates, for her editorial expertise as well as her tenacity and persistence regarding the overall coordination of this book; and to designer Elizabeth Finger for her elegant interpretation of the material and images. Paul Anbinder, president of Hudson Hills Press, graciously agreed to copublish this book, and we appreciate his support.

I feel grateful to be working under the guidance of Dr. Robert E. Knight, director, whose vision and sustained commitment to the museum are exceptional and

inspiring. Special thanks to Valerie Vadala Homer and Richard Laugharn for their friendship and support. And I extend my appreciation to the many lenders to the exhibition who so graciously allowed their works of art to travel for the benefit of a larger audience. Without their cooperation, exhibitions such as this would not be possible.

Finally, I wish to thank Gay Ben Tré for her tireless assistance with the myriad of details relating to the publication and exhibition. And to Howard, whose work speaks for itself, it has been a rare privilege.

DEBRA L. HOPKINS, Curator of Exhibitions

By 1983 it had become evident that along with a glass factory, I needed studio assistants in order to accomplish the larger sculptures. With some hesitancy I sacrificed the privacy of my studio. But over the subsequent years, I was rewarded by coming into contact with many dedicated and talented young artists and craftspeople who passed through the studio on their way to careers of their own. Beginning with Todd Noe, each one of them has contributed to this body of work.

For ten years, Eric Portrais has anchored the studio with his creative ingenuity and responsiveness to executing the work. Whether it is the small maquettes or the full-scale sculptures, his contributions to every aspect of bringing my drawings into three dimensions are uncountable. Eric is often as much collaborator as executor. The Portrais family deserves acknowledgment as well for sharing so much of Eric over the years.

Most of the photography in this book was done by my good friend Ric Murray. Ric's patience, high standards, and keen eye are evident throughout in the excellence of the photos here.

Thanks also go to my mother, Pearl Buchen, and my parents-in-law, Harold and Lauris Guetzkow, for their unwavering support of Gay and me in our life choices. Our son, Benjamin, has been witness to much of the work made over the last twenty years. He has often lent a willing hand at the studio, but more importantly, I know I can count on him for his thoughtful opinions and and loving sensitivity.

For thirty years Gay and I have been lovers, friends, and partners. Whenever there were risks to be taken, I knew Gay would be there to share whatever the fallout might be. She is incredibly generous of spirit and our emotional bond has been a tremendous support in the highs and lows of life. Over the last ten years, as more and larger public projects have been undertaken, Gay's role in the studio has also expanded. She is often now directly involved in concept development as well as overseeing the execution of projects. Perhaps it is rare to live and work together so closely, but we wouldn't have it any other way. This exhibition is dedicated to Gay.

HOWARD BEN TRÉ

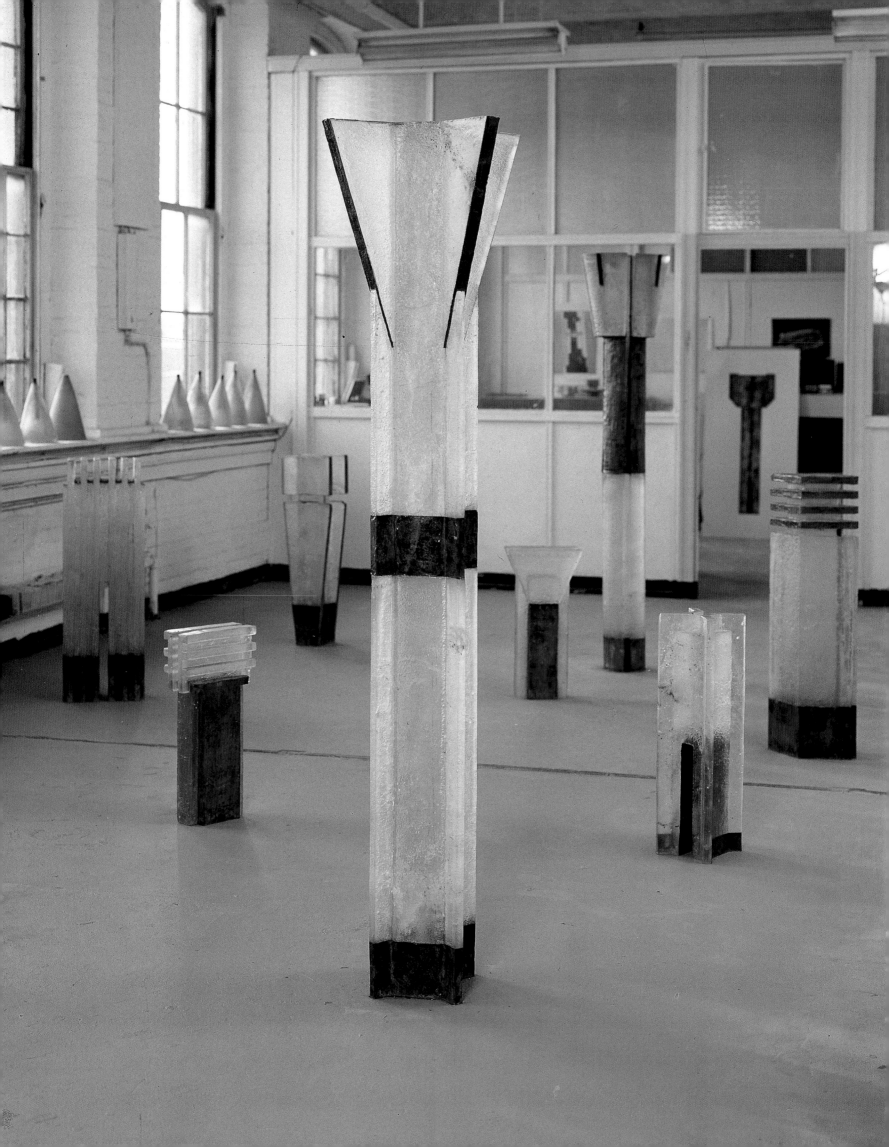

TRANSCENDENT FORMS

Mary Jane Jacob

Art uniquely can speak across time and place, be at once deeply personal and universally profound, transform matter into something greater than itself and transform us upon encounter and much later in ways that point to something greater than ourselves.

Howard Ben Tré's art takes an ancient material and references ancient forms through contemporary and innovative methods of working. It relates to man's historical beginnings and modern achievements. It is of particularized places and everyplace. Ben Tré's art is spurred by his need to express subjects and images of his own artistic imagination. His works tell us about our world today while referencing archetypes, things we know even without actually experiencing them (see fig. 1). In the artmaking process, Ben Tré's materials undergo an alchemical transformation—sand becomes glass, a substance of the earth takes on aspects of the unearthly, matter becomes spirit. His objects affect us, move us, can change us.

Ben Tré's art stretches from the intimate to the environmental; it embraces sculpture and drawing. Through his way of working with glass, he expands its use and changes what "glass" can mean in art. It is a medium and way of working that is between the worlds of life and art and because of this it provides substantive answers to questions of what is art and how does it relate to life.

Howard Ben Tré defines his art as work and his work as art by forging a link between his work as an artist to the American tradition of industry and the modern industrial aesthetic. Ben Tré's family history and the way he came to artmaking allow him to traverse the class lines that divide our image of artist from worker, and which correspond to the imaginary line between the contemporary art and noncontemporary art audience in today's art world. His immigrant father had studied art before World War II at New York's Cooper Union where classes were free and, therefore, accessible to a wide range of individuals. But after returning as a GI from World War II, he took up carpentry and cabinetmaking to earn a living, putting aside any dream of being an artist for the reality of a craftsman.

Howard Ben Tré attended Brooklyn Technical High School and always made things with his father in his shop.[1] Early in his career he held jobs in industry. As he moved toward art, a conflict emerged between doing something useful and making art. An American dilemma, corresponding to a division between the working and privileged

classes, it chafed against both his personal background and growing social consciousness in the 1960s. This was to be resolved by adapting an industrial way of working to working as an artist, adopting an industrial material as an art medium, and developing an open and generous, democratic attitude toward the public as his audience.

Howard Ben Tré's ties to working-class ideals and his admiration of the industrial aesthetic is part of the story of Modern art in the twentieth century, marked at the beginning of this century by the Cubist incorporation of the *objet trouvé*, the Futurist love of the machine's speed, and the Russian Constructivist designs for the masses. It finds expression closer to home in the sculpture of the 1950s New York School constructed of industrial materials using industrial methods. Artists such as Theodore Roszak used processes of welding, screw-cutting, and machining to create sculptures from mechanical parts. David Smith, influenced by his early experience as a metal worker in an auto plant, set up his studio in an industrial site and took his art-making technique and materials as well from industry. Seymour Lipton, like Ben Tré, revealed the process of the making in the textural surfaces of his work. He worked the metal to achieve, as Ben Tré does with glass, an unconventional beauty. Like Ben Tré, he also used this industrial material to create a deeper, spiritual world in objects whose forms have an inner and outer dimension: for Lipton, they were "one in the struggle for growth, death and rebirth in the cyclic renewal process...a sculpture as an evolving entity...a thing suggesting a process";[2] for Ben Tré, the duality of form functions in a contemplative sense of spiritual oneness.

FIG. 2

Cast Forms in Pilgrim Mills studio
Providence, Rhode Island, 1980

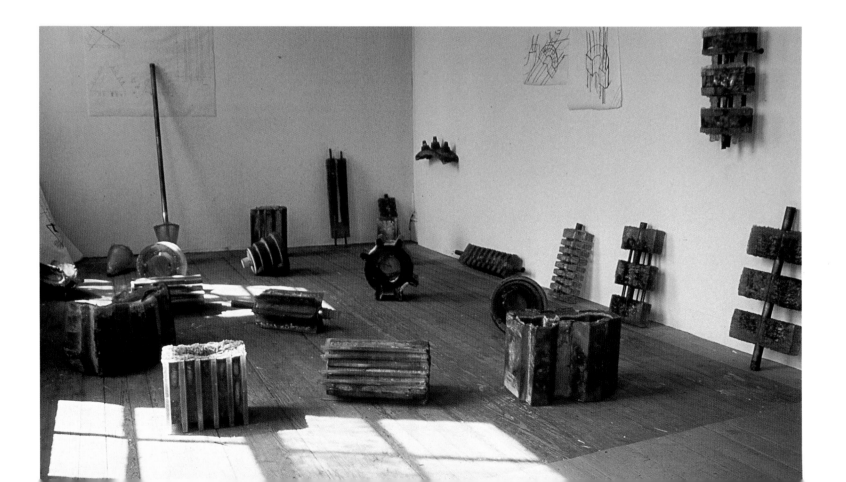

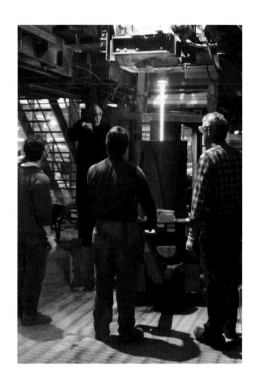

The material most frequently employed by Ben Tré is glass of the industrial variety. Like the Corten steel of Richard Serra's sculpture, it is brought into the world of art by the artist. In its unbleached, unpurified state, this glass maintains the green cast of its iron oxides. It does not resemble the colorful and sumptuous contemporary glass art of the last two decades. Rather, its beauty lies in its sense of light and strength, its own brand of refinement that at the same time preserves a rawness. Industry even figured among Ben Tré's first images: his earliest works in glass, dating from the late 1970s, make reference to small machine parts, gears, and electrical components (see fig. 2).

The labor-intensive methods of Howard Ben Tré intentionally evoke the work of the laborer: "This work alludes to products of the working class because I utilize the techniques of the working class...the accumulation of my knowledge."[3] To make his art, he uses the furnaces of industry. Their drama tells of the worker who must depend on his own technical know-how to get the job done, while at the same time negotiate the real dangers that surround him. Ben Tré is at home in the workshop atmosphere of the factory-cum-studio: "I am comfortable with this period of intense manipulation...me as magician, playing with a potentially dangerous substance."[4] It is with respect for the skill that workers and craftsmen employ that Ben Tré hones his own abilities and then uses them differently in a perpetual inventiveness of process.

Ben Tré's approach requires collaborating with industry and convincing owners and their employees to open up their facilities–and themselves—to his work (see fig. 3). He must demonstrate that *art is work*, a serious and productive occupation, an activity equally of the mind and hand in which material and making are in the service of meaning. Interacting with the workers, getting them to buy into and respect his activity as *work* and appreciate his art as a *work of art*, and then to push their own way of *working*, requires that he establish a dialogue with them about making, about their skill, about art. Here, even before the work is complete, Ben Tré begins his relationship with the public. He begins with the individuals in the places of industry he occupies or on the construction site of his public projects, with those outside the art world with whom he comes in contact during the process of making and who become a part of that process. They are his first audience.

Sand casting is a technique adopted from industry as well as art; it is a process used traditionally with bronze, but with few links to glass. Exploring the potential of casting arose out of a conceptual need when, as a student at Portland State University, Oregon, Ben Tré was unable to achieve the forms he wanted with traditional glassblowing techniques. From the start he pushed the boundaries of the process and soon became the first to cast whole glass objects on a large scale. Later, at the Rhode Island School of Design, he was an anomaly in an environment of glassblowing. The

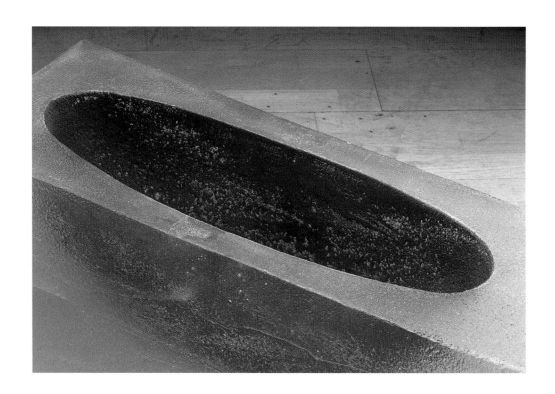

FIG. 4

Basin 11, 1991 (detail)
See cat. 24

FIG. 5

Chinese
Ax *(yue)*, mid-second millennium ᴮᶜ
(Zhengzhou phase)
Bronze, 16 ¹⁄8 x 10 inches
Hubei Provincial Museum, China

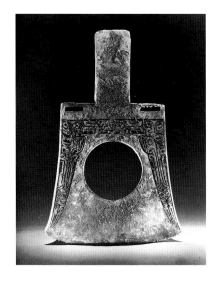

FIG. 6

Basins and *Primary Vessels* in
Lafayette Street studio
Pawtucket, Rhode Island, 1991

path he has followed in casting glass has been self-taught, altering the casting process as he needed. For example, in the early 1980s, he used copper as cladding or fused it with the molten glass inside the mold. Copper was an appealing material because, like the glass, it, too, turned green, producing the effect of something unearthed. Then he expanded his vocabulary, using gold and bronze, followed by metallic powders (iron powder, iron filings, red iron oxide, and others) which created particularly subtle and beautiful effects. Rubbing this loose material into the pores of the glass created depth out of negative space—the sense of another presence within the object. It produced color, too, but not in a decorative way, while still preserving the material's light-absorbent quality. This can be seen in an exceptional group of works called *Basins* (1991), inspired by prehistoric implements in the collection at the Museum of Anthropology in Edinburgh (see fig. 6). Simple, small utilitarian forms, here enlarged, take on the profound nature of religious or ceremonial objects (see fig. 4). Then, in 1993, he began to wrap lead around the diameter of his cast forms, in part referencing the Buddhist ritual of encircling trees and sculpted religious objects with strips of cloth, and further developing the spiritual connotation of his art.

Ben Tré's interest in combining metal with cast glass is no surprise. He came to this technique through casting bronze, first as a high school student, and, importantly, through his study of ancient Chinese bronzes.[5] As with the *Basins*, BenTré has often looked to the past in developing his work. In their greenish color and single-pour process of section molds, these bronzes parallel Ben Tré's own art. But, more

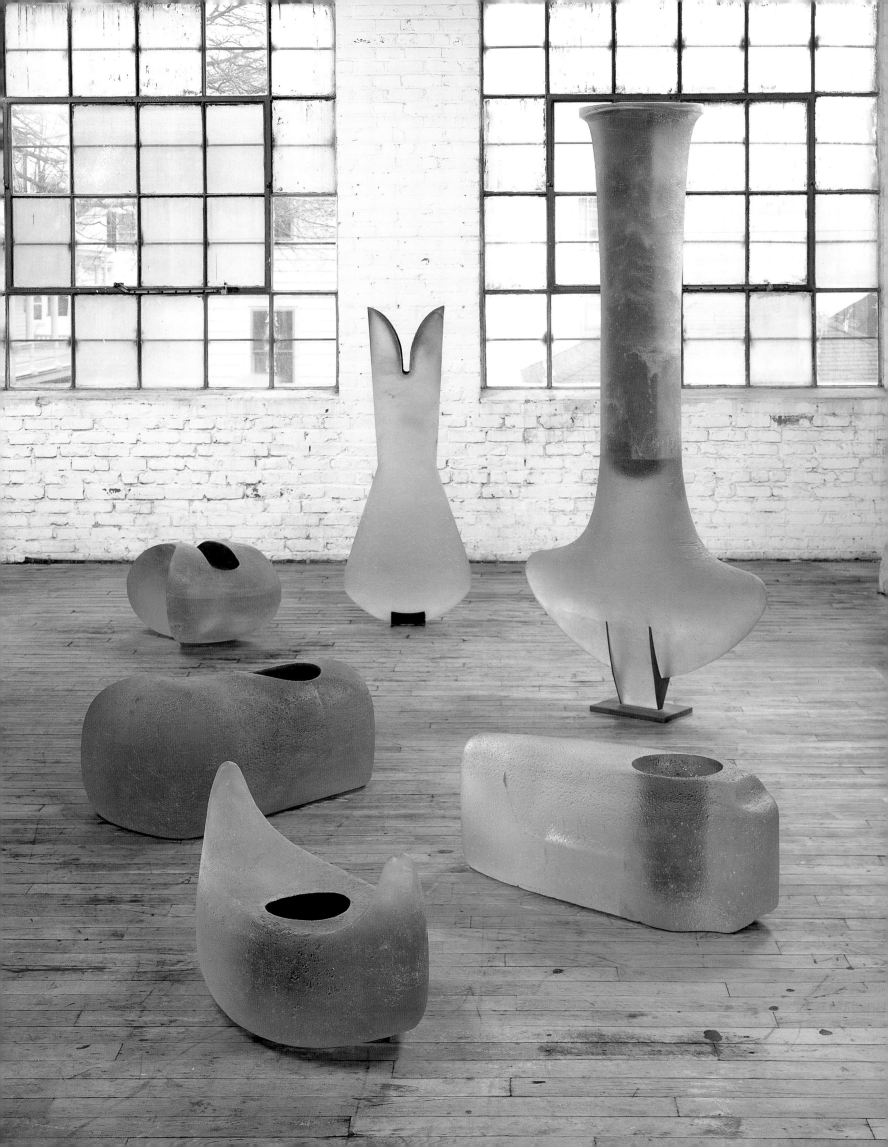

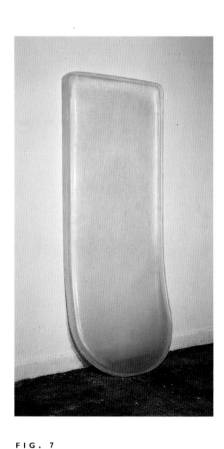

FIG. 7

Rachel Whiteread
Untitled (Clear Slab), 1992
Rubber, 78 x 31 x 5 1/2 inches
Private collection, Switzerland

significantly, these ritual objects, based on ceremonial weapons, possess the sense of spirituality that Ben Tré continually seeks to infuse into his own art. A striking example dating from the Early Bronze Age in China (second millennium BC) is an axe with a circular opening at the center of a large blade (fig. 5).[6] Its powerful relationship of line and shape, silhouette yet sculptural effect, outer form and inner recess, is linked to the way in which Ben Tré develops his sculptures as simple forms, abstract and timeless, that reveal an interior form or inner life. It is with such archetypal shapes—the vessel, the column, the lingam—that Ben Tré transmits a sense of the sacred to the object.[7]

Casting is not only technologically linked to ancient times, it is a method that itself conveys age and memory. As a process, it parallels the unearthing of objects in an archaeological dig, preserving a likeness in a fossil or a death mask, or recording images in a rubbing. Another artist who has employed casting for its evocative associations is Rachel Whiteread (see fig. 7). She re-creates everyday objects, revealing their outer shape, their negative impression, or the under side of things. While her pieces of furniture, mattresses, or bathtubs bear familiar characteristics that belie their banal uses, she aims to show the spirit of these objects and of those who used them. The surfaces of Ben Tré's and Whiteread's works are highly particularized—textured, seductive, and unique—lending a history to each object. Like Ben Tré, Whiteread has a preference for casting industrial materials. When her choice is resin, her castings possess light effects that enhance the sense of depth—a quality pervasive and important to Ben Tré's use of glass. It is through casting that Whiteread and Ben Tré give their objects a transcendent quality and create forms that tap into a universal, unconscious level of memory. But casting has its destructive side, too. For Ben Tré, the fiery blaze of the glass furnace is both formative and threatening, and the creation of an object necessitates the breaking of the mold. For Whiteread, who casts using the actual thing (on a scale from stools to a water tower), the object of origin is lost forever. The tension evoked by the process of casting is one of destruction to preserve the memory of life, a death to arrive at a rebirth.

For Howard Ben Tré, casting is also "performance," "interacting with the energy of the material."[8] It is a blind process, and the element of risk adds to the mystery and power of this way of working. The moment of the casting itself is an intensely physical activity; it is the culmination of an extended period of artistic and technical preparations that take place within the privacy of the studio: conceiving, sketching, making mechanical drawings, constructing patterns and sand molds, undertaking technical calculations. It is also a pivotal moment which is followed by many hours of grinding, polishing, developing patinas, and other finishing techniques. Yet it is in the immediacy of the actual casting—the pouring of molten glass—that sculptural form is born (see fig. 8).

FIG. 8

Casting at Superglass

Brooklyn, New York, 1981

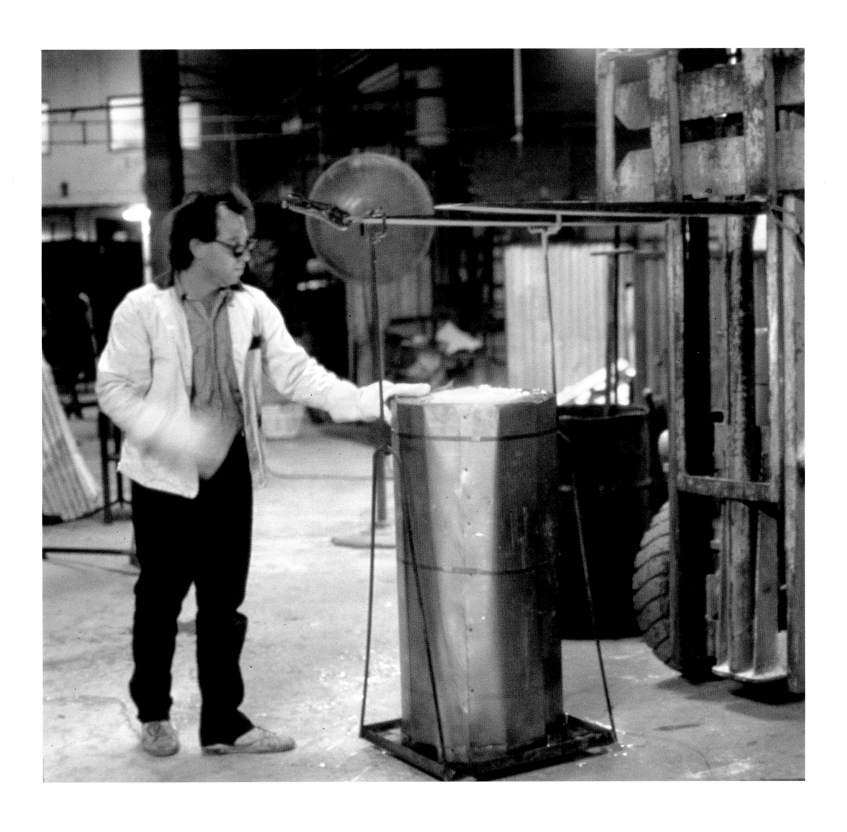

FIG. 9

Notebook Drawing for Large Basin, 1998
Graphite on paper
11 x 8$\frac{1}{2}$ inches
Collection of the artist

Process is also evident in Ben Tré's works on paper—in individual drawings and in the sequence of works on paper that lead to and emanate from his sculptures. The very beginning of translating and making real an image in the mind occurs informally, privately, as a gesture in the artist's notebook (see fig. 9). When an idea is ready to move from notation to drawing, it moves as well into space. These next-stage working drawings—large linear expressions—are made in an enormous, ten-by-twelve-foot drawing area. They immediately assume a scale at which they can be experienced in a one-to-one relationship to the body of the artist, who also stands in for the viewer, and in relationship to the floor and dimensions of the room. Final size and shape remain intuitive decisions of the artist; they are made experientially. Lines, at first gestural and loose, become definite when the form is clear. Ben Tré goes back into the overlay of the many earlier strokes, using drawing tools to fix the image. The resulting mechanical drawing represents a schematic way of thinking and is simultaneously a drawing and the first step in mold-making for glass casting (see fig. 10).

But there is another, independent type of drawing in which Howard Ben Tré engages. A significant body of work is constituted by his works on paper and monotypes. They are artworks in themselves, not part of the sculpture-making process, yet they result from the concept and form of specific objects. These drawings embody the idea of the sculpture in another medium. Perhaps most interestingly, more than any of the preparatory drawings for actual sculptures, these works of art *are*

FIG. 10

Working drawings in Lafayette Street studio
Pawtucket, Rhode Island, 1993

FIG. 11

Work on paper for Wrapped Form 3, 1993
Mixed media on paper
82 x 37 inches (framed)
Collection of David Winton Bell Gallery
Brown University, Providence, Rhode Island

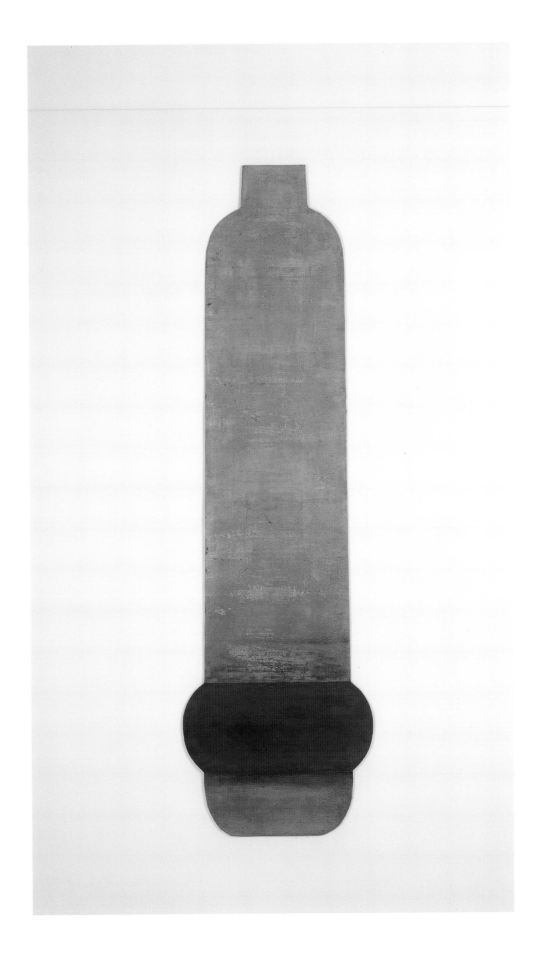

sculptural. Like reliefs, their shapes are themselves dimensional as well as references to the three-dimensional forms of related sculptures. While their silhouette parallels the shape that bounds the cubic mass of a sculpture, their own form is created in a complex manner that goes beyond simple representation of an object on a flat plane (see fig. 11).

A few of these works evidence the casting process, being defined in two halves, one articulated as a volumetric form, the other half remaining a pure and simple outline, a slice of shape. But it is primarily in evidencing their own making as drawings that Ben Tré's works on paper excel and become a major part of his oeuvre. By building up surfaces with a mixture of media (gesso, modeling paste, gel medium, gouache, pigmented wax, paints, graphite, gold leaf or metal powders, and patinas) in a manner somewhere between painting and sculpture, he creates surfaces on paper which, like his sculptures, are substantive and suggestive.

Yet for all the attention to and beauty of his drawings, sculpture is Ben Tré's primary discipline and glass his favored medium—Ben Tré's glass is a metaphor to communicate his ideas as well as a rich formal presence. His glass speaks across time—recalling ancient glass, the product of an earlier era of technology, while reminding us of familiar modern architectural uses. A number of contemporary sculptors have used glass as a part of their oeuvre. Tony Cragg, for example, who began his career assembling color-coded plastic detritus into wall and floor works, has employed both found and fabricated glass objects to make reference to another recognizable category of objects: bottles and beakers of domestic and scientific variety (see fig. 12). In 1989 Ben Tré used similar forms: his *Vases* and *Goblets* enlarge ancient artifacts; his *Flasks* and *Beakers* memorialize objects of the laboratory (see fig. 14). In these works both Ben Tré and Cragg created the surface quality of glass as it has survived the ages or has been sand washed at sea.

Kiki Smith has returned to glass on a number of occasions for its ability to take on the sense of the body: the image of hands, feet, breasts; the vulnerable self; a preserved specimen; or, as with semen, a fluid aspect in movement and transition (see fig. 13). She uses glass for its associations with the feminine—fragility, decorativeness, and craft—then reinvests these qualities with female power, giving the female body a social weight. Ben Tré, on the other hand, has gravitated to the form of male power. His phallus-shaped works dating from 1993 share their identity in form and meaning with the lingam which stands as the image of the god Shiva, the supreme force who is both death and generator of life, Shiva in his procreative aspect (see fig. 26). Ben Tré has previously used vertical forms, most notably for his *Columns* of the mid-1980s.[9] But, like their Indian counterparts, these abstract and archetypal examples become a sign of potency, of life-giving power, the divine force of the universe, an ultimate spiritual force.

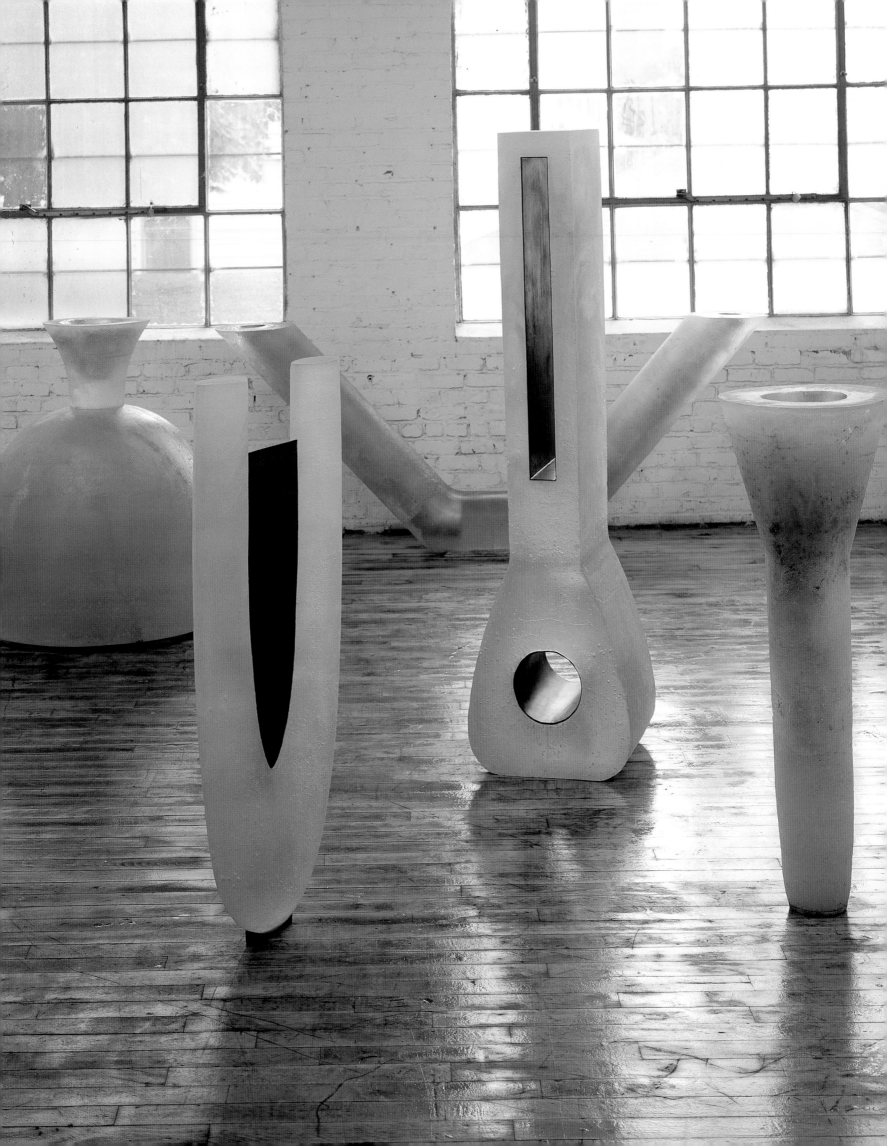

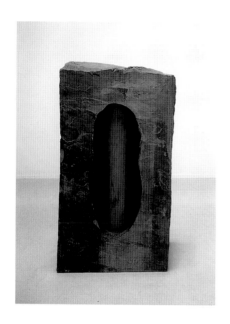

The luminous quality of Ben Tré's material evokes a source of being within his work and some of his lingams even have inner forms. *Solitary Form 2*, for instance, reveals an object within, which he has created by rubbing iron powder into the central cavity (fig. 16). Formally and spiritually, these objects relate to the work of Anish Kapoor, whose large, simple, and sensuous abstract forms are centered on the space within them (see fig. 15). Juxtaposing aspects of the lingam and the cosmic void, the simultaneity of male and female generative powers, both artists unite the outer form of the object and the space within—the dwelling place of mystery, the unconscious, the site within which lies all creativity, all potentiality. Like the Indian lingam that is joined to the symbolic *yoni*, or vulva, Ben Tré also evidences this dual iconography by positioning the vertical form within and one with its circular base, thereby bringing together male and female aspects to connote the primal moment when these two opposite forces come together in an act of (pro)creation (see fig. 17).

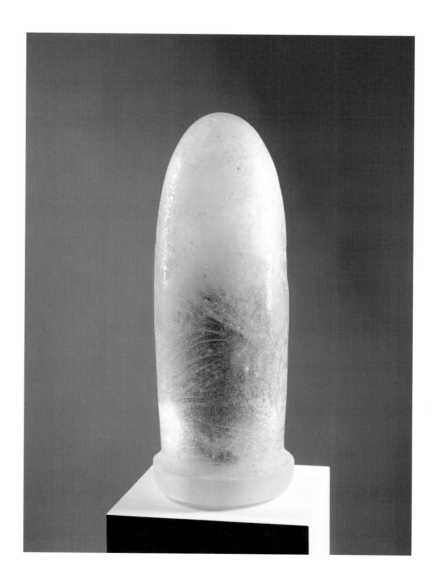

FIG. 17

Solitary Form 1, 1993
Cast glass
54 ¹/₂ x 12 x 12 inches
Collection of the artist

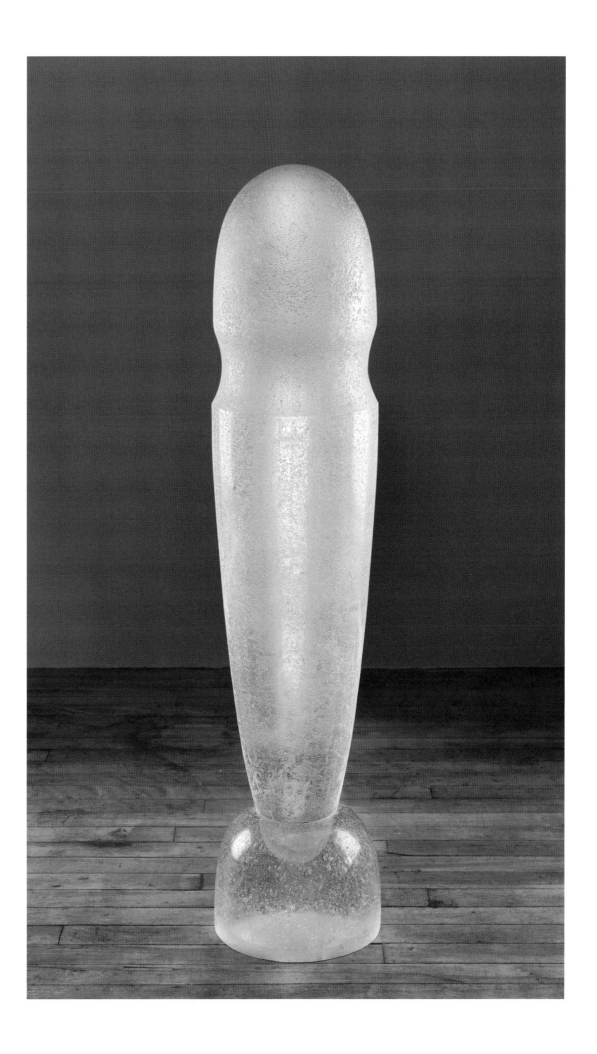

FIG. 18

Column 31, 1986

Cast glass, copper, and patina

92 x 32 ¼ x 24 ¼ inches

Collection of the High Museum of Art, Atlanta

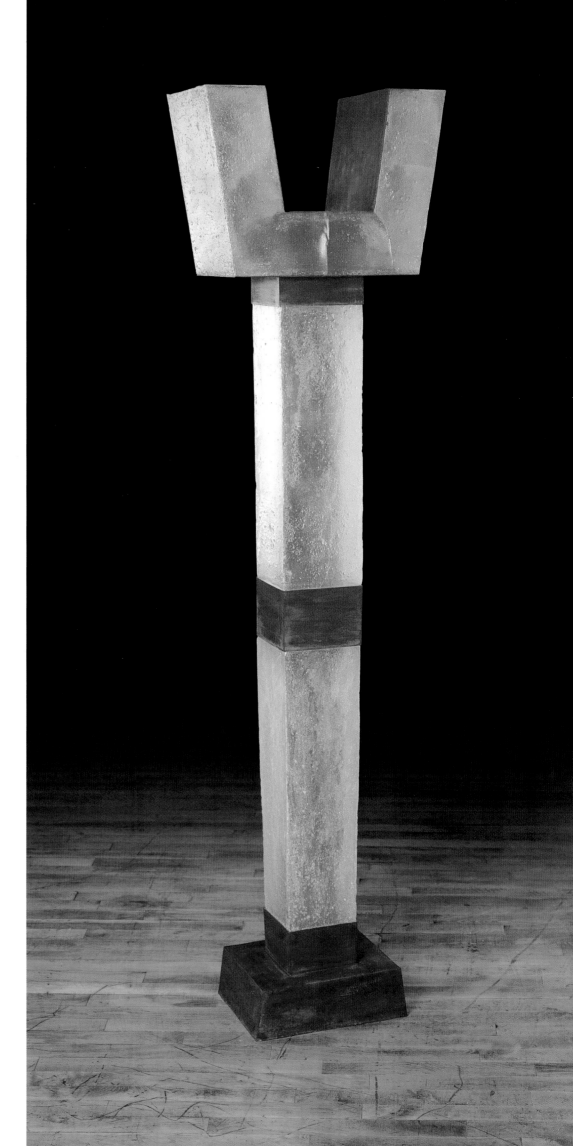

A different source of powerful, archetypal forms is provided for Ben Tré by ancient architecture. For his earliest glass works, he focused on floor plans from the distant past, recasting their spatial configuration into miniature, blocklike sculptures. Glass became more architectural with his *Columns* (see fig. 18). Idiosyncratic in their awkwardness and lack of pristine refinement, they were inspired by a trip to Greece in 1984 and embody Ben Tré's own experience of classical architecture there as fragments of the past, disjunctive in the present. With these works he achieved a sculptural statement in glass, too, that rejected the decorative or ornate. These objects and their employment in projects for public use appropriately evoke the strength of ancient classical as well as American Neoclassical styles built in the image of democracy. To Ben Tré, these architectural elements also suggest human forms; their dissimilar frontal and profile views seem to echo the different sides of human nature. He developed this figurative aspect a decade later in his *Vessels*, again returning to a classical reference.

While glass has been a part of architecture for centuries—stained glass and mosaics were crowning glories of churches in the Middle Ages and Renaissance— it is only in modern times that it has become the structure itself. It became the skin of buildings in the eighteenth century with a rise in building vast glass structures as conservatories, culminating in 1851 with the Crystal Palace in London. In this present century, with architects such as Mies van der Rohe, glass came to be used as the leading feature of office and home. Today we are surrounded by glass; it defines the spaces we occupy while allowing the outside to come in. In the 1950s and 1960s, architects experimented with glass houses as energy-saving, flexible, partitioned space. However, Ben Tré's glass, obscured and sculptural, comes closest in architectural precedent to the work of Frank Lloyd Wright—not Wright's art glass window designs, but his

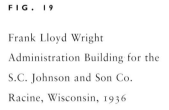

FIG. 19

Frank Lloyd Wright
Administration Building for the
S.C. Johnson and Son Co.
Racine, Wisconsin, 1936

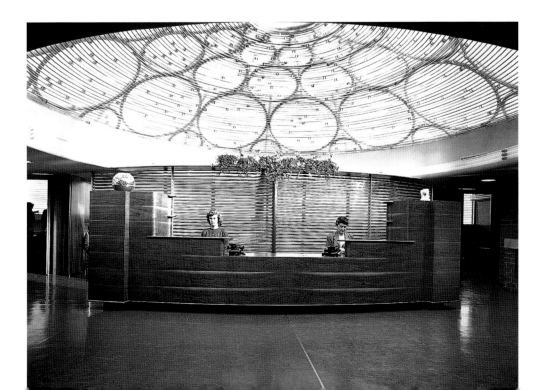

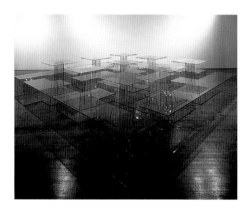

embrace of industry. Wright's use of industrial glass reached its high point of sculptural effect with the Pyrex glass tubes in the Johnson Wax Administration Building in Racine, Wisconsin, completed in 1939 (fig. 19). Wright created ceilings, barrel-vaulted passageways, and screen walls of glass, proclaiming: "Let the modern now work with light, light diffused, light reflected, light refracted—light for its own sake, shadows gratuitous."[10]

In addition to creating sculptures that reference architectural elements, Ben Tré has also made functional architectural elements, specifically benches. Benches have been an oft-employed idiom in public art and the master of this genre was Scott Burton. But there is an inherent irony in the idea of sitting on a fragile, do-not-touch substance. Vito Acconci played off this tension in his *Maze Table,* for which sheets of production glass were cut into rectangular tables and chairs and interconnected so that use required negotiating passage through the glass and past other persons (fig. 20). Ben Tré's industrial cast glass, on the other hand, provides a more stable presence. One of the most beautiful of his benches, *Ring of Knowledge: Ground, Water, Fire, Wind, Void*, with its rough-hewn sides, even takes on the textural look of carved stone (fig. 21).

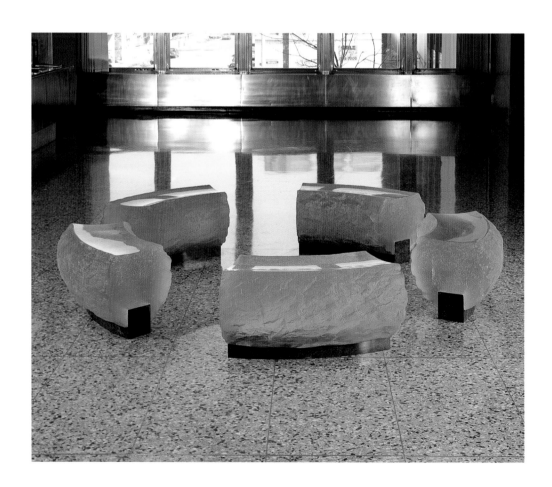

FIG. 22

Robert Smithson constructing
The Map of Glass (Atlantis)
Loveladies, New Jersey, 1969

FIG. 23

Maya Lin
Rock Field, 1997
Glass, 46 components, dimensions variable

Among the most powerfully evocative connotations of glass is its affinity with water. Howard Ben Tré's green glass has the tint of seawater; it is water in captured form. Water has had a profound presence in Ben Tré's life. He grew up in Rockaway Park on Long Island, and, after his mother died, he spent time just walking along the shore. Today he lives in the colonial port city of Providence and during the summer spends time at his ocean-front cabin on an island off mid-coastal Maine. His archetypal forms in fixed-fluid form connect to water and to our deepest memories and feelings.

Glass has been used by other contemporary artists in making sculptures around the concept of water. Rebecca Horn used droplets of condensed water on the underside of a glass lidded box to create the effect of countless teardrops. Robert Smithson created the island of Atlantis out of a vast pile of fragments of broken green industrial glass on a site in New Jersey in 1969, metaphorically suggesting the outlying water (fig. 22). He subsequently used 100 tons of the same material on Vancouver Island, with the intention of creating a monument to entropy: it would be covered by water, decompose, and eventually return to its original form as sand.

Maya Lin, in seeking to work between nature and architecture, has used glass, evoking its origin in natural materials, to represent sand or stone and the cycles of time. Her *Rock Field* (1997) is comprised of forty-six blown-glass elements in the shape of rocks found along a river bed or field boulders polished in the slow passing of a glacier (fig. 23). In *Avalanche* (1998), Lin used eleven tons of shattered blue-green industrial glass spilled out of the gallery corner and onto the floor, like a liquid caught in motion or like frozen bits of ice, while in a related work, *Groundswell* (1992–93), she used the same material to create an ocean floor to address the elusiveness of borders between land and sea that allows for unchecked exploitation.

Ben Tré has not only used glass to evoke water, but he has also combined glass and water in his public projects, drawing upon the innate harmony and unity between these two substances. Water is sensed in the glassiness of his sculptures symbolizing the primordial ocean or amniotic sac within which the formless takes shape. With its fluidlike quality, glass itself seems to be made of liquid. By adding the actual flow of water to the material's implied fluidity, Ben Tré animates his work (see fig. 24). Thus, his public spaces become a meeting of matter, of forces of nature, of solidity and movement, calm and change.

Water is a welcoming focal point in cities, marking a place to gather where sanctuaries are hard to locate. Ben Tré has used it as a basis for the creation of a communal, public, shared experience. Fountains are a universal source of pleasure and beauty. They are psychological outlets and, like hydrotherapy, use the body's need for water and its physiological responses to it to produce changes in human energy. Water in cityscapes reconnects us to our geographic and historical shores and reminds

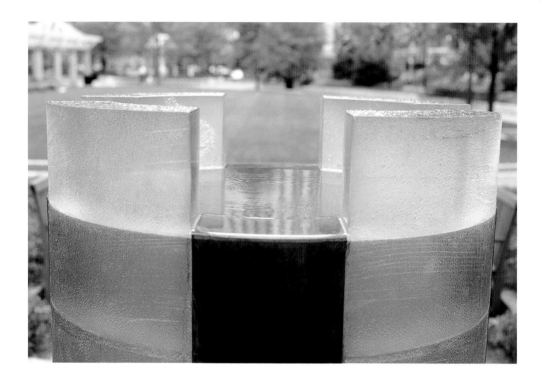

us of the way bodies of water shape the character of places. Fountains can be a means of bringing the sea back to city life. And just as water sources have played a role in the founding of many cities, fountains in public plazas today can play a role in civic improvement and urban redevelopment. They can serve as symbols of revitalization, drawing upon water's restorative power and offering replenishment in the barrenness of the built environment.

Though public art is often a battle ground between commissioned artists and presiding architects, fountains most usually remain the domain of the latter for reasons of engineering and construction. Ben Tré's public projects are works of architecture as well as sculpture. Here his ability to both conceive artistically and accomplish technically arms him in this proverbial tug-of-war, and his overall sense of the site development leads object and space, art and environment, to become one. It is here, too, in these public projects, that the hand and the mind, experience on a bodily and mental plane, the personal and communal aspects of Howard Ben Tré's art, are most resplendently resolved.

In his large-scale plans, Ben Tré has employed water in different forms, creating varied rhythms and meanings, from classical Greek features at Post Office Square in Boston to a more Renaissance sculptural display in his latest Providence project. Ben Tré also brings to his public sites and use of water the image of the Hindu temple. The dominant vessel-shaped sculptures in both the Boston and Providence plazas suggest the ritual act of offering thanks (see fig. 25). In this aspect they can be

FIG. 25

Immanent Circumstance
Norman B. Leventhal Park
Post Office Square, Boston, 1992 (detail)
View of urn fountain, South Plaza

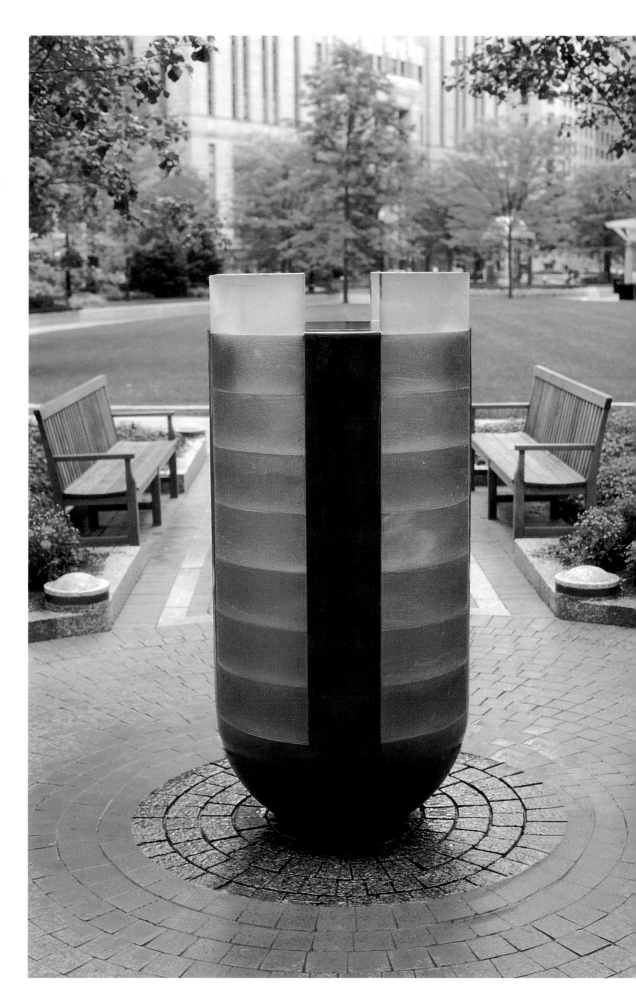

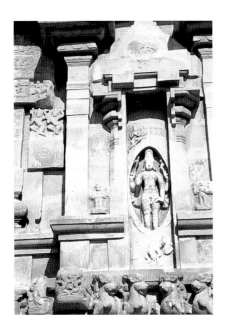

FIG. 26

India

Shiva Lingobhava, Brihadishwara Temple
' Thanjavur, Tamil Nadu, India
10th–11th century (detail)

interpreted as the Indian lingam within the yoni. The water that flows over these sculptural forms continually reenacts the pouring of libations (water, milk, oil, flowers) on the lingam, recalling the birth of Shiva, and ritualizes the flow of semen and Shiva's endless powers of generation (see fig. 26).[11] In actual religious practice this gives a glossiness to the lingam's surface; in Ben Tré's sculptures the state of glorification is made permanent by the medium of glass. This analogy extends to the siting of Ben Tré's sculptures within the plaza when compared to the placement of the lingam in the temple. The lingam is placed at the center of the yoni circle. It is surrounded by a ring of stones to symbolize the relationship of the mountain and the rivers, the life force and the waters that give birth to it, the male and the female. Ben Tré's urns are surrounded by concentric rings of pavers in Boston and Providence, the latter of which also includes a large seating ring (fig. 27). At the Boston site this relationship is echoed at the opposite end of the park where a vertical shaft of descending water is encased within a circle of columns, a seating ring, and, finally, water jets (fig. 28). As the main object of worship, the lingam is located at the center of the temple sanctuary, at the innermost place, the life-center, the axis of the universe. In Boston the two fountains (the urn and ring of columns) and the vessel fountain in Providence each command a key position at the center of the zone of the plaza that they occupy.

FIG. 27

BankBoston Plaza
Providence, Rhode Island, 1998 (detail)
View of urn

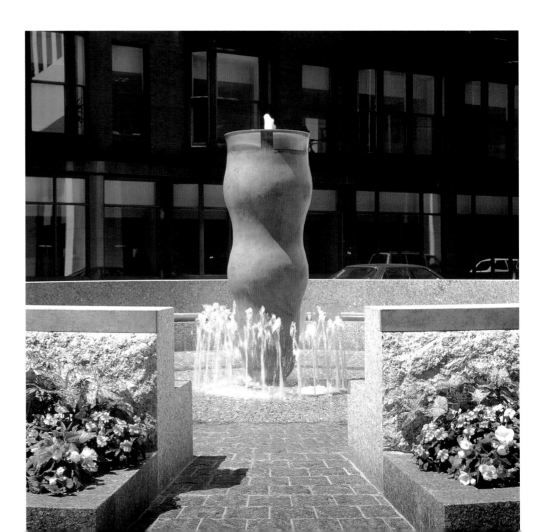

FIG. 28

Immanent Circumstance
Norman B. Leventhal Park
Post Office Square, Boston, 1992 (detail)
View of North Plaza

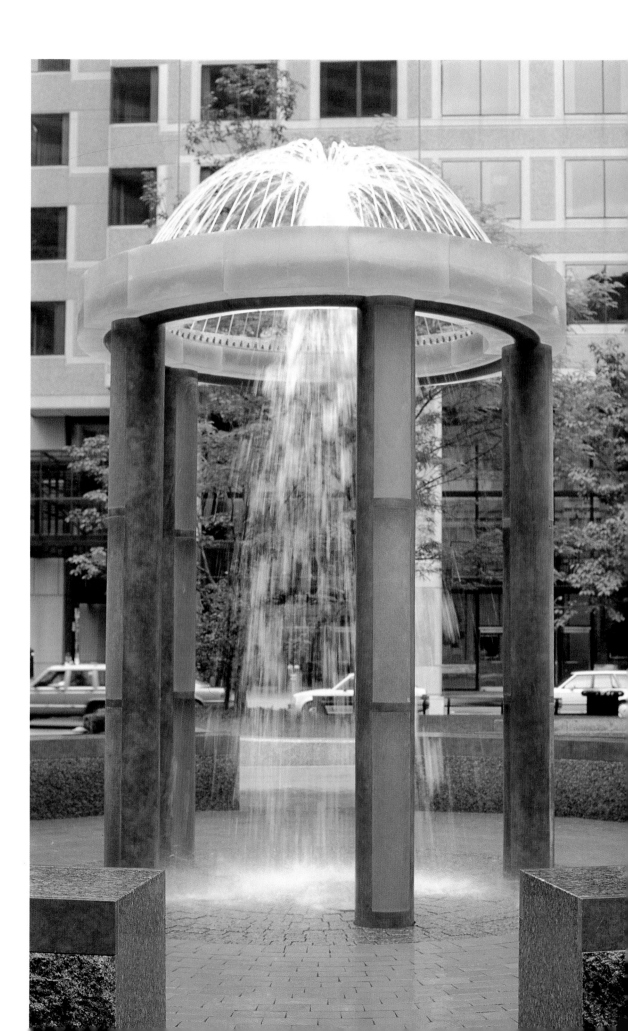

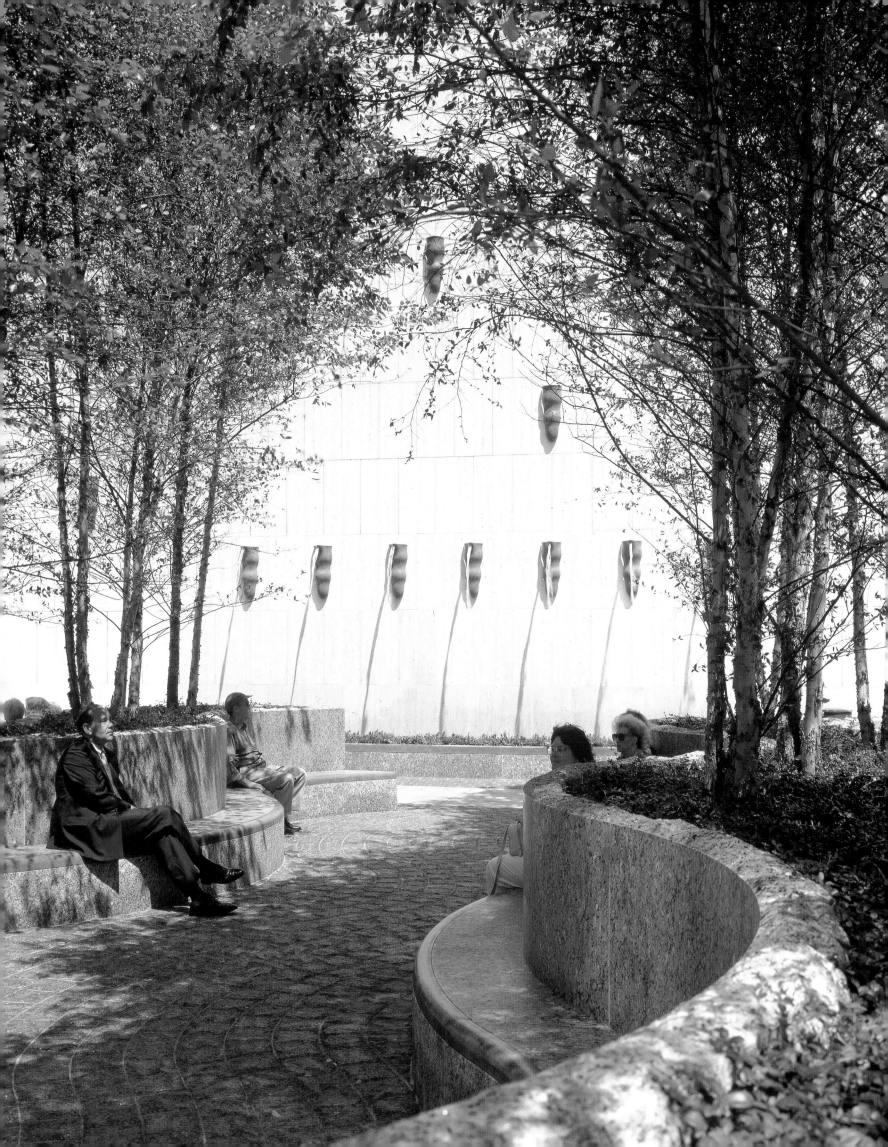

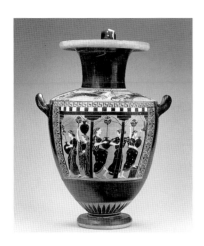

Architectural critic Aaron Betsky has cited four fundamental forms that water can take in architecture: a point, a line, a pool, or an edge.[12] This image of the eternal spring, water bubbling from a single point atop urns, occurs in Ben Tré's fountains in Boston and Providence. These fountains, in not revealing their source, have a mysterious quality that evokes the origin and nurturing of life, physically and spiritually. In their constant flow, disappearing and reemerging, they serve as a sign of life's cyclical renewal and hope.

Ben Tré has also employed Betsky's category of water as a line. One of his earliest efforts, an unrealized project for Hayden Square in Tempe, Arizona, would have resulted in multiple lines of falling water (fig. 31). This proposal recalls a Greek fountain house *(krenai)* of columnar porches or a small, templelike structure that served as an early public plaza, a place for carrying out daily life and meeting (see fig. 30).[13] Ben Tré planned four columns united by a square header from which water would rain down. This concept, transformed into a circular structure, was later built as part of the Boston plaza; lines of water stream down from a halo of jets. Again, lines or streams of water issue forth from a series of jets along a wall in Providence. In this plaza, too, Ben Tré drew the line of the river in the wavelike seating that connects the two ends of the space and makes them flow together (fig. 29).

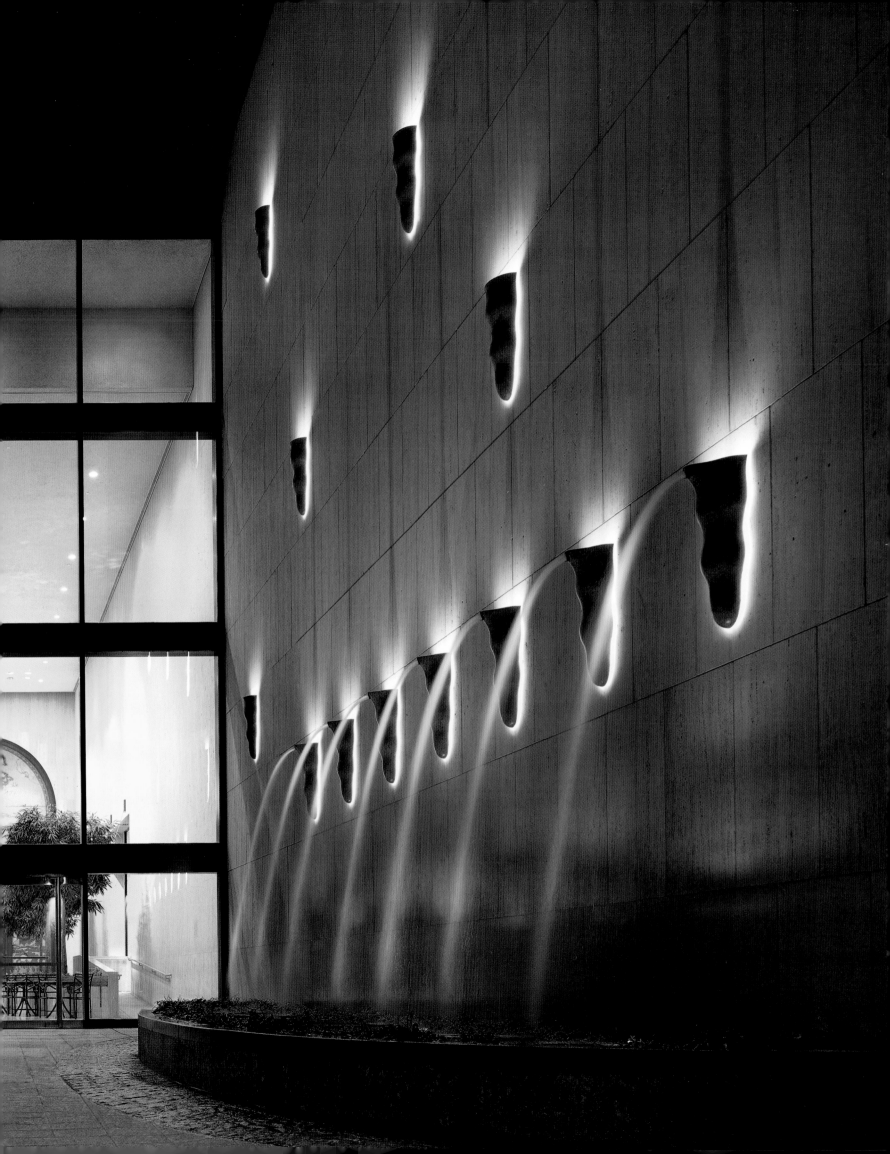

FIG. 33

Elevation for Pinnacle of Stones
(fountain proposal for the
Scottsdale Public Library, Arizona), 1993
Ink on vellum with pressure graphics
24 x 28 inches

Ben Tré's plazas celebrate the coming together of people, allowing for a communal exchange around Betsky's third manifestation—a pool of water. There the sound of his fountains spreads to the surrounding landscape of the plaza or park, enabling the visitor to inhabit a seemingly quiet place, a retreat in a city of activity and noise. Like the Hindu temple that they parallel, Ben Tré's public plazas are places of contemplation. Finally, in Ben Tré's projects, the last of Betsky's types—edges—describes zones within the plaza and between these spaces and the street, the edge we traverse entering and leaving the space the artist has designed for us (see fig. 32). In crossing, cultures and people meet and mix. Crossing this edge offers new possibilities for recreation and for re-creation of the self and of the city.

In contrast to fountains of the past which served as primary sources of water, today in urban landscapes they exist within a society in which water is otherwise hidden by the network of pipes that forms our modern sanitation system. We take for granted that when we turn on the faucet, water will be there. In doing so, we not only disassociate ourselves from the water's source, but also from responsibility for the ecology of water.[14] This subject was taken up by Ben Tré in one of his most beautiful, yet unrealized, designs that was destined for the Scottsdale Library in Arizona (fig. 33). A series of small stones were to form a giant cone and from its crevices water would seep, poetically reflecting the scarcity and preciousness of water in the surrounding landscape. Another ecologically based work, currently in the planning for Las Vegas, confronts the issue of a limited water supply. To resolve one faction's desire for the refreshing and beautiful flow of water, and another's mindful plea concerning the shortage of water, Ben Tré created a plaza of multiple water features—only one of which

FIG. 32

BankBoston Plaza
Providence, Rhode Island, 1998 (detail)
View of sconce wall at night

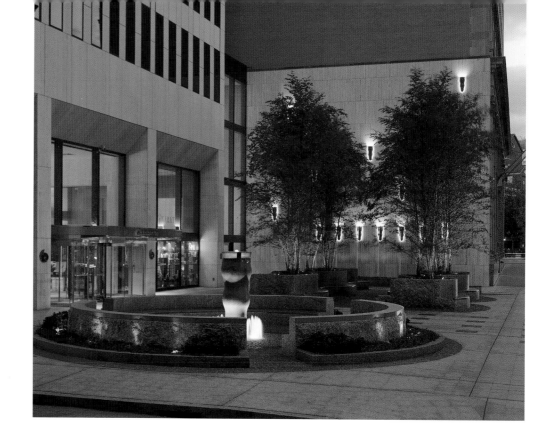

FIG. 34

BankBoston Plaza
Providence, Rhode Island, 1998

can be experienced at a time. In order for alternate manifestations to take place, the others cannot occur: one use has to be sacrificed for another; a choice must be made.

Howard Ben Tré's public projects enable him to reach a larger public, one outside the art world, the one he meets in the industrial workplace, the one in his neighborhood, in the city center, on the street. Creating an experiential meeting ground, he enables audiences to respond outside the framework of art history—from life—and to think about art as part of their lives. All of Ben Tré's work explores art's universal potential to cross class and audience boundaries. His art communicates with a generosity of expression by speaking through multiple languages: the familiarity and beauty of glass, the object excellently executed, architectural and environmental aspects, archetypal forms sensed more than known, spiritual evocations (see fig. 34). It is in this broader communication—taking the personal to a public level and creating works that emanate from and reach out to body and mind—that Howard Ben Tré's art finds its function and meaning.

NOTES

1. In the same way, Howard Ben Tré and his son worked together to restore a boat not only to enjoy the Maine coast, but, more importantly, to reinforce the value and freedom of being able personally to undertake useful activities.

2. New York, Whitney Museum of American Art, *The Third Dimension: Sculpture of the New York School*, text by Lisa Phillips (New York, 1984), p. 31.

3. Howard Ben Tré in New York, Hadler/ Rodriguez Gallery, *Howard Ben Tré* (New York, 1980), p. 1.

4. Ibid.

5. Although Ben Tré came to casting through metal, it is also one of the oldest glass techniques, beginning in the second and first millennia BC with pressing melted chunks of glass into molds or chip casting, pouring crushed old glass into a mold and firing it. By the eighth century BC in Assyria, casting in

closed molds began, a process which resembles that of today. See Marianne E. Stern and Birgit Schlick-Nolte, *Early Glass of the Ancient World: 1600 B.C.–A.D. 50* (Ostfildern: Verlag Gerd Hatje), p. 48.

6. The asymmetrical tangs of the blade would have been inserted into slots in a wooden shaft, secured with thongs, and laced through the central hole.

7. Richmond, Virginia, Marsh Art Gallery, University of Richmond, *Howard Ben Tré: Recent Sculpture* (Richmond, 1996), p. 11: "I've definitely made use of icons and symbols from other cultures, but they are not used in a formal sense...I am trying to meld all of these universal feelings into something archetypal, which becomes formal simply because it becomes an object."

8. Ibid.

9. Not only are Ben Tré's *Columns* and lingam forms formally related, but the Indian lingam is derived from a Neolithic practice of worshipping a stone column. In turn, the column as the dwelling place of the god developed from a burial marker. This association contributes to the genesis of the meaning of the lingam as both an emblem of death and a symbol of life.

10. Bruce B. Pfeiffer and Gerald Nordland, *Frank Lloyd Wright: In the Realm of Ideas* (Carbondale, Illinois: Southern Illinois University Press, 1988), p. 60. Ben Tré also used Pyrex for his fountains in Post Office Square in Boston (1989–92).

11. The origin of the lingam is intrinsically linked to water. See Steven G. Darian, *The Ganges in Myth and History* (Honolulu: University Press of Hawaii, 1978), p. 104. According to one myth of the lingam, Indra, king of the gods, was freed of his guilt in the location of what is now Madura and, looking for the cause of this miraculous experience, he discovered a lingam beneath a tree. He paid worship to it with flowers from a near-by pond, which became a holy place known as "pond of golden water lilies." See Heinrich Zimmer, ed., By Joseph Campbell. *The Art of Indian Asia: its Mythology and Transformations* (New York: Pantheon Books, 1955), p. 283. In the *Kathasaritsagara*, Shiva was born out of water: "And Shiva rose from the lake...in the form of a linga." Rising from the ocean, Shiva appeared as a blazing pillar, a towering lingam crowned with flame. As it grew into infinite space, the side burst open, revealing Shiva in a nichelike aperture, the lord of the lingam, the supreme force in the universe. See Zimmer, p. 129.

12. Aaron Betsky, "Take Me to the Water," *Architectural Design* 65, 1-2 (January/ February 1995), p. 11.

13. The Greek fountain house was a popular improvement over wells and cisterns as a place for women to fill water jars. It also afforded them a meeting place, one of the few where women and slaves could gather. There were other fountain houses where men took showers.

14. Charles Moore, *Water and Architecture* (New York: Harry N. Abrams, Inc., 1994). Historically water sources were important places which were celebrated by fountains as focal points within cities. For architect Charles Moore: "Fountains symbolize both the emergence and disappearance of fresh water," an essential and, therefore, sacred source of life (p. 21). He has written of our changed and dangerous contemporary relationship with water: "At the end of the millenium, we are faced with the dilemma of balancing human needs with respect for nature. If water is being used neither much nor well in our own architecture, then surely some of the difficulty can be traced to our confusion over what sort of attitude toward nature we are trying to express" (p. 23).

INTERVIEW WITH HOWARD BEN TRÉ

Patterson Sims

Meeting together in early October 1998 amidst his orderly and spare studio outside Providence, Rhode Island (see fig. 1), and at a nearby restaurant, Howard Ben Tré and I started talking in the early afternoon and we stopped four and a half hours later. What follows is a carefully abridged and edited version of our conversation with several additions inserted over the next four months. Gay Ben Tré was with us most of the time, and her occasional responses were added in such synchronicity with her husband's that some, with their consent, are simply folded into what he said. Their relationship is clearly a remarkable partnership, with Gay being his actual collaborator for the increasing number of major public projects they are taking on. Their family is completed by their son, Benjamin, who attends Columbia University. Clearly very close to their son, they nonetheless appear to be quite happy being together on their own for the first time since his birth. Straightforward and unpretentious, Ben Tré has a brisk and businesslike personality. Only his long ponytail and wry humor hint that his art would be about purity and transcendence.

PATTERSON SIMS: *Several years ago you said, "I needed to make certain kinds of objects in order to answer certain questions for myself." At the core of what I want to talk to you about is what were the questions you were asking yourself, and how did your art come about?*

HOWARD BEN TRÉ: In 1975, during a period of very intensive introspection, I became involved in "artmaking." The idea of making art objects was new to me and although I enjoyed the physicality of making sculpture, I also wanted the intellectual and emotional engagement of having the objects be explorative and not just process-bound. As part of my introspection, I was questioning how my growth as an individual as well as how my relationship to society in general were impacting what I wanted to make. At that point in time I had rejected all formal religion, but I was very interested in the role of ritual in the creation of belief. My wife, Gay, and I created some family rituals to replace those that we had been brought up with and, as a natural extension of this search for personal "authenticity," I was very interested in what it was that made an object or space have a sense of ritual about it. This question naturally lent itself to

FIG. 1

Howard Ben Tré in his Lafayette Street studio
Pawtucket, Rhode Island, 1999

abstraction. I really liked working with the glass, but just working with it wasn't enough. I wanted to work with it purposefully, and to engage my whole self in my making. I had already taken some art history courses, so I wasn't oblivious to twentieth-century or contemporary art concerns. But the question of pursuing abstraction didn't come about as a response to art historical concerns, but rather as a way to reflect all of my varied interests and discover how best to bring them into the making of sculpture.

PATTERSON SIMS: *Can you talk a little about your early life, your parents, and your family?*

HOWARD BEN TRÉ: My father's side is Jewish Russian and Polish. My father came to the United States when he was sixteen. My grandfather had already been in America for some time before sending for his son and his wife. Although he ended up being a carpenter, my father studied to be an artist at Cooper Union, the endowed art and science college in New York City. I still have some of his figurative sculptures. Unfortunately, he died when I was eighteen, and there is a lot of family history I will never know. My mother was born in this country, in Brooklyn. She was Jewish and of mixed Eastern European descent (see fig. 2). We lived in a working-class, middle-class area of Rockaway Park in New York City. Rockaway Park is a very narrow peninsula. Our house was half a block from Jamaica Bay and three blocks from the Atlantic Ocean. I spent my summers on the beach and many winter evenings as well.

Art was never really part of my growing up. When I knew him, my father's creativity was directed to his craftsmanship and carpentry. I was aware that down in the basement of our house were all these boxes full of his sketchbooks, detailed anatomy drawings, and books about Michelangelo, but visual art was never a priority.

My only sibling, my brother, Steve, is five years older than I am. He was an athlete, and the person I most modeled myself upon. He was the "good guy." He has become a successful businessman. We rarely saw my father, who went to work at six in the morning and came home at ten o'clock at night. We lived in a house that my father built himself. It was surrounded by a flower and vegetable garden that he loved to work in.

My mother died rather suddenly of lupus when I was thirteen. She was sick for a while and then, boom, she was gone. I sat Shiva and went to Mourner's Kaddish for my mother. I went to temple for eleven months, twice a day, at sunrise and sunset. Someone in the family must go, and my father had to leave very early in the morning to go to work. My brother was away in college, so I went two times a day by subway to the synagogue.

A year later my father married a special person. My stepmother, Pearl, worked as an executive secretary all her life, and she loved to go to the opera. She and I would sit

up late at night talking about politics, religion, and everything else. Her brother, Julie, introduced me to jazz. Pearl lives in Florida now and we are still very close.

I was a very intense young kid and they had no idea how to deal with me at home or in school. I had a high IQ, but I was in trouble—all the time. I attended an industrial arts and sciences high school, Brooklyn Tech. As part of their college preparatory program, I had art history courses and, among other things, I studied bronze casting and four years of architectural drawing. Brooklyn Tech's curriculum was demanding. It took one hundred and twenty credits to graduate; at that time in other public schools, you needed only forty-five.

PATTERSON SIMS: *You played football. Were you a great football player?*

HOWARD BEN TRÉ: I was an all-city halfback at Brooklyn Tech and we were the city champs. Although I never graduated from Brooklyn Tech because I didn't attend many classes during my senior year, I was recruited and went to college in Missouri on a football scholarship. I liked playing, but it didn't take long for me to figure out that playing football wasn't really what I wanted to do with my life. I stayed in Missouri the rest of the year but I quit the team after my nose was broken in practice by a teammate whose girlfriend I had befriended. Able to concentrate on studying, I got on the Dean's List and in the spring of '68, three of us held what was without a doubt the first anti–Vietnam War rally in Missouri.

PATTERSON SIMS: *Then did you come back to Brooklyn?*

HOWARD BEN TRÉ: In the summer of 1968, at the end of the school year, I returned to Brooklyn. In the fall I attended Brooklyn College. Of my studies at that time, it was my Greek and Roman civilization class that I found most interesting. I loved reading all of those Greek plays. At Brooklyn College I became a member of SDS (Students for a Democratic Society). I got involved in the strikes at Brooklyn College and Columbia University, the demonstration at Fort Dix, working with antiwar people and the Black Panther Party. Our protests were instrumental in the eventual passage of open admissions at the City Universities; an open admissions policy was part of a list of nineteen demands that the SDS and Black Students Union made during the sit-ins at Brooklyn College in 1969.

PATTERSON SIMS: *At that point were you living at home?*

HOWARD BEN TRÉ: I was living at home with my stepmother. My dad had died in November of my freshman year in Missouri. My father and stepmother had been

together only about three years when he died, but she had a great impact on him. She made him feel respected. He was the carpenter for the richer families who lived just a few blocks away from us. My father wrote phonetically, and he spoke with a heavy accent. He was a working person who experienced a lot of class attitude. Even my mother's side of the family was critical of him because he was an immigrant. These were the kinds of subtle things that eventually came to play a fairly major role in my immersion in the politics and activism of the '60s.

PATTERSON SIMS: *When did you meet Gay?*

HOWARD BEN TRÉ: Gay and I met in Cuba. In November 1969 we had both gone separately to the island at the time of the tenth anniversary of the Cuban revolution. People came from all over the world to cut sugar cane in a symbolic gesture (see figs. 3 and 4). That year was supposed to be a major sugar cane harvest, ten million tons, which was going to lift Cuba out of underdevelopment and into autonomy from the Soviets. This was the "heroic" era of the revolution. Gay and I were part of a group of one hundred young Americans (the Venceremos Brigade) of a variety of political persuasions who went down there to symbolically break the ideological and economic blockade. (Although frowned on by the State Department, it was not illegal to go.) For one thing, Cuba, as did Gay and I, supported the Vietnamese people's right to self-determination. But, more importantly, Gay and I were both drawn to this small island where we perceived the great social experiment of our lifetime was occurring. In 1969 the most pressing issues for our generation other than the Vietnam War were ending racial discrimination, changing the role of women in our society, and breaking down economic inequalities. We wanted to see firsthand how these issues were being tackled in Cuba.

After returning from Cuba, we both dropped out of college and put all our energy into political activism. Having been brought up in a country with a great tradition of utopian beliefs, Gay and I passionately wanted to help change our world for the better. Using the facilities of a neighborhood church in Brooklyn, we organized a community-based food cooperative, a rent strike for tenants' rights at a derelict apartment building in the neighborhood, and we worked to mediate and improve the tense relations between the black and white teenagers in our community.

In late 1970 we lost our sublet apartment and the church that provided space for our activities began receiving anonymous bomb threats. Wanting to move out of the city and believing we could effect greater changes by organizing on the job in our work places as well as through community-based activities, we moved to Portland, Oregon, where we knew of a loose network of young people with similar goals. There Gay worked in a sewing factory and I did construction jobs. We tried to

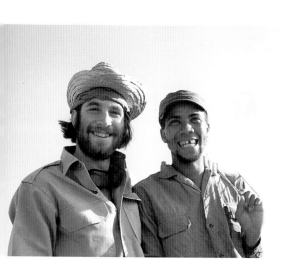

FIG. 3

Howard Ben Tré with a Cuban tobacco worker mobilized to cut cane in the historic *10 Million Tons* sugar harvest, 1969

live our politics. By then the "Movement" had imploded; the Black Panther Party leadership was in jail or dead and the Weather People we knew had taken their politics to a negative and violent extreme.

PATTERSON SIMS: *Was this the time in 1975 that you called at the beginning of this interview "a period of very intensive introspection?"*

HOWARD BEN TRÉ: Yes. By 1975 Gay and I had come to feel that the nature of our personal connection to people was as political and as important as trying to organize people in some kind of overt political direction. We realized that there are many different ways to make changes occur in society. Gay and I are always looking critically at ourselves and trying to understand who we are and what's right and how what's right fits into what we are doing with our lives.

I began going to school at night at Portland State University. Along with a science curriculum, I took several art history courses. The Dada artists really interested me because of their political side. Their art drew me into taking studio art classes, including sculpture, drawing, and printmaking. In retrospect, I believe this was a means to try to feel more connected to my father and deal with his death.

PATTERSON SIMS: *You seem to have moved very swiftly from social work to making objects in glass; how did you come to focus upon this medium?*

HOWARD BEN TRÉ: Portland State University had one of the earliest glass programs. Right away, I found glass to be a seductive and fascinating material. At that time everyone was blowing it. There were so many things about glass that drew me to use it: the material's interplay with light and its transforming physical states. I loved the physicality and heat of it. You could just stand in front of the furnace, and there would be that energy. Either you go up to the glass furnace and then want to step back six feet or you are somebody who wants to get inside of it; I wanted to get inside of it.

I started by blowing glass. However, my ideas were way ahead of my skills. My natural inclination was to think as a sculptor. The tension and the dialogue of the inside and the outside fascinated me. I found blowing glass very limiting; whatever you do on the outside happens to the inside. My interest in architecture and early cultures and civilizations couldn't really be explored or expressed through glass blowing. It was too narrow for my needs. One day I looked into the furnace and realized that the glass was another molten metal, not dissimilar to bronze. Once I realized that I could cast this material, I was swept up with the performance of capturing this molten material, ladle by ladle, and pouring it into my molds. I was never very interested in the transparency of glass. By forming the glass through casting, I could create

FIG. 4

Gay Ben Tré at the Venceremos Brigade Camp Havana Province, 1969

FIG. 5

Howard, Gay, and Benjamin Ben Tré
at Alternative Art Space 220
Providence, Rhode Island, 1999

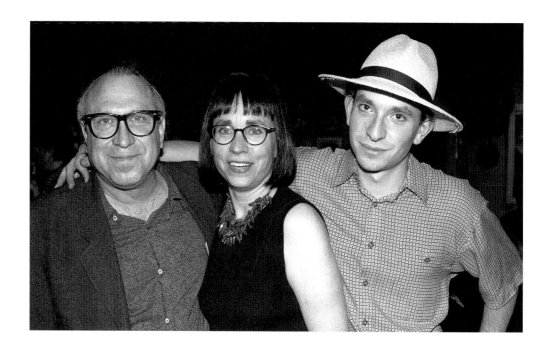

a thickness and density that trapped the light within the sculptures rather than letting it pass through. It is this translucency to which I connected.

PATTERSON SIMS: *Did you try to have other people come to Portland State and to set up a real program?*

HOWARD BEN TRÉ: Even though I was just an undergraduate student, I tried to make the program into something more expansive. I asked Dale Chihuly and Italo Scanga to come and talk to the students. That summer I went to the Pilchuck Glass School [a nonprofit school for glass-making outside Seattle begun by Chihuly and others]. The people I met at Pilchuck who were most interesting were the artists who had gone to the Rhode Island School of Design. I think that my professor at Portland State felt threatened and didn't want the program to change. In order to get the chemicals we needed, we students had to get them from the ceramics department late at night. We would go to the Goodwill and the Salvation Army and buy bed frames to make the angle iron for equipment. It was very much an outlaw program, and I liked it that way.

So I had an intense education. Meanwhile, Gay and I also were busy. We bought land about twenty minutes away in the West Hills outside Portland. We pretty much built the house we were living in and we built ponds, stone walls, dams, fences, and gardens. Gay and I did all that stuff together. It was a beautiful little spot. I remember people like the artist Alan Saret coming to visit who couldn't believe it when I said that I wanted to leave Portland to go to the Rhode Island School of Design.

PATTERSON SIMS: *But you felt you had to leave Portland and go to RISD if you were going to be an artist.*

HOWARD BEN TRÉ: During this time we were trying to start a family. When we found out that we couldn't, I was devastated. I felt as though I had no past that I related to and that we were not going to have any future. That's when I made up my mind to go to graduate school at RISD. I asked Gay if she would come with me. Later, when I was halfway through the Master's program at RISD, in 1979, Gay became pregnant and our son, Benjamin, miraculously arrived (see fig. 5).

PATTERSON SIMS: *When did you actually get married?*

HOWARD BEN TRÉ: I don't remember, maybe late in 1971.

PATTERSON SIMS: *And you changed your name when you got married?*

HOWARD BEN TRÉ: Before that. In fact, instead of getting legally married, in the spring of 1971 we changed our names. We had been living together and, at that time, mainstream society really frowned on such an arrangement. We were constantly being hassled about everyday things, so we decided to take a common name since we had already made our commitment to each other. But I didn't feel comfortable taking her name and Gay wanted to keep her own identity, so we decided to choose something new and meaningful to both of us.

PATTERSON SIMS: *Was it something like shortened parts of each of your family names?*

HOWARD BEN TRÉ: No. It's from Ben Tre, the first city in South Vietnam to fight against the French colonialists in the Indochinese War and, later, to resist the American occupation that eventually escalated into the Vietnam War. In 1969, the year we went to Cuba, a new town was built and it was called Ben Tre in recognition of that community of people who wanted to determine their own destiny. We were guests at its inauguration when we were visiting Cuba, and so we liked all these associations.

PATTERSON SIMS: *Getting back to your art, I am just going to name a number of artists and see what your reactions are. Brancusi seems like a good starting point. For me, your affinity has to do with a complete assimilation of world culture, very careful process, love of materials, and an ability to interconnect the spiritual and sexual sides of objects and art.*

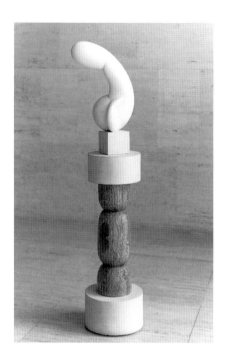

FIG. 6

Constantin Brancusi
Princess X, 1916
Marble, 22 x 11 x 9 inches
Sheldon Memorial Art Gallery
University of Nebraska-Lincoln
Gift of Mrs. Olga Sheldon

HOWARD BEN TRÉ: For me, Brancusi is a key figure in twentieth-century sculpture. Reading biographies of creative people is an interest of mine, and I had read several books about Brancusi. But until I went to Romania three years ago as a guest of the Romanian government for a conference on the legacy of Brancusi, I hadn't realized how much Brancusi's work is infused with his country's folk art, images, and traditions. All over Romania, in old houses, on picket fences, and on roof peaks, you see traditional folk carvings that were shifted in scale and context and turned by Brancusi's hands into the first Modern sculpture. His sculptures, like the *Endless Column*, are traditional folk carvings made on a completely different scale with different intentions. In Paris, of course, his work expanded because of other influences, especially African art.

One of Brancusi's important contributions was the relationship between his sculptures and their bases. At times the bases are integrated into the sculptures. At times the bases are sculptures themselves, as in *Princess X*'s smooth, polished marble form on rough-hewn timber (fig. 6). There is this great juxtaposition of surface and texture within the overall work.

I also identify with the sensuality of Brancusi's work. The brain and the intellect are most revered in Western culture and emotions are suspect, as evidenced by the tremendous influence of Duchamp. As a kind of homage to my father, I've made a real point of keeping a certain roughness about myself. I saw casting glass and the industrial processes it required as a way of exploring the sensual. Even though the forms of my sculptures often look refined, I also want the flaws, cracks, and irregularities of the material to be present.

PATTERSON SIMS: *Getting back to the influence of specific artists, what can you say about Eva Hesse?*

HOWARD BEN TRÉ: Lucy Lippard's book on Eva Hesse probably had the single greatest impact of anything I read while I was at RISD. Hesse's growth as an artist, her time in Germany and return to New York, the intense commitment and the somber facts of her life and death were incredibly moving to me. It is a book I have given, on occasion, to young artists. I respond most especially to Hesse's cylinders, their slumping movement and, of course, their translucency (see fig. 7). Eva Hesse worked with a "plastic" material, not transformed by heat the way glass is, but transformed through chemical catalyzation. In glass the shape is formed through temperature and time. Resins are formed through chemical reaction and time. These slumping cylinders are the result of Eva Hesse's manipulation of the chemical reaction and time. Because of the fiberglass in the resin, there is an opalescence or translucence that implies visual penetration of the volume and infuses them with an ethereal quality.

PATTERSON SIMS: *How about Christopher Wilmarth?*

HOWARD BEN TRÉ: Chris Wilmarth was a friend and someone whose work I was interested in from the beginning of my working with glass. We both reference industrial processes and products and have taken Minimalism to the next level: we've put our hands and souls back into it. Industrialization is not the final step in artmaking. You can go into the factory and use an industrial process in another way. You can be in control of that process and make art out of it. Donald Judd and Carl Andre are true Minimalists. Their art is concerned with the industrial production of an intellectual idea and that is that. Their art ignores the other aspects of creativity that are so important to me.

PATTERSON SIMS: *Are there any other artists you want to talk about who have influenced you?*

HOWARD BEN TRÉ: Isamu Noguchi. His art is sensual and spiritual. He was a person from no specific place, rejected by his father and initially in Japan as being American. At the same time, Noguchi never felt at home in America. He traveled the world in search of places where he felt grounded. Noguchi's global quest for venerated places and cultures and to find himself by traveling have always strongly appealed to me. In Noguchi's solitary sculptures there is a denseness, an inwardness, that touches me. One senses his profound affinity with the stone. He worked with earth materials—stone, bronze, and water—materials that have universal meaning and integrity.

Like Noguchi, I've wanted to make both public and private work. The fact that he could create his sculptures, do the Martha Graham stage sets, and make paper lamps, playgrounds for kids, fountains, or entire environments seems just wonderful to me—a life full of opportunities to make art.

PATTERSON SIMS: *You have made families of individual works; let's talk about some of these groups of works and the development of your art.*

HOWARD BEN TRÉ: Well, if you go back to my first, smallest objects, they were kind of a melding of my interest in architectural spaces and ritual objects (see fig 8). The first sculptures that had a specific focus to them referenced ziggurats, Mayan temples, and apses in naves of churches, but metamorphosed into the scale of ritual objects such as a Chinese bronze. During this time we traveled to Chaco Canyon and the Anasazi ruins of the American Southwest. I saw forms and spaces in foundations and architectural footprints. Years later I came across a quotation I really like from Louis Kahn: "Ruins are architecture freed from the burden of use."

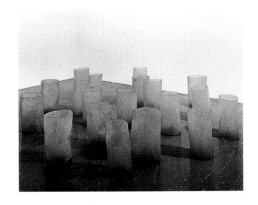

FIG. 7

Eva Hesse
Repetition 19, III, 1968
Nineteen tubular fiberglass units
h. 19 to 20^1/4 inches, dia. 11 to 12^3/4 inches
The Museum of Modern Art, New York
Gift of Charles and Anita Blatt

PATTERSON SIMS: *Where did you move from these first, small objects?*

HOWARD BEN TRÉ: The next group of work was based in the detritus of industry. Here in Providence I was confronted with defunct factories and outdated machinery. The legacy of the industrial revolution was its own obsolescence, but its discarded gears, cogs, and levers had proportion and geometry in common with classical architectural forms. I had an insight that you could take those machine-age artifacts and expand them into architectural scale and, on the other hand, you could take an architectural space and condense it into a mechanical form (see fig. 9). During my second year of graduate school, I made a group of pieces that were based on architecture, but looked like mechanical forms. They were exhibited in New York in 1980.

After I got out of RISD in 1981, I was separated from access to molten glass. Unlike many other people working with glass at that time, I didn't want my own glass studio. I saw that as a dead end for me as an artist. So I searched for an industrial glass factory that I could rent from time to time. By using an industrial facility, I would be able to increase the scale of my work because there would be large amounts of glass at my disposal.

With graduate school behind me, I started making my own works at Blenko Glass Factory, a commercial glass-making factory in West Virginia. Working at the factory allowed me to produce the next group of sculptures, which were architectural in scale (see fig. 10).

FIG. 8

Cast Form Type III, 1978
Cast glass
4 x 7⅝ x 6 inches
Collection of the artist

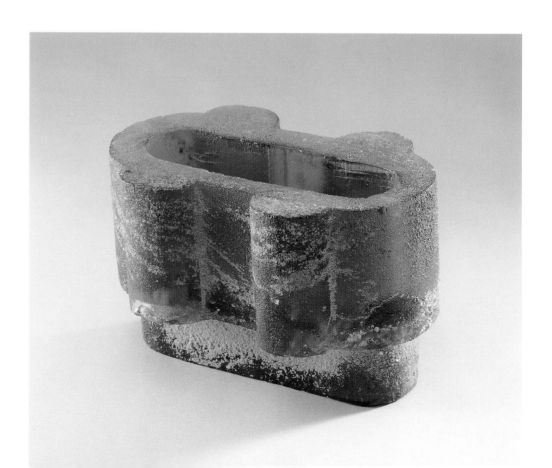

From Otto H., 1980

Cast glass and copper

12 x 16 x 7 inches

Collection of James and Daisy Fitzgerald

PATTERSON SIMS: *This is a good time to talk more about your use of glass factories.*

HOWARD BEN TRÉ: Those first two years when I went to Blenko Glass Factory were among the most difficult of my life, driving twenty-four hours to get to West Virginia and sleeping in the van because I had no money for a motel. Benjamin was very young and Gay and I were excited about what we were doing, but we were so broke that we were always on the edge. I was able to execute the larger work of that period only because of support from several collectors and help from our friends (see fig. 11).

In 1982 I began working with Superglass in Brooklyn. Superglass had its own issues and over the next sixteen years I made a lot and lost a lot of art there! Experimenting with factory processes meant that castings often had to be discarded.

PATTERSON SIMS: *Where do you cast your sculpture now?*

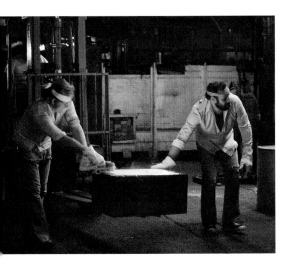

HOWARD BEN TRÉ: I rent different facilities depending on the kind of glass I want to use. For example, I have worked with Corning UK in Sunderland, England; Schott Glass Technologies in Pennsylvania; and currently, I have a special relationship with Lawson, Mardon, Wheaton in New Jersey.

FIG. 10

Casting at Blenko Glass Factory

Blenko, West Virginia, 1981

FIG. II

Cast Form XXIV (also Blenko #4), 1981
Cast glass and copper
23³/₈ x 13⁵/₈ x 11 inches
The Toledo Museum of Art, Ohio
Commissioned by George and Dorothy Saxe

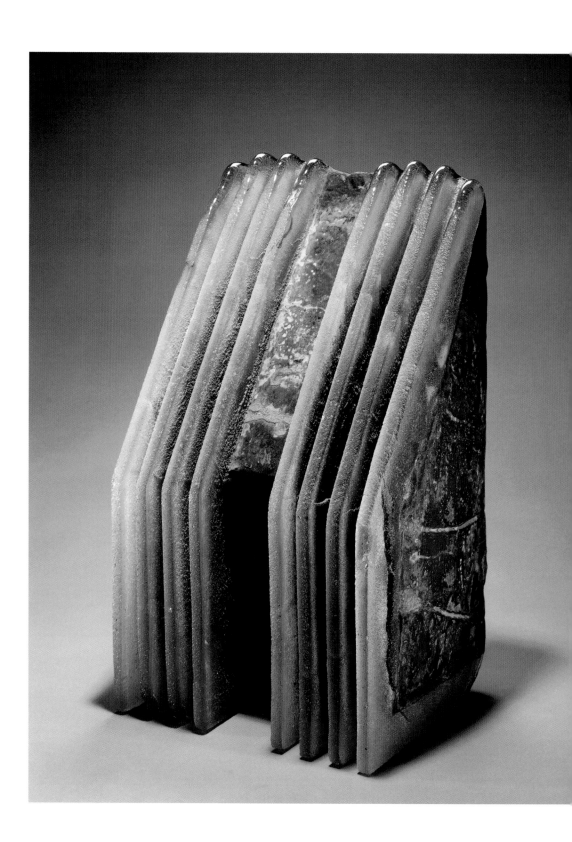

PATTERSON SIMS: *It is pretty clear to me that the definitions of craft versus sculpture or debating whether you "make" an object or have it fabricated from your careful drawings by artisans and studio are extraneous to your creative life. The point of what you do, regardless of the pursuit of defining craft as opposed to art or handmade process versus factory production, is the creation of transcendent art objects.*

HOWARD BEN TRÉ: Patterson, I think you've described my attitude better than I can. I have a great appreciation for crafts people. In fact, my father's carpentry and his attention to detail resulted from his craftsmanship. However, when I began working with glass, one aspect of the casting process that pleased me was the lack of control I had when pouring the glass, and the accidents that resulted. My lack of attachment to craft has allowed me to use whatever process I need to realize my ideas. Because I rejected glass as a material to make craft from, I was able to appreciate the conceptual value of the "flares" that are so apparent in my sculptures.

PATTERSON SIMS: *Let's move back to your work in 1982.*

HOWARD BEN TRÉ: By 1982 I was working in a variety of scales simultaneously. The smallest pieces became sculptural models for architecture. The larger works, the *Columns*, became literal architectural elements. Underlying all this was my exploration of the Western idea of the supremacy of the vertical as the means to creating spiritual presence. The *Columns* were very contemporary, yet not really modern (see fig. 12). Their green cast was industrial, yet imbued with timelessness. The forms had nothing to do with history, yet the texture and the surfaces seem to assert that they are ancient. Your eyes could travel into their thickness and this made their mass and density important.

Around this time I started making works on paper. I've always done a lot of preparatory drawing for my sculptures. These are gesture drawings that I turn into full-scale working drawings. By looking at these drawings as architectural plans, I started to fill in areas with gouache and copper leaf, creating a sense of volume and orchestrating spatial relationships within the different areas of the drawing (see fig. 13).

My sculptures are carefully conceived. I will draw and redraw a single line for days. More recently, creation of monotypes and works on paper always follows the completion of the sculptures. Conceptually, each work on paper describes the volume of its sculpture in a way most similar to my initial gesture drawings, but also reflects the information that I have accumulated through the making of the sculpture. Creating the work on paper enables me to summarize the concepts of the sculpture in a simple and direct way, in contrast to the protracted experience of making the sculpture. This

FIG. 12

Columns in the Capitol Industrial
Center Building studio
Providence, Rhode Island, 1982

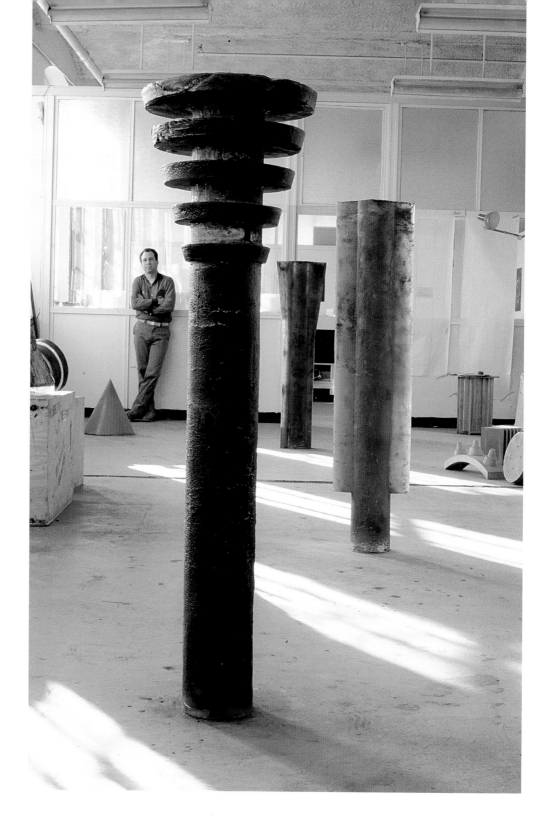

summarization at once gives me closure and a chance to reflect on possibilities. When I'm drawing, there comes a point in a group of work when the work speaks back to me and suggests a transition or change in direction.

The later *Columns* started to take on a figurative presence and became less about looking as if they were holding something up and more about holding something within. In 1987 I drew and then executed the *Figures* and then the medium-scaled *Dedicants*. These sculptures delineate the centering component of the body and the intellectual component. They also contain two forms, the outer and the inner. As you move around these sculptures, they get very thin or narrow (see figs. 14a and b).

FIG. 13

Untitled 10, 1984

Mixed media on paper

61 $^{1}/_{8}$ x 26 $^{1}/_{8}$ inches (framed)

Collection of Goldman Sachs and Company

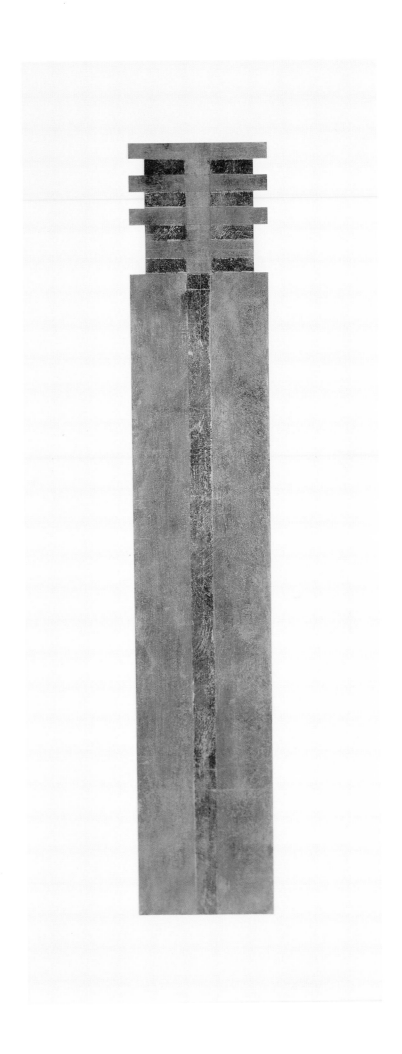

Eighth Figure, 1988

Cast glass, brass, bronze, gold leaf, and patina

$85\frac{1}{4}$ x 34 x 14 inches

Collection of the Centro Cultural Arte

Contemporaneo, Mexico City

Eighth Figure, 1988 (side view)

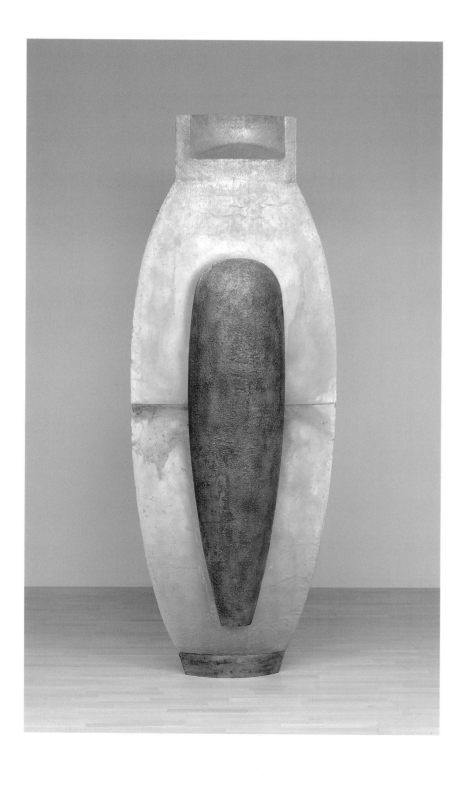

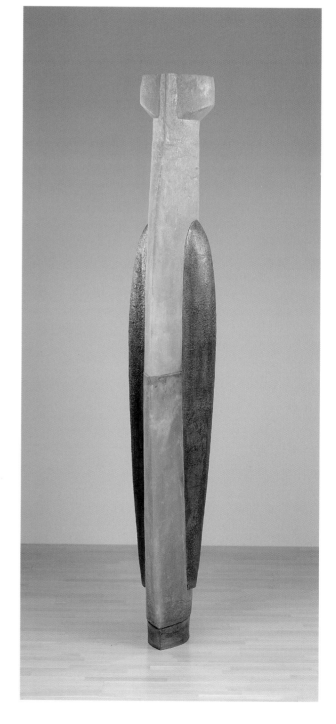

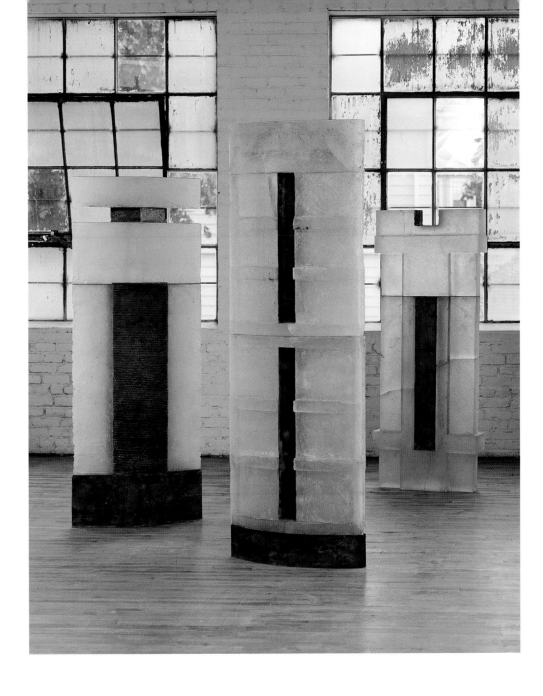

These dualities reflect the way humans present themselves, the outward self and the inner, private self. So, rather than being a literal human form, these sculptures express humanness. The *Figures* stand directly on the floor, inhabiting the ground plane with the viewer. By eliminating a formal base, they occupy the same space and are in immediate relationship with the viewer (see fig. 15).

PATTERSON SIMS: *Was the work becoming simpler or more complex?*

HOWARD BEN TRÉ: By the end of the *Figures*, from the *13th Figure* onward, I got involved in creating internal cavities visible inside the sculptures, but encased within the glass. The *Vessels* developed as I worked through the relationship between these internal cavities and the larger sculpture. In the various vessel forms, there are always two cavities or hollows which never connect (see fig. 16). This separation speaks to me of the disconnect that exists between the sexual, spiritual, and intellectual aspects of ourselves. Many times the cavities are coated with gold leaf with an overlay of lead,

FIG. 16

Siphon, 1989
Cast glass, brass, gold leaf, and
pigmented waxes
$38^{1/2}$ x 95 x 10 inches
Collection of The Metropolitan Museum of Art
New York

so that when you look through the glass, you see the gold, but when you look into the cavity, you see the exposed lead surface (see fig. 17). As with the *Dedicants*, where lead inserts are leafed with gold, I was interested not only in the alchemical idea of turning lead into gold, but I was speaking about perceived value (see figs. 18a and b).

PATTERSON SIMS: *Now let's talk about your subsequent works, the Basins and Primary Vessels.*

HOWARD BEN TRÉ: After years of focusing on the supremacy of the vertical and its architectural references, I wanted to explore ideas based on landscape and the non-Western perception of the earth as the ultimate power source. As with all of my work, there are many layers of reference and meaning. One aspect of the creation of the *Basins* was suggested by Japanese tea ceremony water basins. These basins are often carved from old stone temple parts and fragments and used for ritual cleansing (a transformation from vertical to horizontal use). To emphasize their hollow cavities,

FIG. 17

Second Flask, 1989
Cast glass, brass, lead, gold leaf, patina, and
pigmented waxes
71 x 19 x 18 inches
Collection of Simona and Jerald Chazen

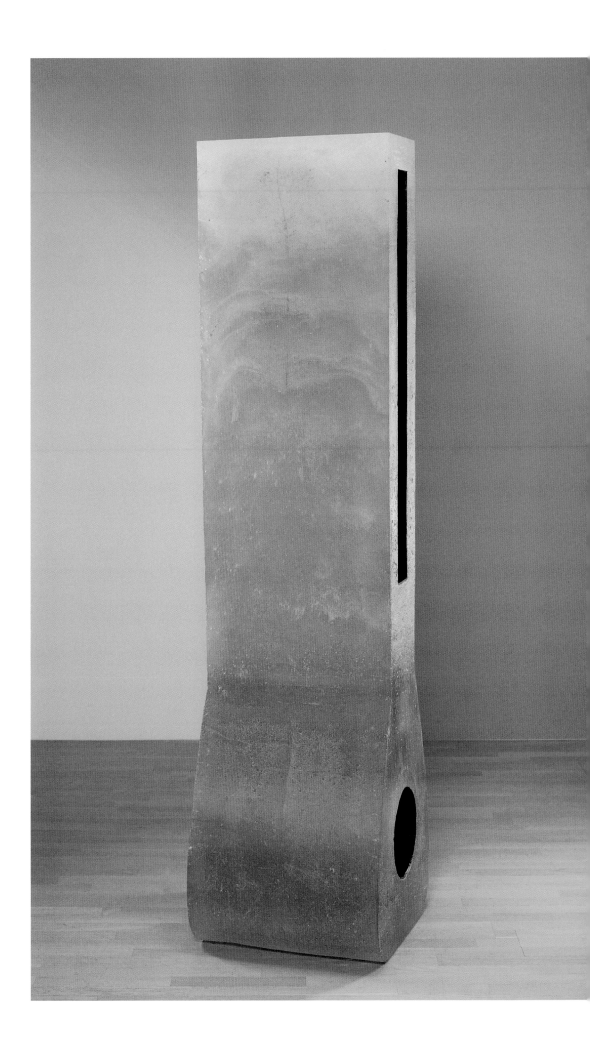

Dedicant 9, 1987
Cast glass, brass, lead, gold leaf, and
pigmented waxes
46 x 15$^{1}/_{2}$ x 13$^{1}/_{2}$ inches
Private collection

Dedicant 9, 1987 (detail)

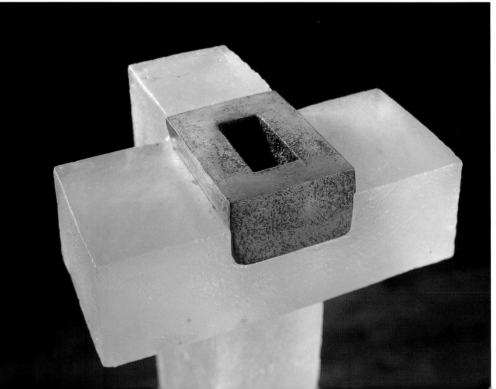

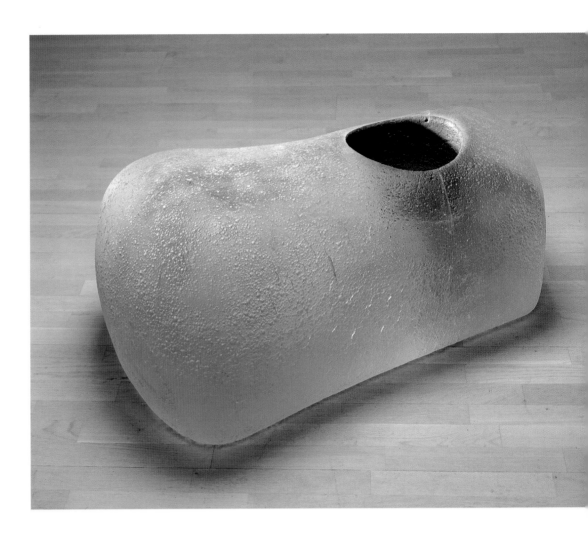

my *Basins* are filled with different earth oxides. Another layer of reference is prehistoric stone implements. These objects are identified with hunting and maleness. By coating the cavities to indicate a femaleness, I felt I was feminizing them. The negative space, coated with dark oxides, absorbs light, while the larger, exterior form transmits it (see fig. 19). The *Primary Vessels* are a coming together of my interest in the figure, the vessel, and the implement. Like the *Basins*, the *Primary Vessels* are engendered with large cavities lined with soft metal powders (see fig. 20).

PATTERSON SIMS: *Did your fountains come much later?*

HOWARD BEN TRÉ: Actually no, my first fountain proposal was made in 1981 for a park in Mexico City. The first realized fountain was made in 1983 for a home in Los Angeles with a Japanese-style garden. It was a post-and-lintel structure in which rainwater would collect and then spill (see fig. 21). The first active fountain was in Bethesda, Maryland, in 1985 (see Danto, fig. 4).

Primary Vessel 3, 1991
Cast glass, iron powder, and steel base
54^{1}/4 x 51 x 13 inches
Collection of Jan Cowles

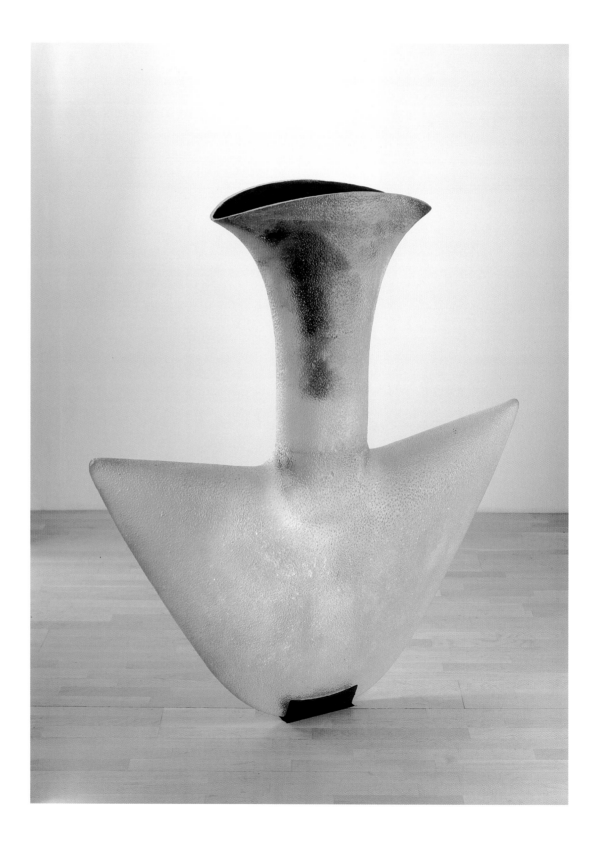

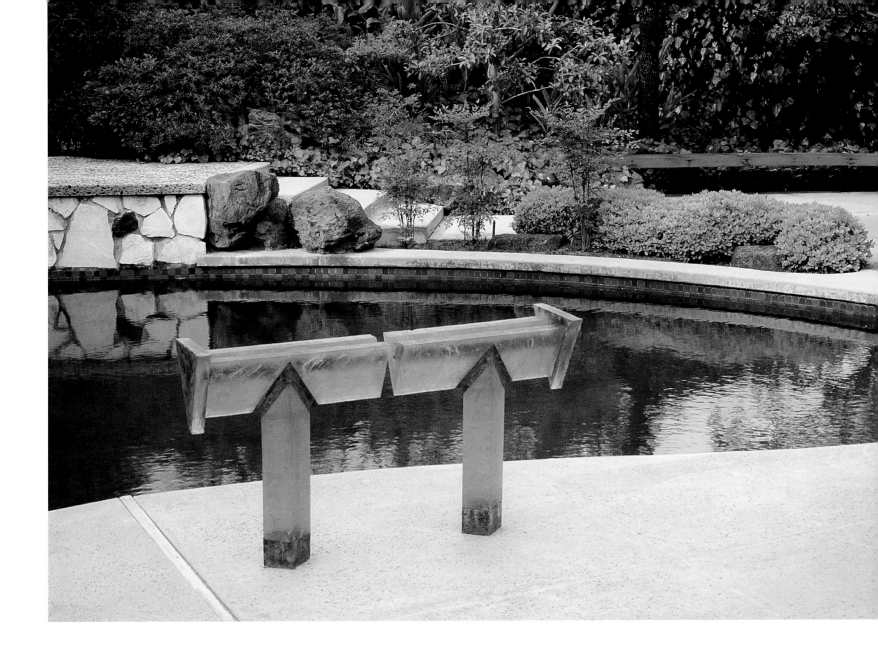

FIG. 21

Gate (passive water fountain), 1983

Cast glass, copper, and patina

25 x 48 x 8 inches

Vernal House, Los Angeles

PATTERSON SIMS: *Can you imagine doing a big project now and not having a water component?*

HOWARD BEN TRÉ: It really depends upon the project and what's going to work in the space. Water has profound expressive powers. It offers me a broad palette of sculptural elements: density, mass, directionality, texture, sound, tactility, and constant change. For example, at Boston's Post Office Square, in the North Plaza fountain, the architectural structure is completed by the water dome. In contrast, at BankBoston Plaza, the water overflows the urn, hugging the surface and enhancing the movement inherent in the bronze form of the sculpture and multiplying the changes effected by light. In my proposal for *Animated Volume* for Tempe, Arizona, I wanted to create a translucent volume with a porous perimeter that could be entered by the viewer. Once inside the volume, surrounded by illuminated glass and the sound of falling water, I envisioned the elemental experience of standing with your feet in the water, looking up, and feeling a direct connection to the infinite night sky.

FIG. 22

Wrapped lingams at Purah, Bali, 1990

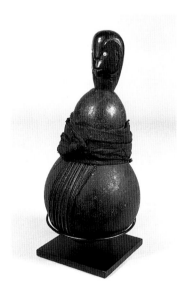

FIG. 23

Kwere, Tanzania

Gourd Container, n.d.

Haffenreffer Museum of Anthropology

Brown University, Providence, Rhode Island

Gift of William W. Brill

PATTERSON SIMS: *I've noticed that you use metal wrapping in some of the fountains. Where do your wrapped forms come from?*

HOWARD BEN TRÉ: Wrapping is a very basic part of human ritual. I have a strong memory from my childhood of my grandfather's ritual of *davenning*, which he did twice a day. He would wrap his arms and forehead with *tefillin* (thin leather straps with boxes at the ends containing prayers). He would whisper preassigned prayers and kiss those little leather boxes as he wrapped the leather strapping around himself and, with his *tallith* draped over him, he chanted and rocked, seeking transcendent experience. Through the ritual of wrapping, my grandfather transformed the everyday soul into the spiritual soul.

The *Wrapped Forms* are simple, elemental lingams emblematic of the figure. In all the numerous photographs that I've taken on our trips, in Bali no less than in Greece, it is the fragments, footprints, and the details that I focus on. In the same way that I've mentioned how industrial forms are akin to the geometry and proportions of architectural plans, I always try to fathom the humanness within proportion and geometry; I always see the little and find the big in it.

In my travels to Asia, I found that lingams and the fragments of temple sculptures were wrapped to signify their sacredness (see fig. 22). By wrapping my sculptures in lead, I intended to emphasize the mass and density of the forms and contrast the opacity of the wrapping with the translucence of the form itself.

In *Double Wrapped Form* I used thick sheet lead, which had its own sense of weight. Sometimes I used very thin lead foil to reveal the surface underneath or to create folds in the lead as I was wrapping it. In the way that braiding and wrapping are female activities in much of Africa, and the wrapping of fetishes and carving of braids on masks signify fertility, I also wanted to engender my elemental forms. In *Wrapped Form 2*, I wrapped the figure by rubbing iron powders into the open pores on the surface of the glass so that the powders are actually intermingled with the glass. In *Wrapped Form 4*, I placed a cast pewter "braid" onto the top of the lingam (fig. 24).

PATTERSON SIMS: *It is increasingly clear to me that even the most "abstract" of your sculptures are surrogates for the figure, emblems and surrogates of human spiritual essence.*

HOWARD BEN TRÉ: The human presence is in my work in one way or another from the beginning, but the *Paired Forms* introduced more explicit figuration and created a dialogue within the sculpture. One of the paired pieces, *Paired Forms 3*, joins a single vertical lingam form and, where the second figure would have been, a basin shape. It is male and female together, but not as one. The lingam has a skin of iron powder over

FIG. 24

Wrapped Form 4, 1993
Cast glass, pewter, and patina
55$^1/_2$ x 16$^1/_4$ x 16$^1/_4$ inches
Collection of Robert Orton, Jr.

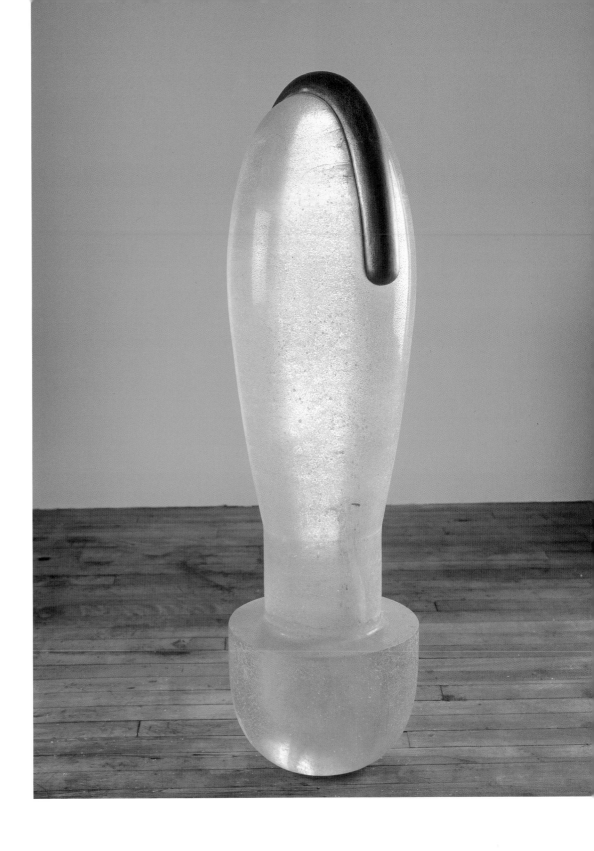

it so that depending upon how the light is coming through it, the vertical piece is either very opaque or translucent.

Eventually the *Wrapped Forms* became less like lingams and are now more like caryatids. But fueling that transition were the *Bearing Figures*. Starting with the vessel as a metaphor for fertility (see fig. 23), the *Bearing Figures* focus universal vessel forms and the figural surrounds they inspire. I see the interplay of the vessels and figures as a specific exploration of the general human impulse to create forms that are anthropomorphic.

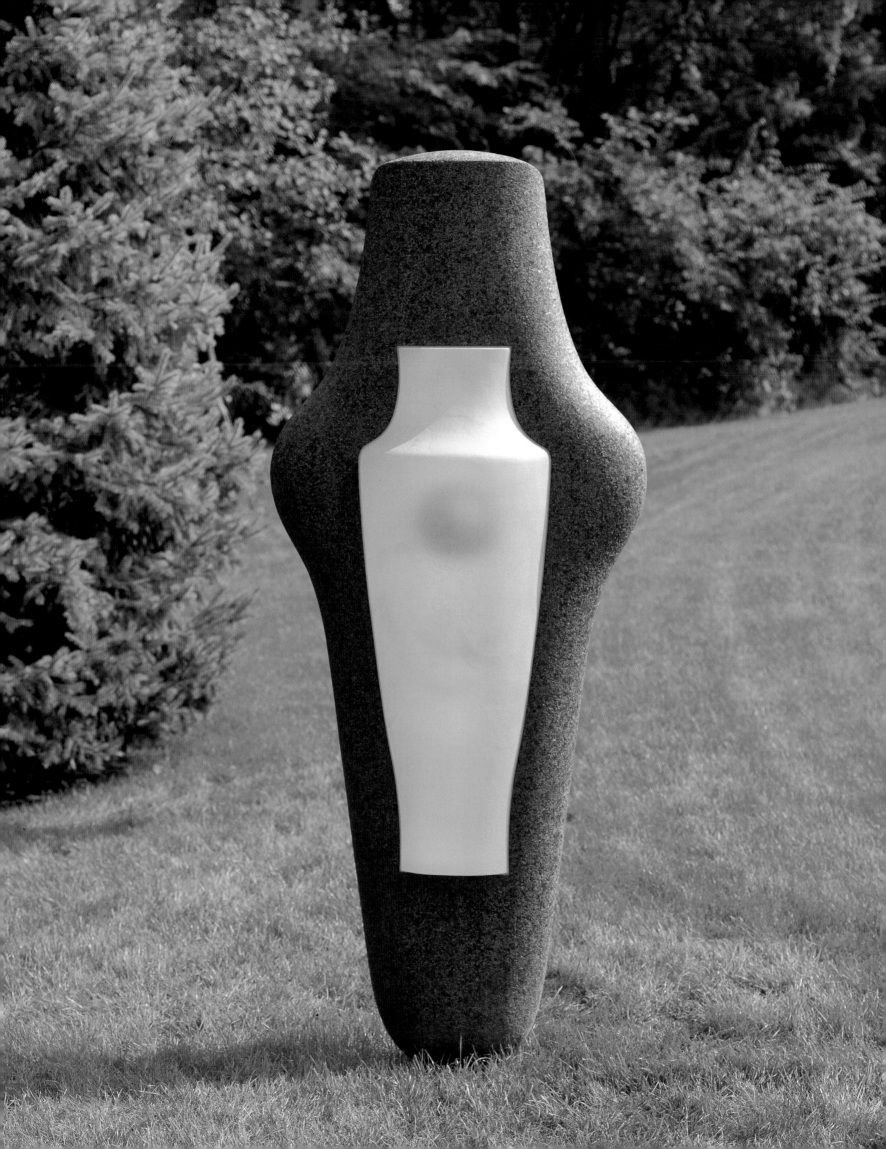

Most of the *Bearing Figure*s were intended for siting outdoors and, not coincidentally, the glass vessels are borne within the "protective" surround of granite or bronze. Of course, again there is the duality of the outer and the inner. The figural surround narrows as you walk around the sculpture and the full volume of the vessel and its penetration of the figure bearing it is revealed. Enclosed within the vessel is a cavity that is lined with metal leaf and appears to be a solid inclusion. Because in the *Bearing Figures* I sandblasted the glass, these cavities are somewhat obscured. They are fully seen only when the glass gets wet with rain (see fig. 25).

PATTERSON SIMS: *What role has travel played in all of this?*

HOWARD BEN TRÉ: Well, as I think you know, for many years we used to take a big trip as a family at least once every eighteen months. Included in these trips were visits to various architectural sites. One of the most moving we encountered was in Burma. Gay, Benjamin, and I took a predawn donkey-cart ride to one of the temples. We climbed to the top and watched the sun rise over the Irrawaddy River Basin and reveal the remains of several thousand temples scattered across the Plain of Pagan. By offering direct experience, travel has been key in my continuing search for the true and archetypal sense of things, which has in turn enabled the invention of my own forms. Likewise, that is what I hope happens to the person who encounters one of my works, whether it is a sculpture or a large public plaza. My public works invite visitors to live totally in their senses in a special physical environment and, in doing so, be transported.

PATTERSON SIMS: *Can art change us?*

HOWARD BEN TRÉ: After a time Gay and I saw the political as one part of the spectrum of humanness and politics as one way to propel change. Our activism was a step on the way to the spiritual, rather than being off on its own track. Art also can help propel change. What art can do is help us see things in a different way and thereby learn to change. My art is not cynical or ironic. It is hopeful, and you have to have hope in order to embrace change. Organized Western religions are hierarchical and I'm not interested in having that kind of relationship with my own spirituality. As an artist, I am trying to deal with the negative elements in society by taking what we perceive as disconnected and, in fact, connecting it experientially through the creation of transcendent moments, for myself and, I hope, for others as well. For me, spirituality is the integration of the different parts of the self. My sights haven't shifted from wanting to be part of creating a utopian world (see figs. 26a,b,c, and d).

FIG. 25

Bearing Figure with Amphora, 1997
Cast low expansion glass, gold leaf
inclusion, and granite
84 x 36 x 18 inches
Private collection

Model for Town Centre Pedestrianization
and Street Design Scheme
Warrington, England, 1998

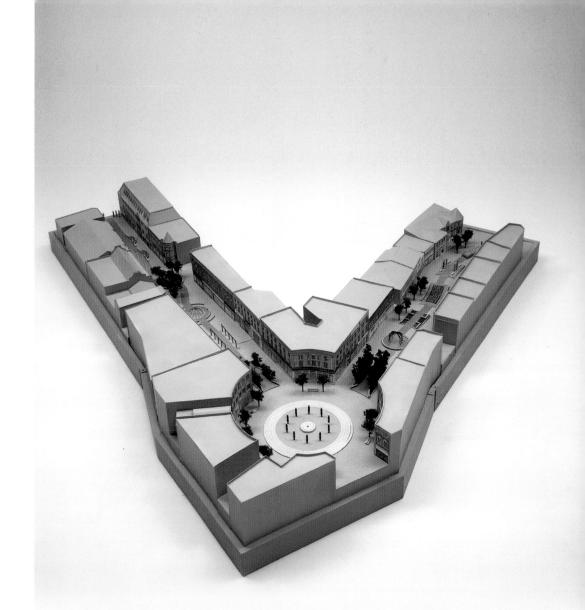

Model for Town Centre Pedestrianization
and Street Design Scheme
View of Market Gate

Model for Town Centre Pedestrianization
and Street Design Scheme
View of Horsemarket Street

Model for Town Centre Pedestrianization
and Street Design Scheme
View of Buttermarket Street

CITY OF GLASS

Arthur C. Danto

The goal of this essay is to connect Howard Ben Tré's use of glass, both as a substance and as a medium of representation, with certain of his political values. I have employed the concept of an ideal city as a device for bringing the artistic and the moral dimensions of his work into an integrated whole. From ancient times, the city has been the fulcrum for utopian political vision—Plato's Republic, Aristotle's *polis*, Saint Augustine's City of God, Bacon's New Atlantis, and so on. In the modern city, people are very much strangers to one another, but its public spaces—the piazza, the agora, the park—offer the promise of dissolving the walls that isolate us from one another, if only for a moment, and to glimpse the possibility of existing on a higher plane of communication. I have imagined what it might mean if the city itself were made of glass. The essay is entirely speculative, but it is anchored to various statements Howard Ben Tré has made in different interviews, and in conversations with me. The challenge is to see if an internal relationship between Ben Tré as artist and as the architect of an ideal polity can be used to confer a unity on his work beyond the fact that it is made of glass, worked in a recognizable and unique style. It will be central to my enterprise to think of his forms as not merely made of glass, but as representing objects themselves made of glass (see figs. 1 and 2).

GLASS AND REPRESENTATION

In the Walker Art Center in Minneapolis, there is a large glass sculpture of a fish, one of several executed over the years by the architect Frank Gehry. It is not, as it were, a fish cast in glass, like the crystal fish manufactured as ornaments by firms such as Baccarat or Steuben. Rather, it is made of superimposed fragments of what looks like window glass, somehow clamped together to form an image of a fish diving through water as transparent as the sculpture itself. The fact that the latter is made of pieces of glass, as sparkling and transparent as its faceted composition allows, suggests that the fish itself has become one with its medium, sparkle and transparency being properties of swiftly moving clear water. The facets themselves even seem to belong to the experience of seeing a fish flash through water, reflecting, refracting, and scattering light.

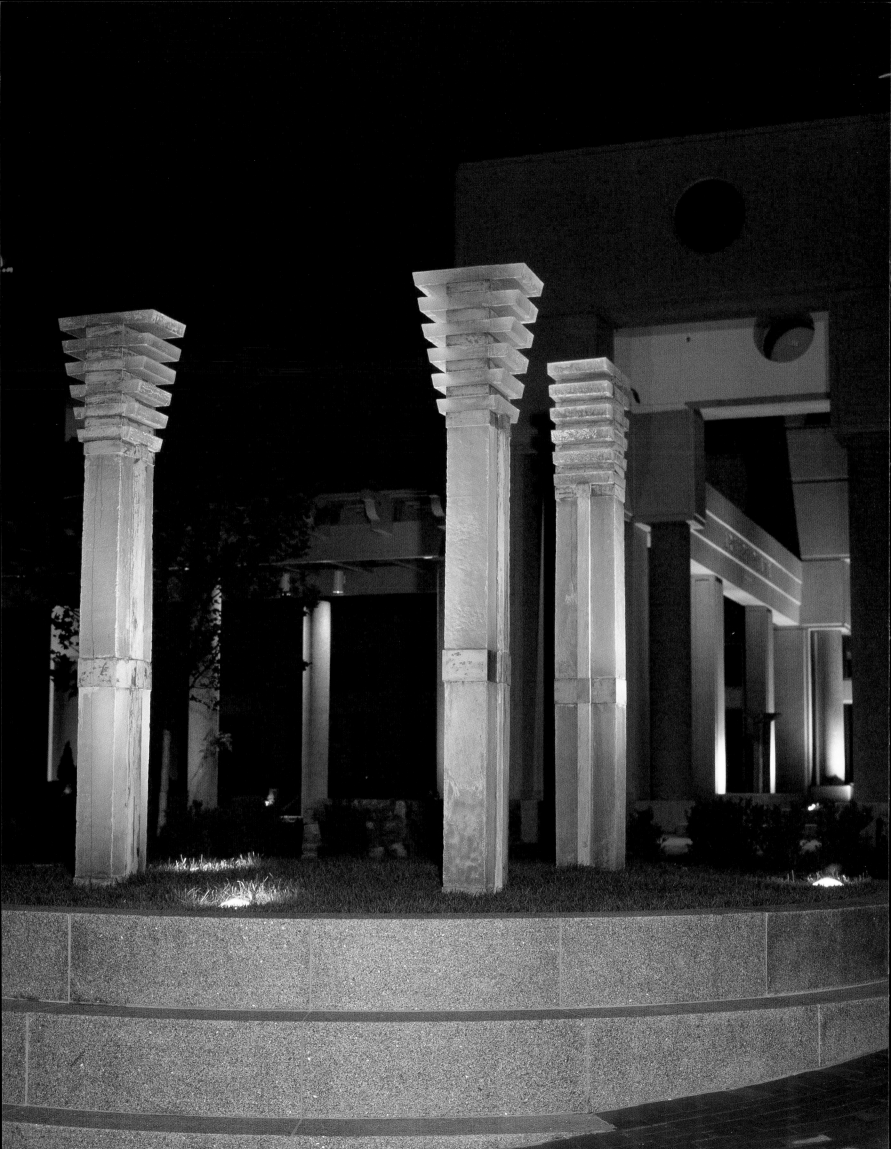

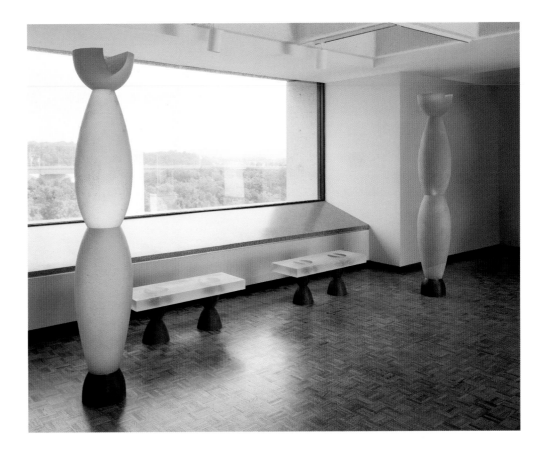

There are many sculptures of fish in the history of art, but rarely are they made of glass (and when they are, as with Steuben or Baccarat, they are mainly intended as knick-knacks for table tops or what-not cabinets or as trophies for desks). Any number of carved marble dolphins, for example, disport themselves in Italian fountains, plashed over by jets of water, or spurting water from their own mouths onto the heads of sea-nymphs or finned horses. But they lack the speed and freedom that fragmented glass confers on Gehry's fish: the splashing water does not bring them to life. Even Brancusi's smoothed and polished fish refers more to the fish-monger's counter than the aquarium. There are wooden fish and metal fish, sometimes used as weathervanes, and though there are deep parallels between air and water as media, there is no possibility of the illusion that glass helps Gehry's fish achieve, that the fish are swimming. They hold their forms however fast the wind blows, and from whatever direction, and look like whirly-gigs rather than fish plunging through water.

In the vast literature on mimesis, as old as the first known philosophical speculations, by Plato and Aristotle on the nature of art, there is remarkably little said about the mimetic powers of the *material* out of which images are made. This is easy enough to understand. Very few subjects of mimetic representation are made of the material used by artists. Perhaps the only subjects consubstantial with paintings of them are paintings themselves, as in the somewhat limited genre of paintings of paintings—of

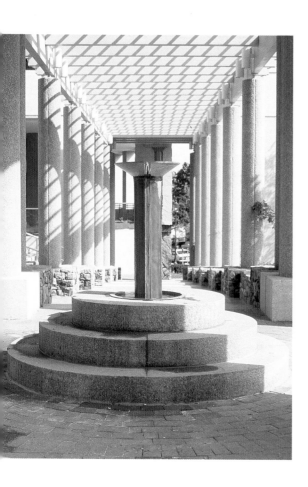

paintings *in* paintings. Mostly, it is a convention that the substance of paintings has no interesting contribution to make to mimetic success or failure, or there would *only* be paintings of painting, since nothing other than paint is consubstantial with paint. The blackness of a drawing's ink is not exported from the sheet on which it is deposited to the subject drawn: a black drawing of flowers is not a drawing of black flowers. Nor are the properties of the drawing as a drawing necessarily applicable to the subject drawn: a powerful drawing of irises is not a drawing of powerful irises, there being none. And this, for the most part, is true of sculpture as well. A folk-art statue carved in wood would never be taken as a sculpture of an Indian whose substance is wood. Bernini's angels on the Ponte Sant'Angelo in Rome, carved in marble with such mimetic exactitude that their garments seem to be whipped by the wind, are hardly to be thought of as consubstantial with whatever substance it is of which angels themselves are made. And in a way, Gehry's glass fish do not, save as a visual metaphor, imply that fish themselves are made of glass.

But glass is like paint in the sense that there are certain subjects consubstantial with their representations—where a painted image refers mimetically to a thing made of paint (like a painting of an artist standing before his self-portrait), or a glass sculpture refers to a glass subject. Imagine, for example, that a sculptor is commissioned to execute in tempered glass a version of Cinderella's slippers, perhaps for a children's playground, the children to be allowed to climb freely in and out. Suppose further that the artist is charged to base several different glass sculptures on the footwear in fairy tales and nursery rhymes—like the shoe in which the Old Woman lived with her multitude of children. The difference between these two glass shoes is that in the case of Cinderella's slippers, the subject is consubstantial with its representation. The statue is in glass and of glass. The slippers being made of glass gives someone the right to think a representation of them in glass is somehow especially appropriate.

Something like this is true, in my view, of the sculptures of Howard Ben Tré. They are unmistakably referential—they refer, more or less abstractly, to columns, to basins, to benches, to steles (see fig. 3). But it is irresistible to project the fact that the sculptures are glass onto their references, as if they are of things made of glass. It once occurred to me that with Ben Tré's later work—the posts, the columns, the abstracted figures, the basins, the steles—and the shapes to which we can assign no specific reference but which we cannot consider meaningless—he is engaged in inventing the forms of an imagined civilization, which has discovered how to mold glass and, taken by its beauty, decided to use it as the material of its public structures (see fig. 4). Think of the way in which sheets of glass, used as curtain walls, give lightness and transparency to our office buildings in the modern metropolis, and compare with that an imagined architecture in which massive columns of glass form porticos within

FIG. 5·

Benches for Claude, II, 1992
Cast glass, brass, and patina
Each section $19^{3}/8$ x $26^{5}/8$ x 54 inches
Collection of The Toledo Museum of Art, Ohio
Museum Commission

which glass fountains play and people sit on glass benches rigid enough to support their weight (see fig. 5). There could be glass monuments and glass memorials. The municipal pier could be buttressed by glass pilings. There might even be glass roads. It would be like the Emerald City!

The artists of a city that defines itself in glass have somehow learned to make vitreous objects by making patterns out of wax (Ben Tré uses Styrofoam) to vaporize when molten glass is poured into molds and allowed to cool and harden. Ben Tré has added certain refinements to this age-old technology, mainly in order to produce objects on a very large scale, but he continues an ancient practice and perhaps shares an aesthetic with whoever they were who first made, thousands of years ago, glass beads and tiny effigies in glass. The refinements were added in order to produce a *world* of glass—a nearly magical habitat for persons who have to respect the material limitations of the objects they live among if their city is to endure.

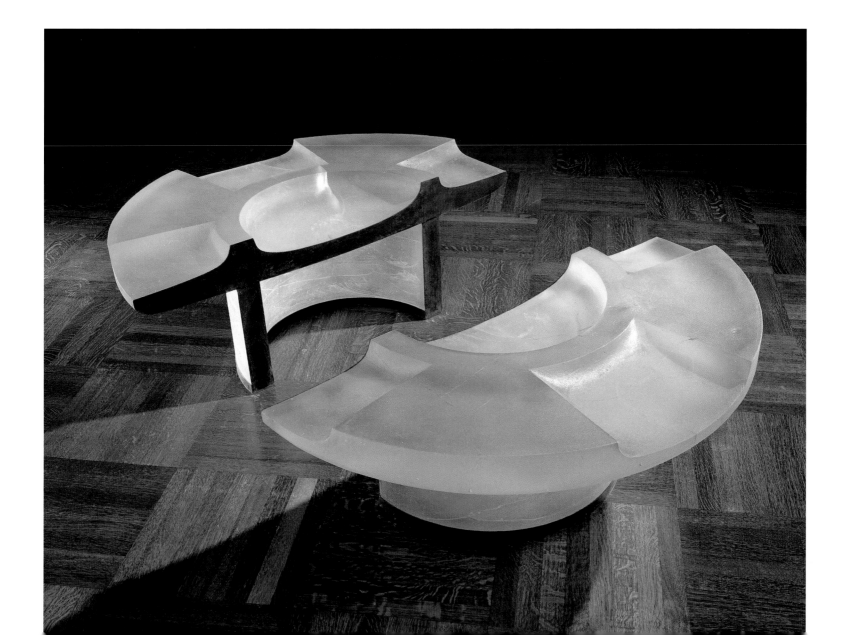

FIG. 6

Wrapped Forms and *Paired Forms*
in Lafayette Street studio
Pawtucket, Rhode Island, 1993

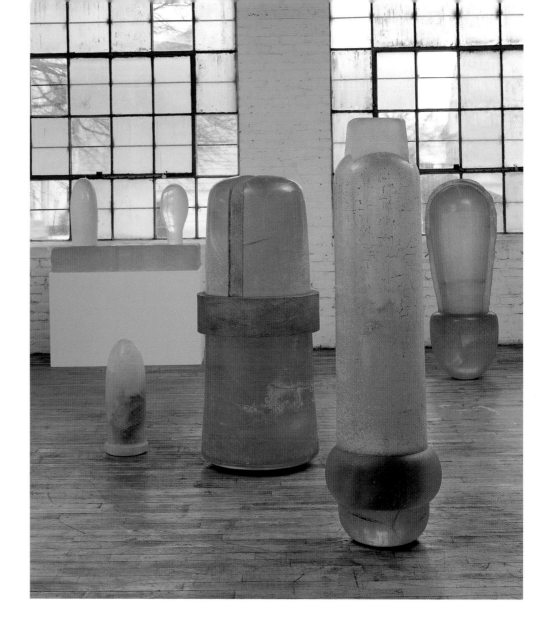

GLASS AS REPRESENTATION AND REPRESENTED

Envisioning such a city helps make vivid for us the poetry that glass evokes, beginning with the way in which earth, inert, opaque, with no form of its own, is transformed through heat into a substance sparkling, transparent, and rigid. There is a reason why the transparency of a crystal ball connotes the clairvoyant's power to look into the future, or into someone's soul. There is a reason why the Crystal Palace sounded like something from a fairy tale, rather than simply an early exemplification of the iron-and-glass utilitarian structures used until well into the twentieth century to make railway stations and covered marketplaces. There is a reason why Shakespeare spoke, somewhat disparagingly in *Measure for Measure*, of man's "glassy essence," by which—I think—the poet meant to suggest that we know about ourselves only what we see reflected in looking glasses, and so not our true internal selves. There is a reason why even the frangibility of glass lends itself to poetic representations of the human soul, as when the great Islamic philosopher Al-Ghazali discusses the loss of faith in terms of a shattered glass, incapable of being mended but capable of being melted down and made anew, which Al-Ghazali (he was professor of divinity in Baghdad when he died in 1111 AD) hoped might happen through the ecstatic practices of the Sufi mystics.[1]

FIG. 7

Bearing Figure with Ming Vessel, 1997
Cast low expansion glass, silver leaf
inclusion, and granite
84 x 37 x 20 inches
Collection of Maxine and Stuart Frankel

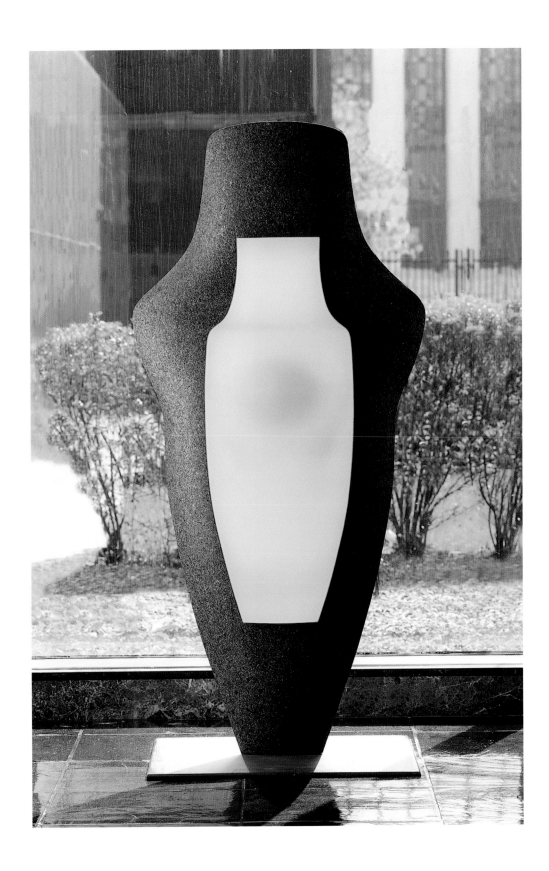

FIG. 8

Pomegranate, 1996
Cast low expansion glass, steel, silver leaf,
pigmented wax, and gold leaf inclusion
50 x 31 x 31 inches
Collection of Sheila and Hughes Potiker

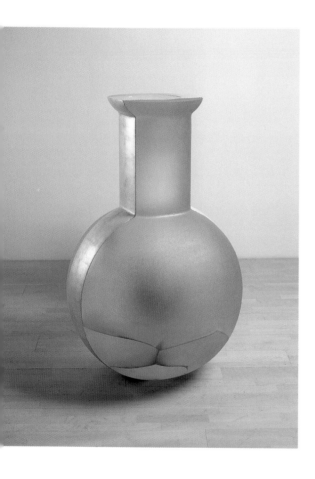

One admires Al-Ghazali for finding in one of the familiar disabling properties of glass—its disposition to shatter, its brittle reality—a metaphor for hope. It is this reality that makes Cinderella's slippers so entirely magical. It is not enough that Cinderella's feet can fit into the shoes: she must dance in them! Even the most decorous of courtly minuets, suitable to dancing with princes, puts pressure on glass slippers that glass is not created to withstand. The magic derives from the incongruity of the least suitable of materials being formed into an object intended to symbolize Cinderella's delicacy and grace, as well as, through its transparency, her honesty and goodness, but ordinarily incapable, physically, of much by way of physical pressure. That is why the conjunction between glass and slipper is magical, and almost miraculous, like the tiny bit of oil in the lamp that burns for eight days. In the end it is the striking of the clock rather than the shattering of the slippers that brings the dance to a close.

The consubstantiality between matter and content in Ben Tré's work makes the latter representational in a very basic way. His works exemplify what they are about, the way a sample, drawn from a population, represents the population because it shares the latter's defining properties. Thus a swatch or a color chip exemplifies what it represents. Exemplification was rather rarely used in artistic representation until, perhaps, the advent of collage, when physical objects or fragments of physical objects were used to represent themselves—a wine label to represent a wine label, woven cane seats to represent seats woven of cane, or, to cite a glass example, Coca Cola bottles used, by Rauschenberg, for example, to represent what they were, namely, Coca Cola bottles.

Ben Tré uses glass to represent glass. His glass columns, for example, are really columns and at the same time about glass columns. His glass benches and basins have the same duality. So it is true that his columns both are and represent what they look like. It is not incorrect, accordingly, to speak of certain phalluslike forms as *lingams*, as long as we recognize that, in consistency with the logic of exemplification, they would also be *of* lingams—as if there was a practice of making effigies of the penis in the ritual precincts of the glass city. A lingam, however, does not typically exemplify what it represents—only an actual penis, as in an anatomy lesson, could do that. So the lingam-likeness of so many of Ben Tré's forms cannot be referred back to a deflected form of sexual exhibition on his part, but rather to his recognition that whole cultures monumentalized the organ of generation as an emblem of fertility and prosperity (see fig. 6). Inevitably, Ben Tré feels, the heavy glass objects he makes do express certain facts of maleness. "There is some psychological spiritual meaning to the male as a maker and in the way males see themselves in society," he once said. "So while these works are not intentionally referenced to the penis, I'd say they do represent maleness." The artist is entirely right. Maleness is not exclusively concentrated in the penis, any more than femininity reduces to vaginality. It is involved

FIG. 9

Tenth Figure, 1988
Cast glass, brass, gold leaf, and
pigmented waxes
88 x 28 x 8 inches
Collection of 404 Wyman Street Association
Waltham, Massachusetts

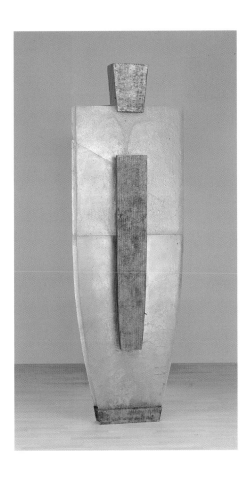

in a whole way of relating physically to the world. If the Hindu lingam-makers man-handled the material in the process of shaping their monuments, the works would embody maleness and also refer to the male organ. But maleness, in this sense, would be embodied in the shaping of the *yoni*, understood as an attribute of femininity, or in anything the making of which gives evidence of the kind of strength conventionally regarded as male. Ben Tré is justifiably impatient with the sort of taxonomy that divides objects into the male and female on the basis of their forms alone. If any of his works refers to femaleness, it would be those large glass forms that incorporate a vase or other container where the womb would be — as in *Bearing Figure with Ming Vessel* or *Pomegranate* (figs. 7 and 8). "Bearing" means carrying an external burden, or carrying a child within the womb.

It is as though Ben Tré had invented the artistic style, distantly related to the Cycladic, an imagined ancient civilization would use in its monuments, as in *Tenth Figure* (fig. 9). For me it is impossible not to see *Wrapped Form 2* save under the perspective of Brancusi's *Kiss*, in which two persons, carved of the same stone, are locked front to front, and, in Ben Tré's version, ritually bound to one another by hoops of metal, like a wedding ring (fig. 10). A more tender version of an embracing couple can be read in *Eleventh Figure* (cat. 11). It is as if the iconography of the glass city's monuments refers to love — to the spiritual bondings between its citizens.

Because the artist chose glass as the best medium to represent a world of glass objects, imagined as performing structural or ritual functions, his works are magical for the same reason that Cinderella's slippers are: they exemplify objects commonly made of other materials far more suited to human wear and tear or to withstand the forces of nature. He is building a world, we might say, with objects in it which in most worlds would not be made of glass, for a variety of practical reasons, which Cinderella's slippers again exemplify. This gives to Ben Tré's work the quality of fantasy or of dream, just as Cinderella's story treats myth as if, for a moment, it were historically possible. The magic of his objects is awakened by the fact that glass seems as hostile to their uses as it is to the uses of slippers on the feet of a dancing girl.

GLASS AS MORAL METAPHOR

Glass is the paradigm of the brittle, the fragile, the delicate, the small — as in the glass menagerie which serves as a metaphor for the heroine's frailty and sensitivity in Tennessee Williams's eponymous play. One feels that, like her tiny glass animals, the heroine can be shattered by a breath. Ben Tré 's works are massive and monolithic, and cannot be held up to the light or easily rearranged, the way the animals in the glass menagerie can. They can be raised and moved only by the use of heavy equipment. Most objects made by artists of glass are too small to serve as structural utilitarian

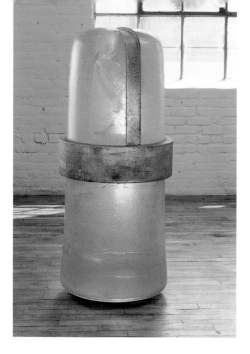

objects for a city of glass. Their natural site is the protective vitrine, where the transparency of the glass walls allows the objects to be seen but by convention protects them against being touched. But even industrial glass objects, objects built to serve a function—insulators, floats, *verrerie*, bottles, picture glass, plate glass, laboratory paraphernalia, lenses—are subject to glass' physical limitations. Beakers break, windows shatter, insulators crack. Critics often stress the contribution to the meaning of Ben Tré's sculpture of the fact that the glass he uses is industrial, and fabricated in factories. There are no industrial products I know of, made of glass, which resemble, in form or scale, his characteristically large works—glass steles, about the same height as human beings, for example—though his works, typically, evoke the visionary glass city in which they are to function, and thus radiate an aura of utility, and imply some specific purpose (see fig. 11). But for all their massiveness—which carries an aesthetic of its own—his works inherit the inescapable facticities of glass: the propensity to crack, to break, to shatter. Had Shakespeare thought of this in speaking of man's glassy essence, he would have meant our own propensity to crack, to break, to shatter, unless we are sheltered from traumas of the world.

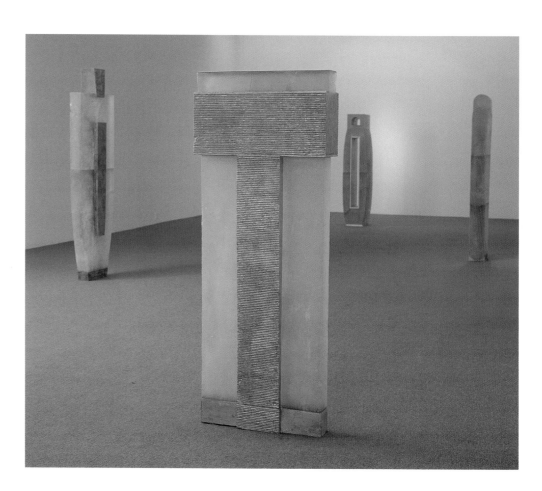

FIG. 12

Large Beaker, 1989
Cast glass and lead
74$^{1}/_{2}$ x 28$^{1}/_{2}$ x 28$^{1}/_{2}$ inches
Private collection

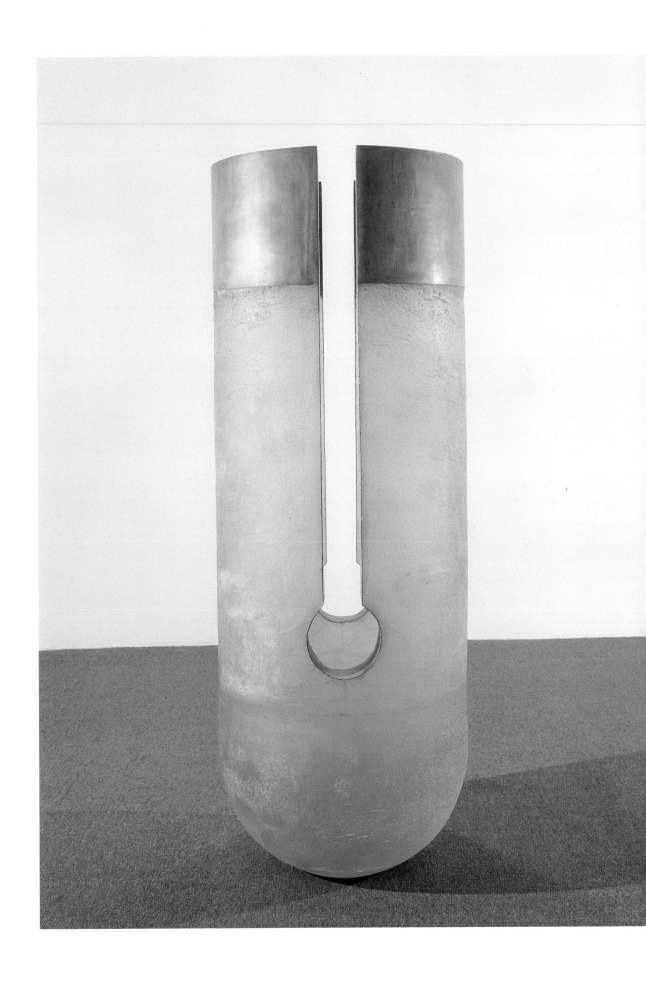

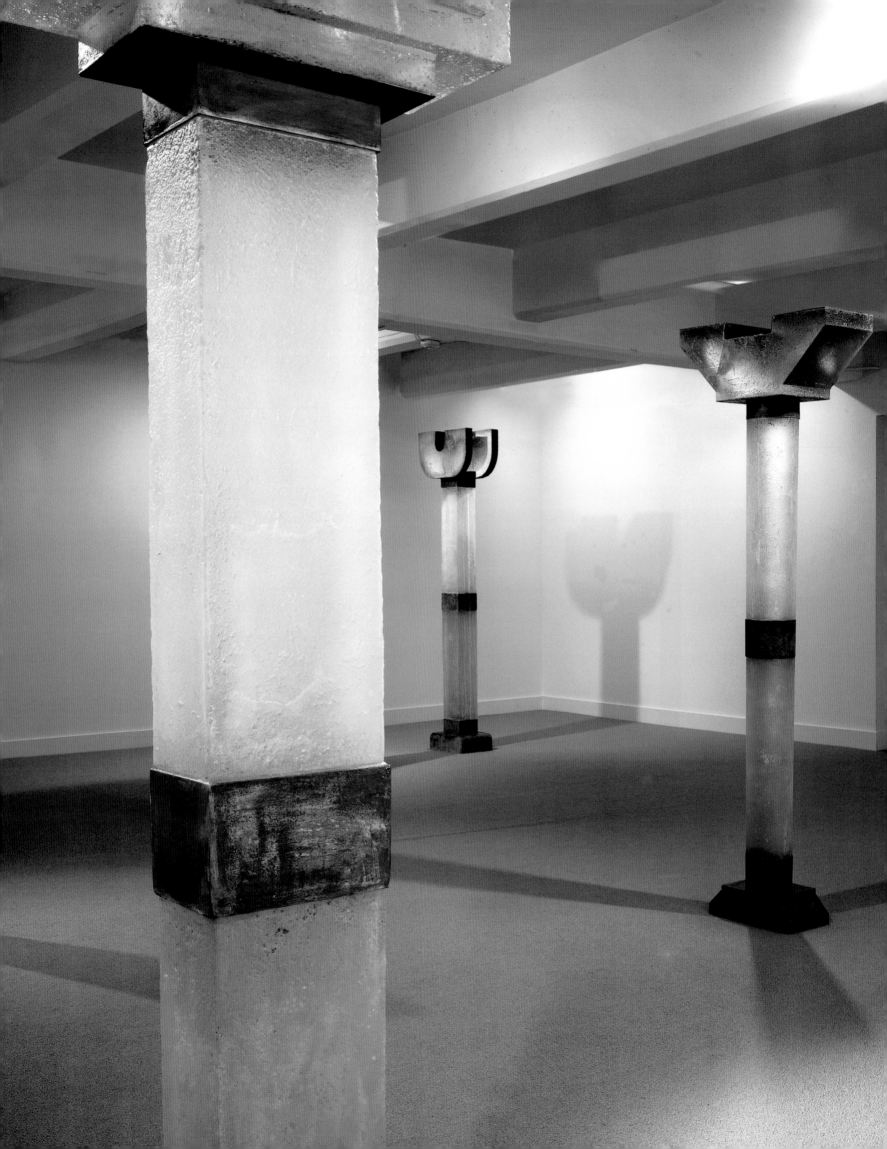

FIG. 14

Alembic, 1990
Cast glass, brass, bronze, lead, and
pigmented waxes
47 x 20$\frac{1}{2}$ x 20$\frac{1}{2}$ inches
Collection of Oscar and Dede Feldman

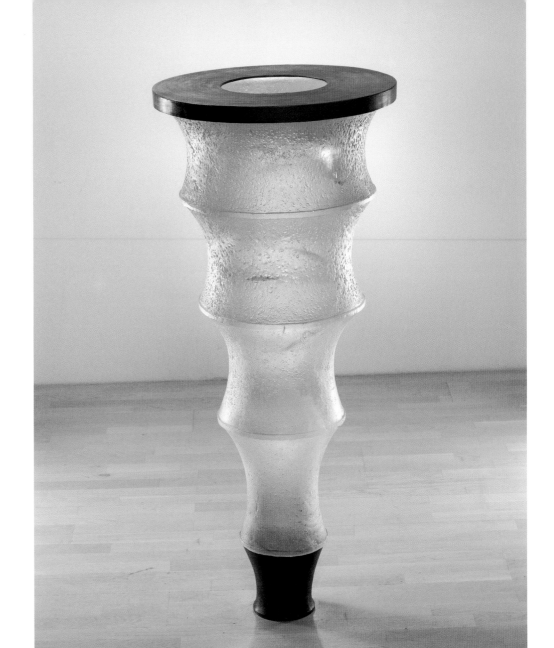

FIG. 13

Installation of *Columns* at
John Berggruen Gallery, San Francisco, 1986

I admire the fact that Ben Tré cherishes what in much industrial glass would be flaws and imperfections, grounds for rejecting the objects that show them (see fig. 12). There is no room for bubbles in glass lenses. A fissure in an electrical insulator is dangerous. A crack in a piece of chemical apparatus can ruin the experiment. An imperfection in an astronomical mirror makes it worthless for computing the angular momentum of galaxies. A champagne flute with imperfections would somehow sully the celebratory wine it is supposed to contain, distracting from the celebration. At a certain stage, Ben Tré adhered to the ethics of culling that governs industrial products: "When I first started casting objects out of glass, if they cracked I would look at the people around me who were also working with glass and they would say, 'Oh, gotta throw that one out because it's cracked.' I used to think, 'Okay, I'd better throw that one out.'" The difference between manufacturing glass objects and making art out of glass, lies in the fact that there are certain imperfections that belong by nature to glass as glass, and that can be treated symbolically (see fig. 13). It would be inconsistent to keep industrially produced glass, with the cracks, spots, splits, and fissures, as if to

certify that it was made of glass. There is no room for symbolic imperfections in Pyrex dishes or crystal beakers. But in a glass column for a glass city—which anyway cannot be used to bear much weight however massive it may be—the flaws serve as memento mori, the palpable vulnerabilities shared by the architectural structures of the glass city, and by those who live among them. The city would be an allegorical portrait of its human inhabitants. Its beauty would be the beauty of mortality, and of spirit. Hegel writes that artistic beauty is born of the spirit and born again—*Aus dem Geistes geboren und wiedergeboren*. The glass city would be the outward embodiment of the glassy essence of its dwellers, with all their visible imperfections, their fractures and fissures, but also their hospitality to—their thirst for—clarity and light. Kant once spoke of "the crooked timber of mankind," meaning by this the difficulty of integrating human beings into an ideal social order. One could as readily speak of the flawed and faulted glassy essence of mankind, refractory to social harmony.

GLASS AND IMAGINARY ARCHITECTURE

Since glass has been used architecturally since the Middle Ages, it is possible to imagine many different kinds of cities made of glass. New York in midtown is largely a glass city because of the curtain walls hung between metal supports. A city could have been built on the model of the iron-and-glass structure of the Crystal Palace. A city of Gothic cathedrals would be made of stone and glass. These glass cities are possible only because there is another material—steel, iron, or stone—which is not subject to the fragilities of glass, but which therefore lacks the beauty glass confers on the spaces it defines. In Ben Tré's city, the *supports* are themselves made of glass. The architecture is glass through and through. Glass is the anatomy rather than the skin of its structures. And the styles of its components seem drawn from archaic and preindustrial models—from Minoa and Mexico, Babylon and Bali, temples and cemeteries (see fig. 14). The artist is interested in something archetypal and universal, a kind of heavenly city, in which humans from anywhere else might feel at home. "I've definitely made use of icons and symbols from other cultures, but they are not used in a formal sense...I am trying to meld all of these universal feelings into something archetypal," he told an interviewer.[2]

In truth, Ben Tré's objects fit many people's image of what the lost city of Atlantis might have looked like, an image underwritten by their abraded surfaces, etched like sea glass, and brought up from the deep. Our image of Atlantis comes from Plato's *Critias*. Its kings undertook "to construct and beautify their temples, royal residences, harbors, docks" in the magnificent city which "lay open to the sun." Glass as such is mentioned once by Plato, and never by Aristotle, so of course its availability for architecture would probably not have been imagined, though the

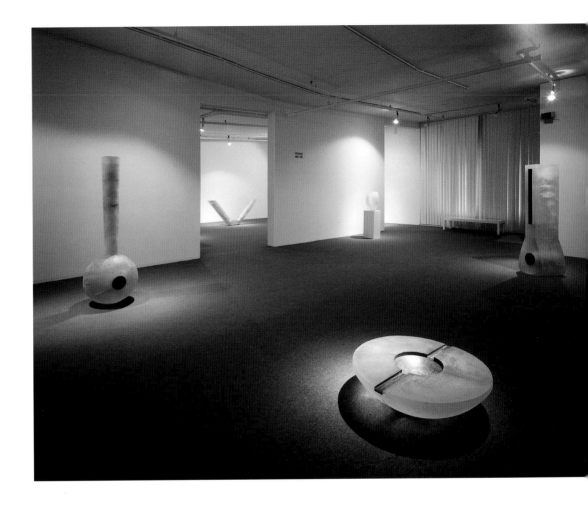

description of the magnificent, doomed city is exceedingly detailed. There are the openings between columns in classical temples, between which sheets or assemblages of glass could have been suspended like curtains, had the Atlanteans known how to produce it. But it is difficult to believe that ancient architects would have wished to employ glass this way. It would be inconsistent with the inner temple, in which rituals are enacted, to have transparent walls—and inconsistent as well with the way inner and outer spaces interpenetrate in colonnaded porches. Rather, it seems to me, the architects would imagine, just as Ben Tré does, that the columns themselves be made of glass, but only in the public buildings in which the main rituals of religion and of political affirmation were enacted. An exhibition of Ben Tré's is like an archaeological display, with translucent posts and columns, and basins designed as if for the sacrifice of bulls, with runnels to carry their blood to the soil. Everything seems like a remnant of a submerged metropolis (see fig. 15).

In its glory, before the war between Atlantis and Athens, 9,000 years before Socrates' narration in the *Critias*, there was a moral beauty in the Atlanteans that matched the sensuous beauty of the architecture that defined their public lives.

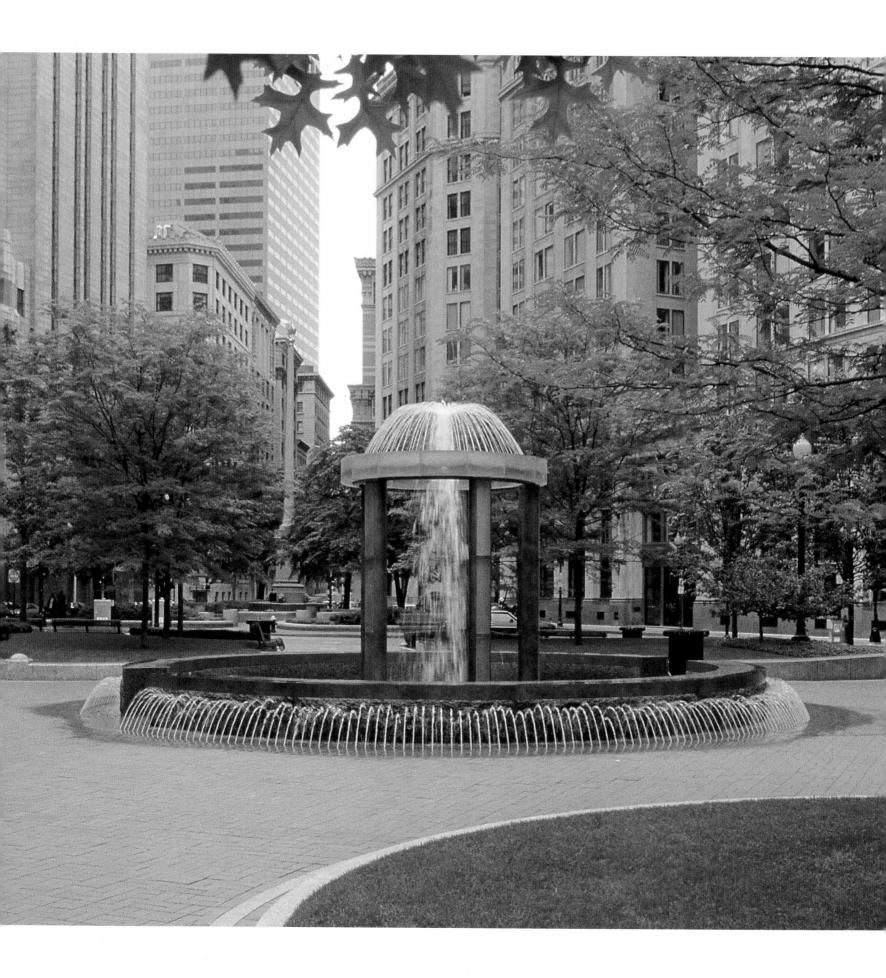

The roof of the temple dedicated to Poseidon was "of ivory throughout"—and the fact that ivory was prized for its translucency suggested that it would have been made of glass had the Atlanteans possessed the requisite technology. "It was ornamented with gold, silver, and orichalch [a golden ore prized by the ancients] and all the rest, walls, columns, pavement, were covered with orichalch. There was an altar of size and workmanship to match the edifice; the palace, too, was no less worthy of the grandeur of the empire and the magnificence of its temples." Plato refers to a ritual in which "clots of blood from a sacrificed bull would be mingled with the wine in a vessel, one clot for each man present. The rest of the blood they cast into the fire." The people themselves reflected the excellence of their public architecture. "They were indeed true-hearted and great-hearted, bearing themselves to one another and to their various fortunes with judgment and humbleness. They thought scorn of all things save virtue and counted their present prosperity a little thing."

For someone with the artistic and political values of Howard Ben Tré, the thought that the moral character of citizens and the aesthetic character of their cities should be reflections of one another, as in the Atlantean model, would be especially compelling. He is not altogether an architectural determinist, holding that we are in effect the product of our architecture, which would make us different kinds of persons if we lived in different kinds of houses. Not even the Atlanteans were saved by their marvelous architecture. Despite it, at a certain moment, "the human temper [began] to predominate," moral decay set in, and Zeus "was minded to lay a judgment on them."

THE POSSIBILITY OF COMMUNITY

So architectural goodness is not sufficient to induce an abiding moral goodness. But there remains the hope that the shaping of public spaces can contribute to the attitudes and conduct of those who use the spaces, and this has tended to define the way Ben Tré has approached the problem of public art. He sees his public art as a way of "elevating the consciousness of the people who view or use it"—and he wants to make the work attractive enough that people will be drawn to use or view it. So beauty is a means to transform consciousness onto a new level.

Ben Tré said, in regard to the marvelous fountain he built in Post Office Square in Boston, that through it he is "trying to deal with a negative element in contemporary society. The anonymity that's hard on the human soul." His declared effort is to create space that breaks down that anonymity, in fact, that invites people to participate in either a contemplative or interactive way, and "to focus in on one another." It has, he goes on to say, been his intention to "create a more humanistic space which asks people to interact with one another" (see fig. 16).

FIG. 16

Immanent Circumstance
Norman B. Leventhal Park
Post Office Square, Boston, 1992
View of North Plaza

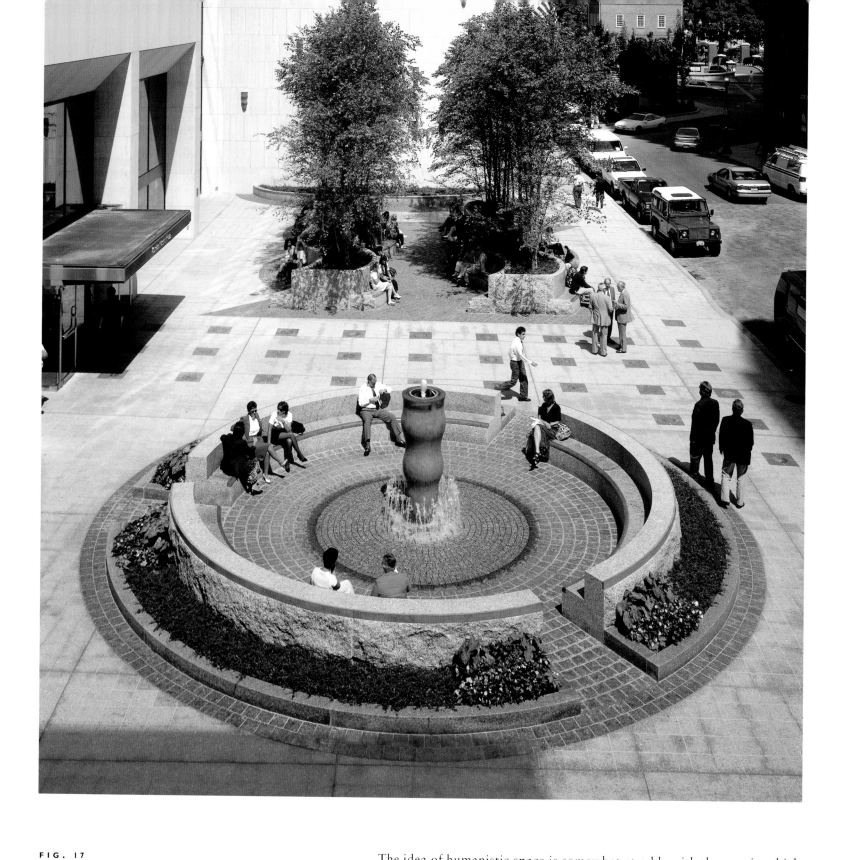

The idea of humanistic space is somewhat at odds with the way in which public art has typically been conceived. As a paradigm of a nonhumanistic space, one need go no further than Richard Serra's ill-conceived placement of his *Tilted Arc* in Federal Plaza in New York—dividing the users of that space from one another and from the space itself, like the Berlin Wall. *Tilted Arc* prevented its people from using the space for anything beyond staring at the rusted walls of the immense Corten steel curve he had placed there. Public art has had the consequence of colonizing public spaces into external galleries of art museums by placing works of art outdoors, and hoping the public would act as if it were in a museum, responsive to

the aesthetics of space and object. In a way, public art so conceived was analogous to corporate art, in the sense that corporations commission large sculptures, by famous artists, to place outside corporate headquarters as a sign of the corporation's dedication to cultural values.

For Ben Tré, the art must bring people into the space, and serve as a means for dissolving the psychic walls between individual and individual, as well as the differences between people and place (see fig. 17). They do not enter the space merely to look. They come, on hot days, because of the coolness of shaped water, not even necessarily conscious that what they are engaged with is art, but, with luck, they become as conscious of one another as of the rush of water. Perhaps glass is a metaphor for the transparency of human beings enabled to see into one another's hearts. Perhaps an architecture without walls is a metaphor for dissolving the walls between us as individuals.

There is, in these public pieces, a conception of a society more ideal than the one we live in, which goes with the sense one has of Ben Tré's individual pieces being detached elements of an ideal city of glass, in which the populace and monuments mirror one another. It is a way of making the ideal city real. In the Fifth Book of the *Republic*, Socrates is asked what the good is of imagining a perfect society if one cannot make it real. Socrates answers that to have discovered the pattern is in effect already, partially and fragmentarily, to live in conformity with it. In his public art, Ben Tré defines actual spaces which exist on two planes of political being. In just the way in which his single pieces exemplify their references—are what they are about—a fountain or a seating ring makes present a piece of the ideal city—it is at once ideal and actual. There is a kind of imperative that governs public art so conceived. Create art such that to live together with it is to live, if but momentarily and fragmentarily, the life an ideal city would make possible as a matter of course.

The beauty of Ben Tré's work is connected with this imperative. He uses beauty as a critique of patterns of contemporary society that alienate us from one another, and at the same time to exemplify what it would mean to live in a society defined by beauty. He carries aesthetics onto a political level because of the material and the references that define his art. In this sense, everything he does is public art.

NOTES

1. Abu Hamid Muhammad Al-Ghazali, "Deliverance from Error," in W. Montgomery Watt, *The Faith and Practice of Al-Ghazali* (London, 1951).

2. Howard Ben Tré in Richmond, Virginia, Marsh Art Gallery, University of Richmond, *Howard Ben Tré: Recent Sculpture* (Richmond, 1996), p. 11.

PLATES

PLATE I

Untitled #2, 1983
Mixed media on paper
61 ¹/₈ x 31 ¹/₄ inches (framed)
Collection of the artist
cat. I

PLATE 2

Column 19, 1984
Cast glass, copper, and patina
80$\frac{1}{2}$ x 22 x 22 inches
Collection of Robert and Vera Loeffler
cat. 3

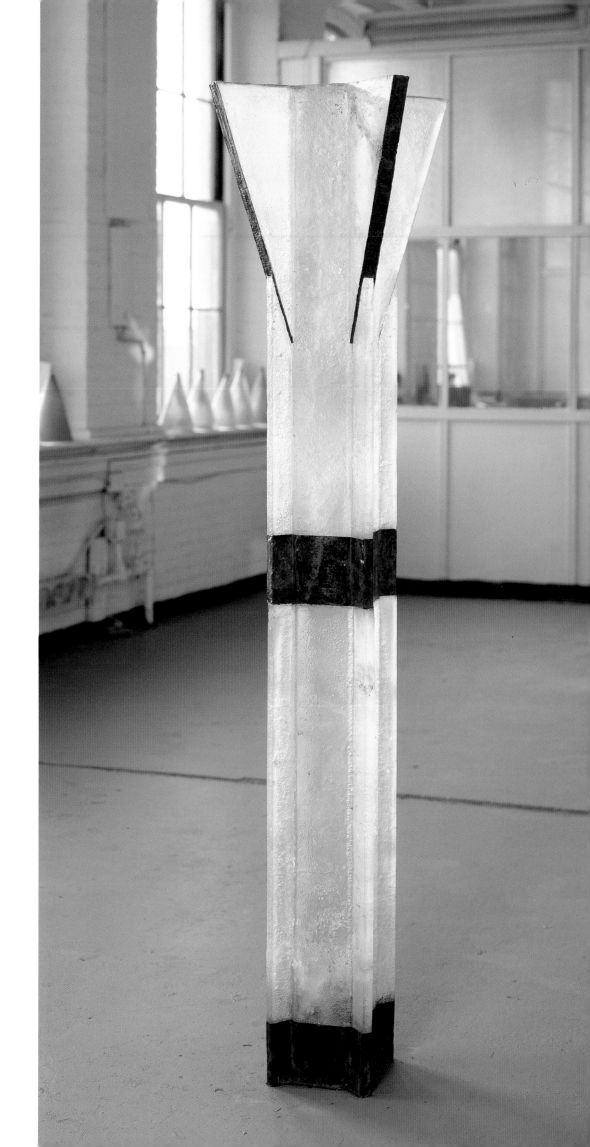

PLATE 3

Structure #13, 1984
Cast glass, copper, and patina
$39^{1}/_{2}$ x 14 x 8 inches
Collection of the Margulies family
cat. 4

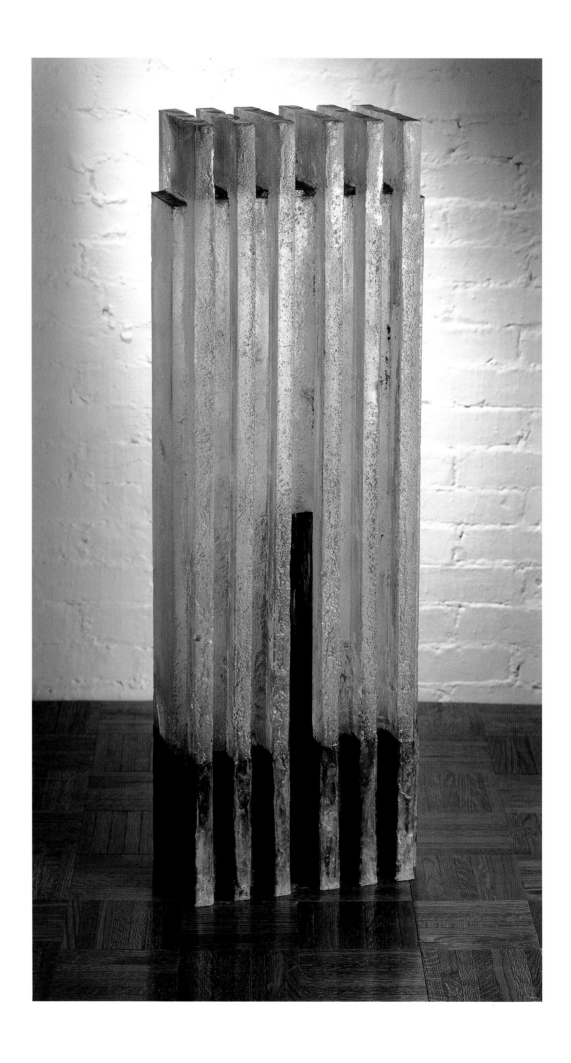

PLATE 4

Cast Form 43, 1984
Cast glass, copper, and patina
25 x 12 x 6 inches
Collection of Stanley and Merle Goldstein
cat. 2

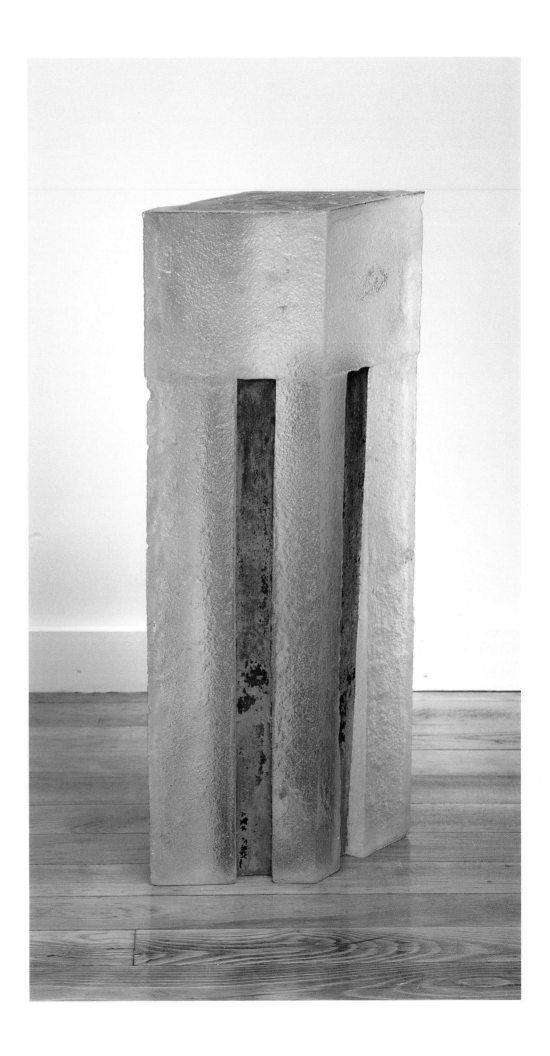

PLATE 5

Structure 24, 1984
Cast glass, copper, and patina
$41^{1}/_{2}$ x $12^{3}/_{4}$ x $10^{1}/_{4}$ inches
Collection of Stephen and Mitzi Schoninger
cat. 5

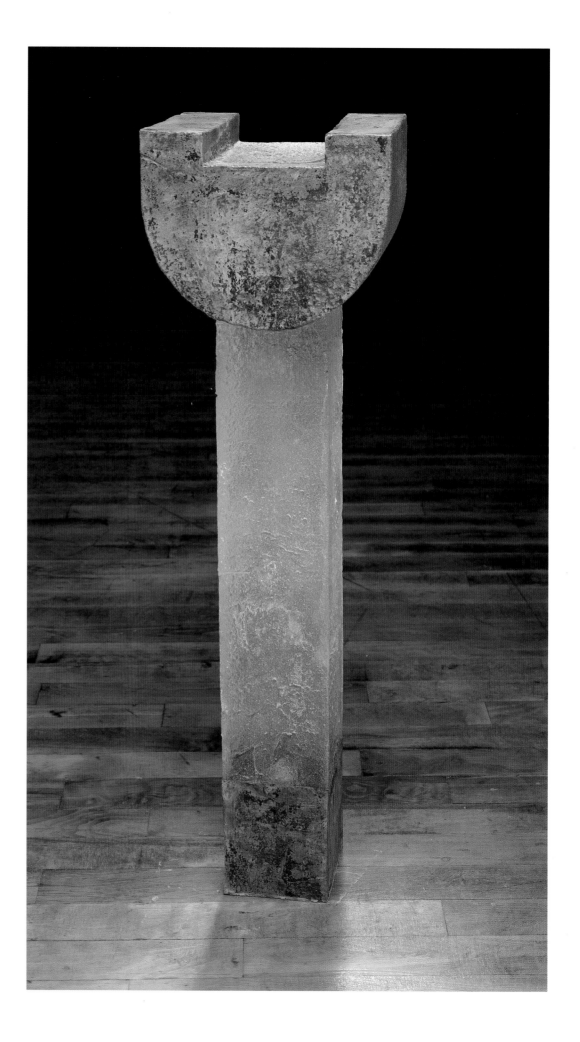

PLATE 6

Untitled #15, 1985

Mixed media on paper

22³⁄₄ x 43 inches (framed)

Collection of Dr. and Mrs. Joseph A. Chazan

cat. 6

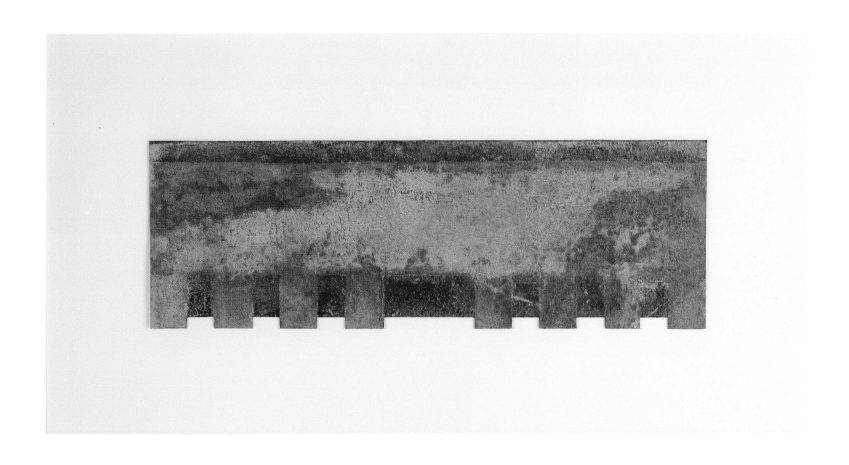

PLATE 7

Cast Form 65, 1986
Cast glass, copper leaf, gold leaf, and
pigmented waxes
$28^{1}/_{2}$ x $9^{3}/_{4}$ x $4^{1}/_{4}$ inches
Collection of the artist
cat. 7

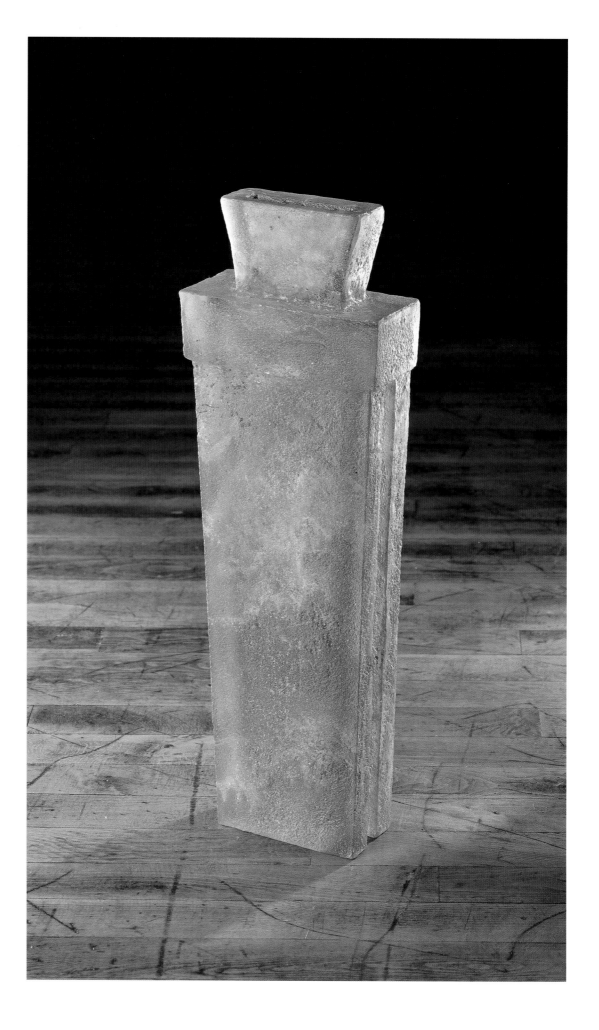

PLATE 8

Column 36, 1986 (remade 1998)
Cast glass, copper, and patina
97 x 32 $^{1}/_{2}$ x 14 $^{1}/_{4}$ inches
Collection of the artist
cat. 8

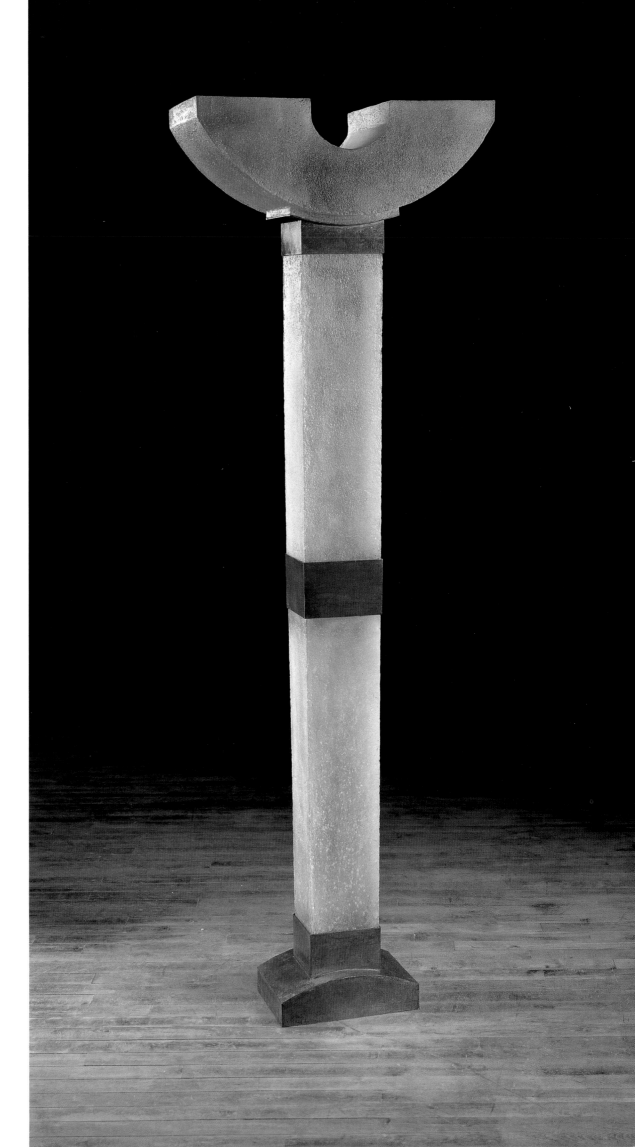

PLATE 9

Fourth Figure, 1986
Cast glass, brass, gold leaf, and
pigmented waxes
72 $\frac{1}{2}$ x 29 $\frac{3}{4}$ x 9 $\frac{3}{4}$ inches
Private collection
cat. 9

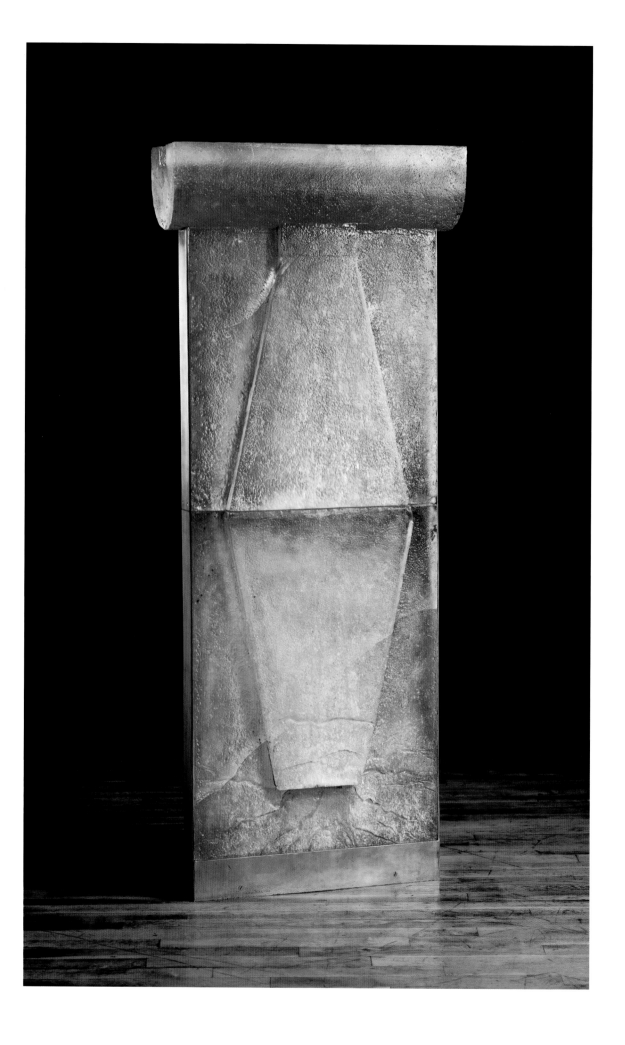

Dedicant 12, 1988
Cast glass, brass, lead, gold leaf,
pigmented wax, copper leaf, and patina
49$\frac{1}{2}$ x 18$\frac{1}{2}$ x 16$\frac{1}{2}$ inches
Collection of the Norton Museum of Art
West Palm Beach, Florida
Gift of Mr. and Mrs. Ridgely W. Harrison
cat. 10

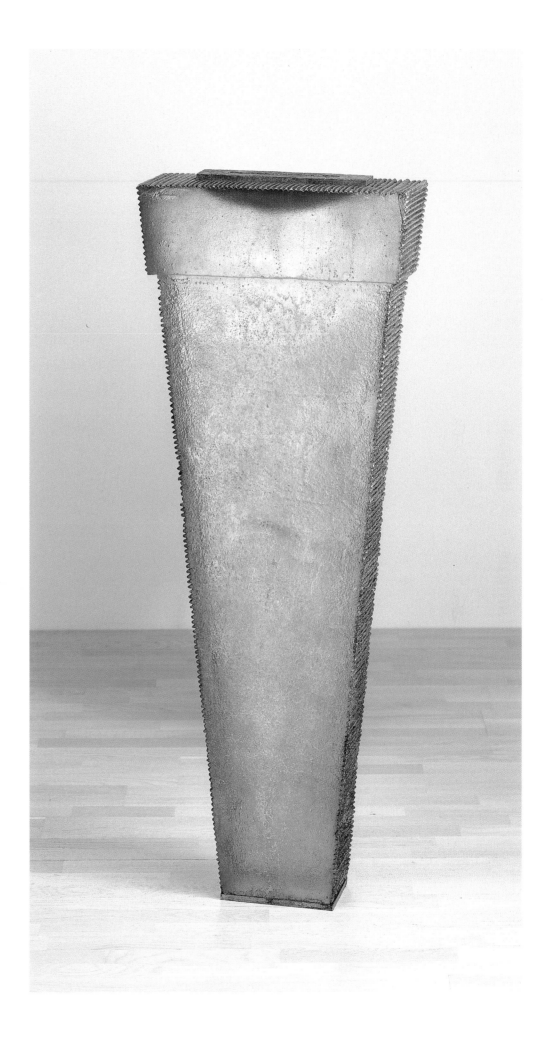

PLATE II

Section 7, 1988
Cast glass, lead, gold leaf, and pigmented waxes
11 x 36 x 10$^{1}/_{2}$ inches
Collection of the artist
cat. 13

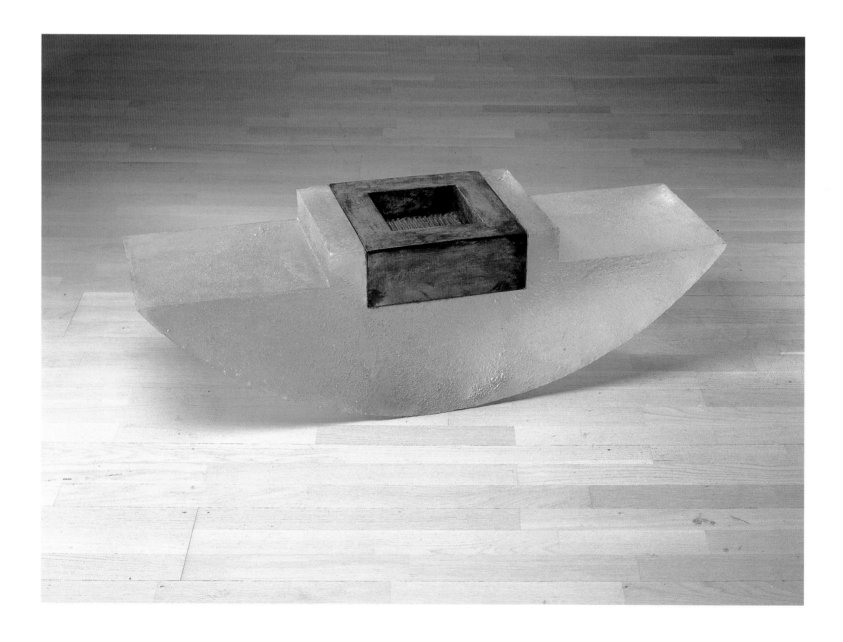

Eleventh Figure, 1988
Cast glass, brass, gold leaf, and
pigmented waxes
$54^{1}/_{2}$ x 15 x 13 inches
Collection of Daniel Greenberg and
Susan Steinhauser
cat. 11

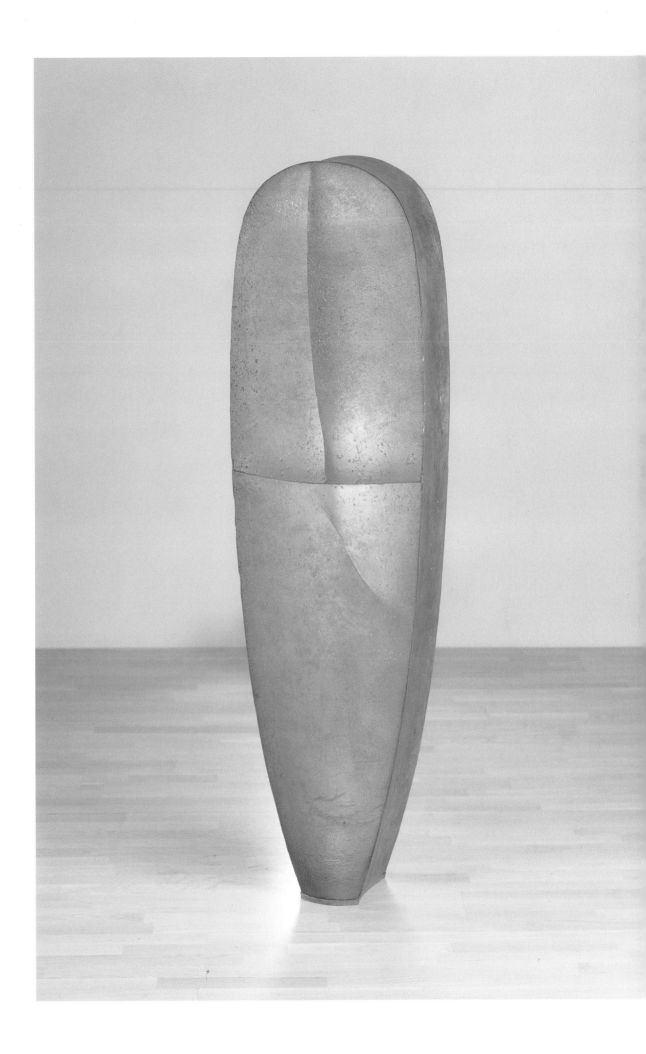

PLATE 13

Untitled No. 28, 1988
Mixed media on paper
48 x 19 inches (framed)
Collection of Dr. and Mrs. Joseph A. Chazan
cat. 14

PLATE 14

Section 6, 1988
Cast glass, lead, gold leaf, and pigmented waxes
10$\frac{1}{2}$ x 32 x 12 inches
Collection of Michael and Virginia Schroth
cat. 12

Second Vase, 1989
Cast glass, gold leaf, and bronze powder
71 $^{1}/_{2}$ x 23 x 23 inches
Collection of the Indianapolis Museum of Art
Gift of Marilyn and Eugene Glick
cat. 16

PLATE 16

13th Figure, 1989

Cast glass, brass, gold leaf, and pigmented waxes

79 x 18 x 9$\frac{1}{2}$ inches

Collection of Jon and Mary Shirley

cat. 17

PLATE 17

First Flask, 1989

Cast glass, brass, lead, and patina

71 x 24 x 12 inches

Collection of Gloria Dobbs

cat. 15

Bench 11, 1990

Cast glass, brass, steel, gold leaf, and pigmented waxes

27 x 52 x 14 inches

Collection of Mallory and Peter Haffenreffer

cat. 19

PLATE 19

Dedicant 17, 1990
Cast glass, brass, gold leaf, and pigmented waxes
54 x 14 x 18 1/4 inches
Collection of Helen and David Kangesser
cat. 20

PLATE 20

Fountain Maquette for
Immanent Circumstance
Norman B. Leventhal Park
Post Office Square, Boston, 1989 – 92
Mixed media
11 x 9 x 9 inches
Collection of the artist
cat. 18

PLATE 21

Working Drawing for
Basin 6, 1990
Graphite on paper
79 x 38 inches (framed)
Collection of the artist
cat. 21

PLATE 22

Working Drawing for
Primary Vessel 10, 1990
Graphite on paper
106 x 38 inches (framed)
Collection of the artist
cat. 22

PLATE 23

Primary Vessel 10, 1991
Cast glass and bronze powder
77 x 34 x 34 inches
Collection of the artist
cat. 26

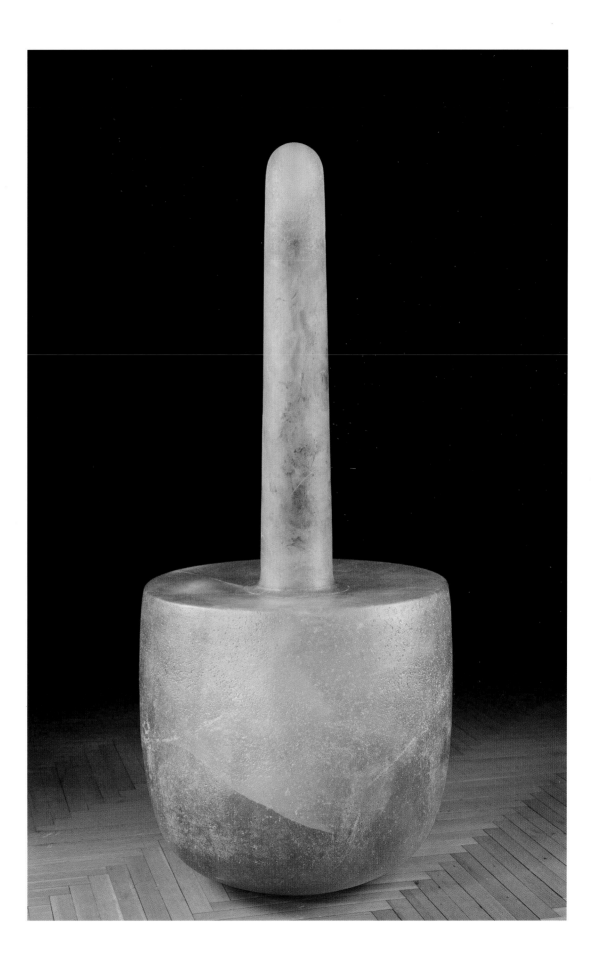

PLATE 24

Basin 3, 1991

Cast glass and lead powder

16 x 36 $\frac{1}{2}$ x 21 inches

Collection of Maxine and Stuart Frankel

cat. 23

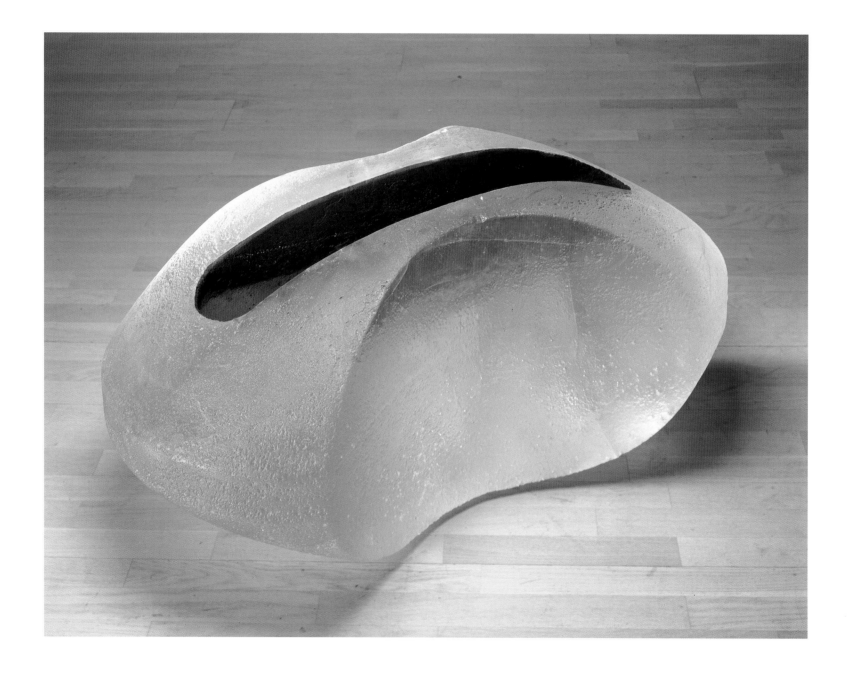

PLATE 25

Basin 11, 1991

Cast glass and red iron oxide

12¾ x 29¾ x 10 inches

Collection of the artist

cat. 24

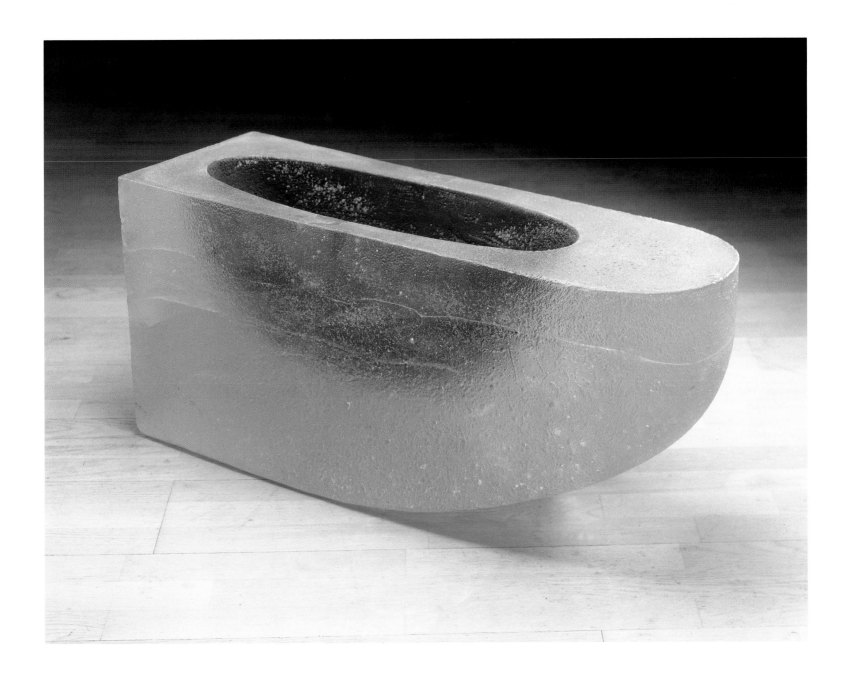

PLATE 26

Primary Vessel 5, 1991
Cast glass, brass, steel, and patina
$42^{1}/_{2}$ x 35 x $18^{3}/_{4}$ inches
Collection of Charles Cowles
cat. 25

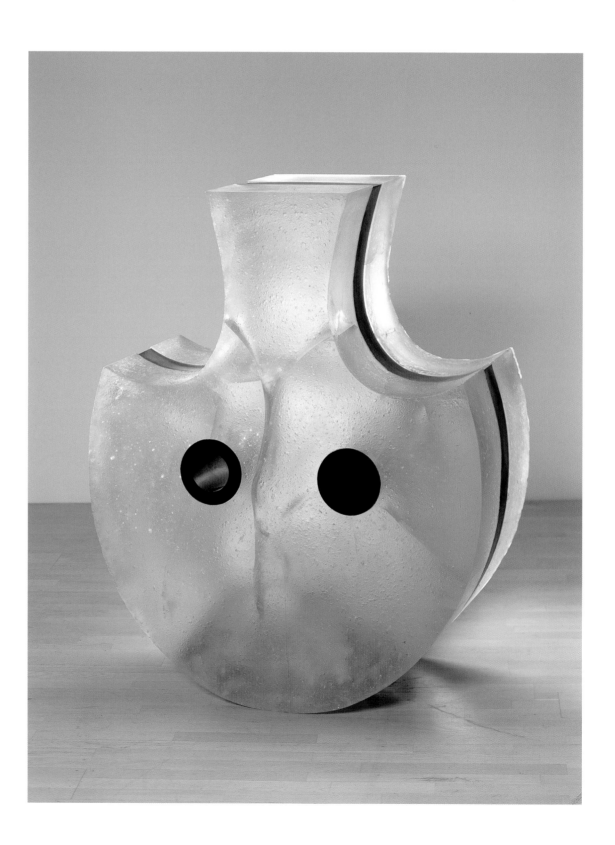

PLATE 27

PV2, 1992
Mixed media on paper
34 x 28$\frac{1}{4}$ inches (framed)
Collection of the artist
cat. 27

P.V 2 *H Benton* 9/92

PLATE 28

Maquette and Drawing for Ring of Knowledge:
Ground, Water, Fire, Wind, Void, 1993
Commissioned by the Grosvenor Society, Inc. of Buffalo, New York, in
fulfillment of the gift of James William Kideney and Isabel Houck Kideney
to the Buffalo and Erie County Public Library, Buffalo, New York
Mixed media
Maquette: five parts, each $1\frac{1}{2}$ x 3 x $1\frac{1}{2}$ inches
Drawing: $24\frac{3}{4}$ x 24 inches
Collection of the artist
cat. 28

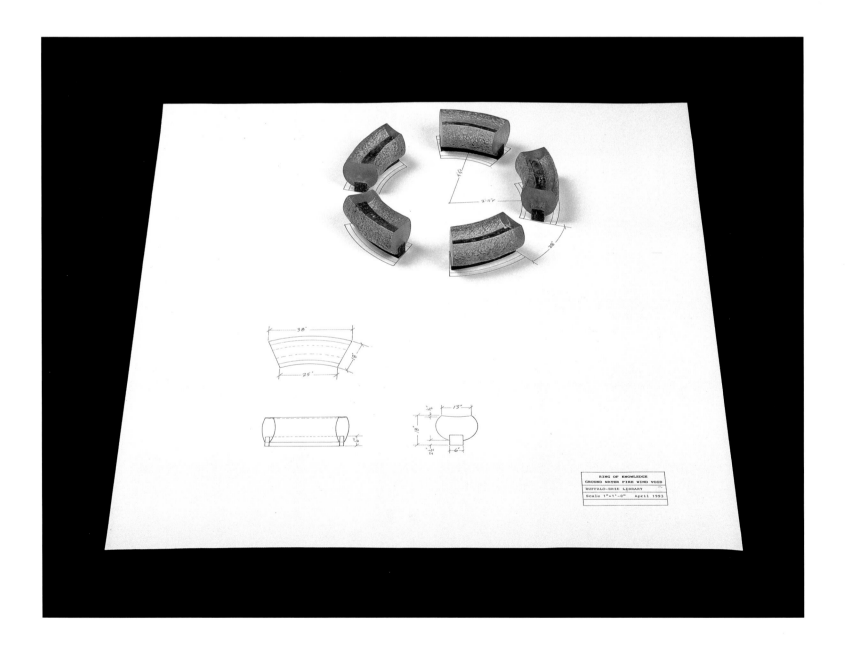

PLATE 29

Work on Paper for Wrapped Form 4, 1993

Mixed media on paper

76 x 36 inches (framed)

Collection of Ric Murray

cat. 30

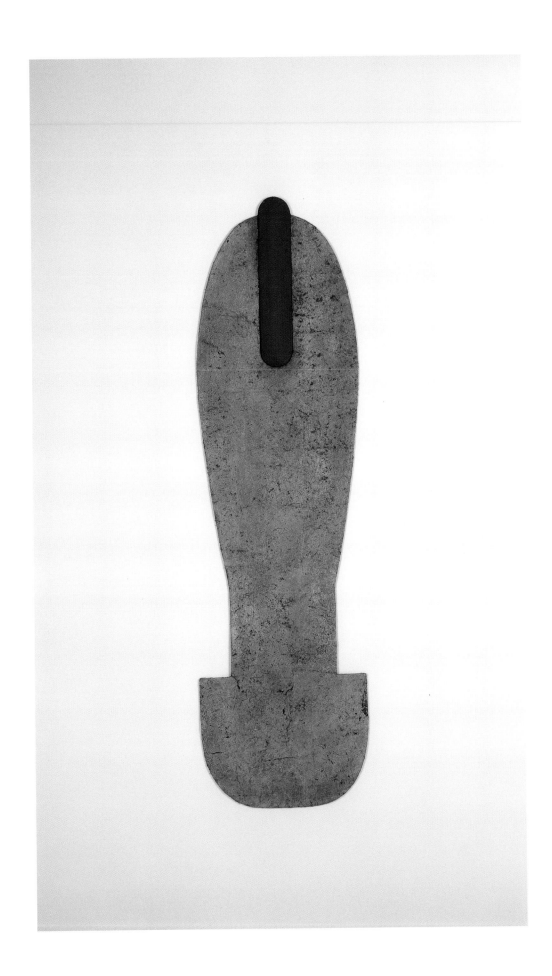

PLATE 30

Wrapped Form 1, 1993
Cast glass
$54\frac{1}{2}$ x $19\frac{1}{4}$ x $19\frac{1}{4}$ inches
Collection of Francine and Benson Pilloff
cat. 31

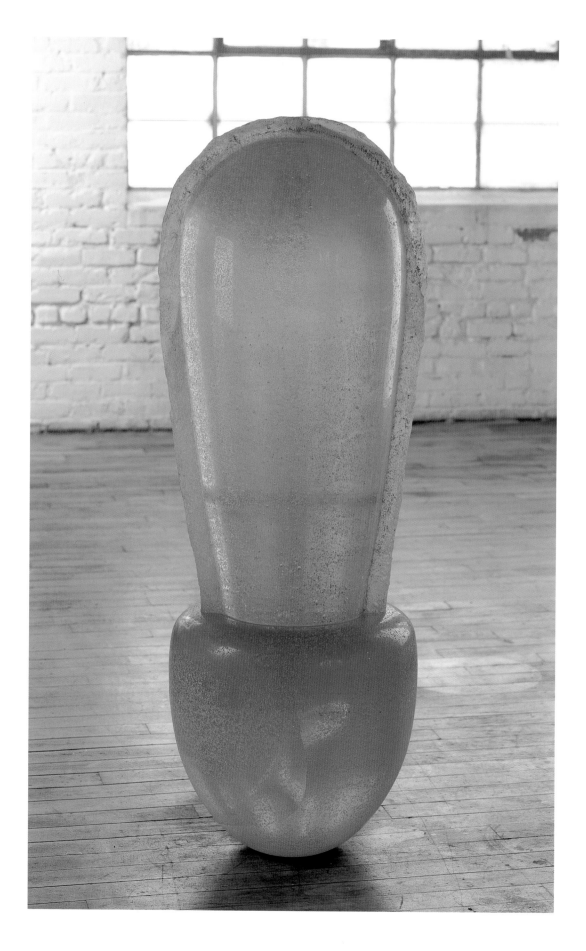

PLATE 31

Paired Forms 3, 1993
Cast glass and iron powder
53 $\frac{1}{4}$ x 32 x 16 $\frac{1}{2}$ inches
Gift of Dr. and Mrs. Joseph A. Chazan
Collection of the City of Scottsdale —
Scottsdale Museum of Contemporary Art
Arizona
cat. 29

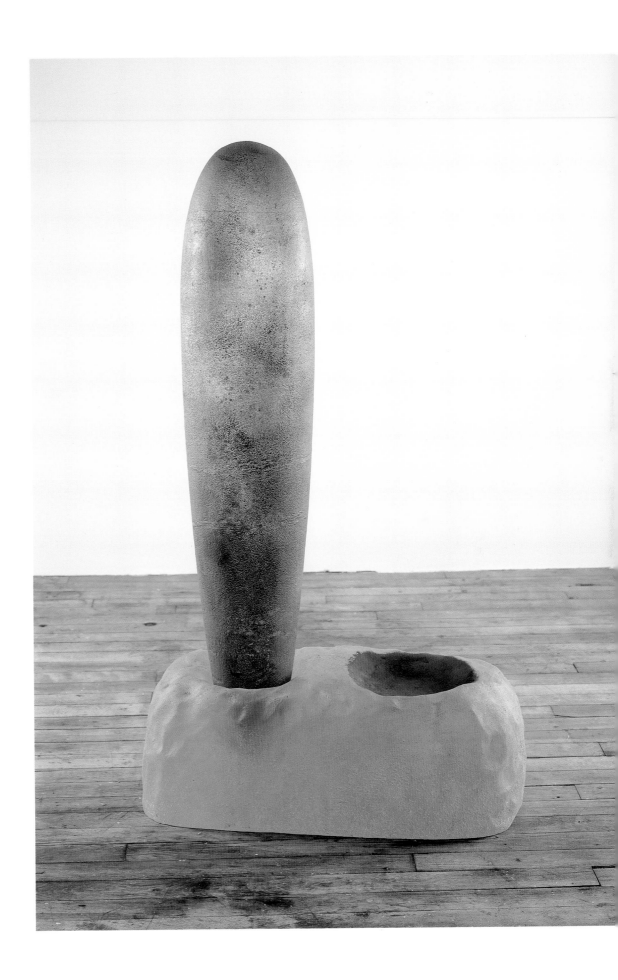

PLATE 32

Work on Paper for Double Wrapped Form, 1994

Mixed media on paper

77 x 47 inches (framed)

Collection of the artist

cat. 33

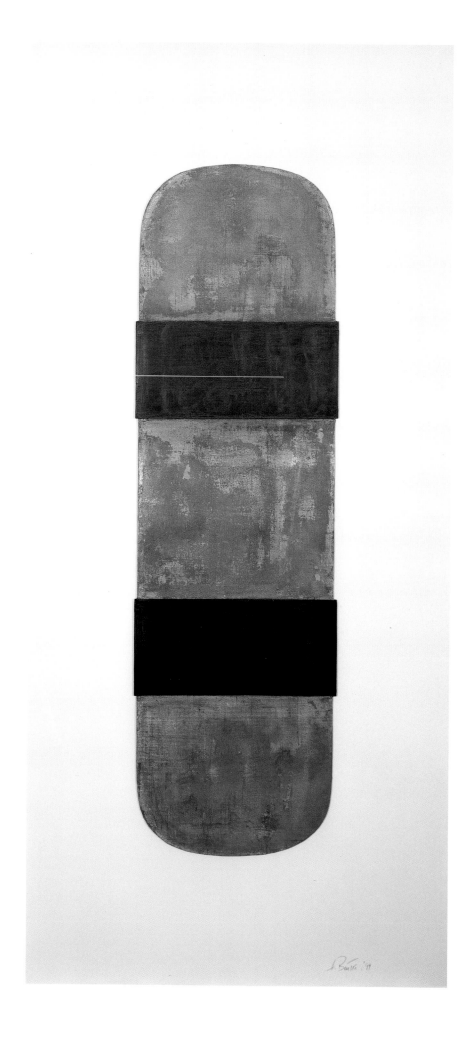

PLATE 33

Double Wrapped Form, 1994
Cast glass, lead, and patina
57 x 18 $^1/_2$ x 18 $^1/_2$ inches
Collection of the artist
cat. 32

PLATE 34

Bearing Figure with Alabastron, 1996
Cast low expansion glass, bronze,
patina, and gold leaf
75 $\frac{1}{2}$ x 29 x 16 $\frac{1}{2}$ inches
Collection of the artist
cat. 34

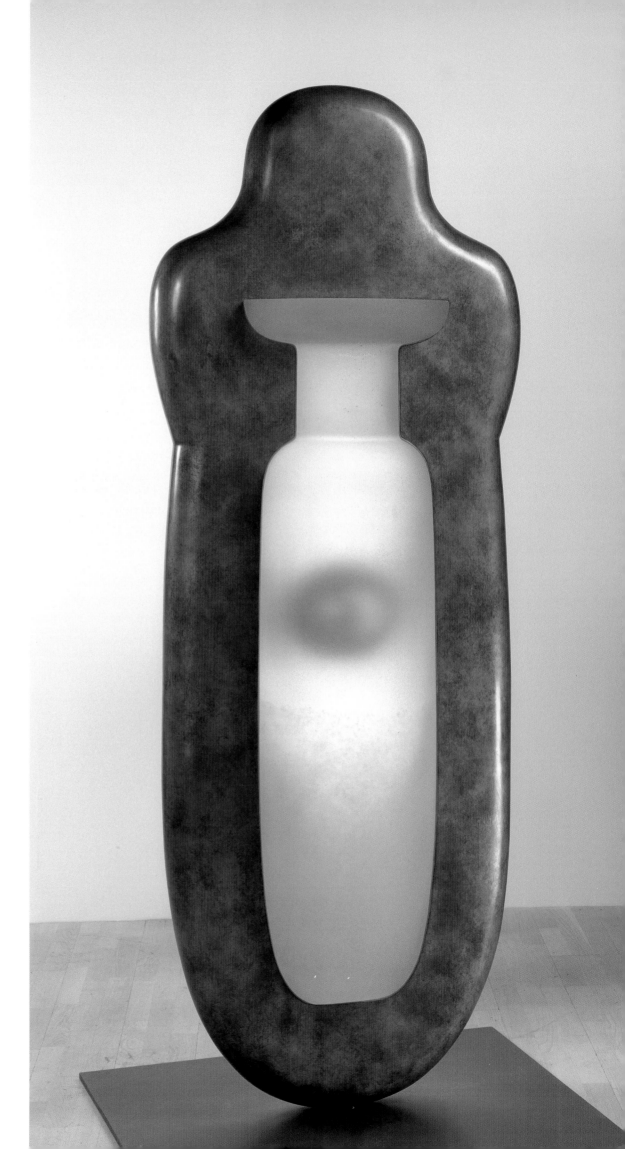

PLATE 35

Bearing Figure with Collared Vessel, 1996
Cast glass, steel, bronze leaf, and patina
18$^{1}/_{2}$ x 10 x 6 inches
Collection of the artist
cat. 36

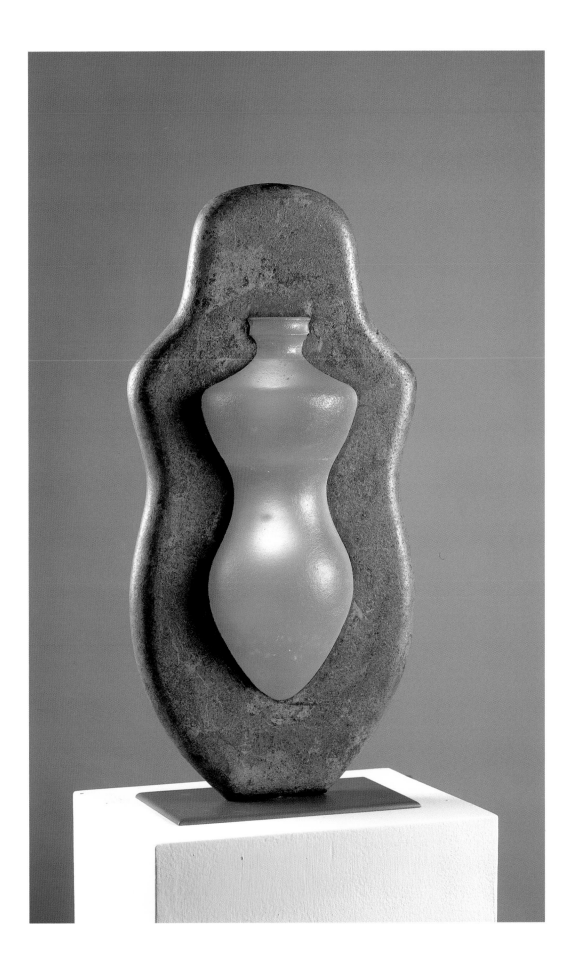

Bearing Figure with Aryballos, 1996

Cast glass, steel, and patina

17 x 13 x 5$\frac{1}{2}$ inches

Collection of the artist

cat. 35

Bearing Figure with Aryballos, 1996 (side view)

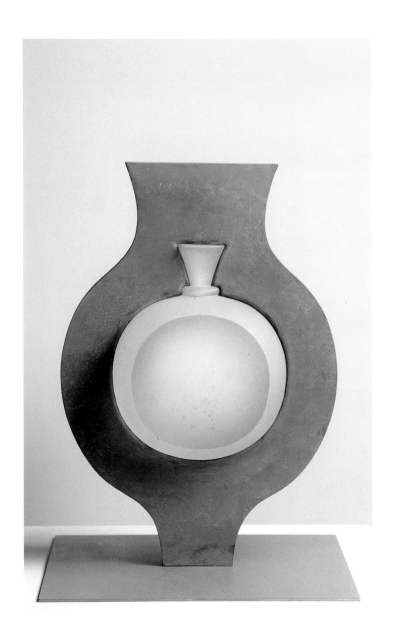

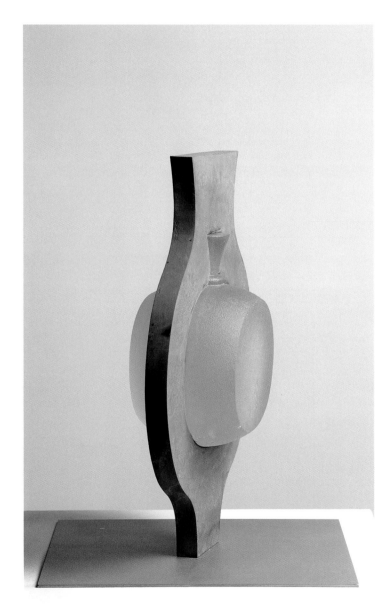

PLATE 37

Bearing Figure with Undulant Vessel II, 1996
Cast glass, granite, and silver leaf
54 x 30 x 14 inches
Collection of Bob and Karen Felton
cat. 37

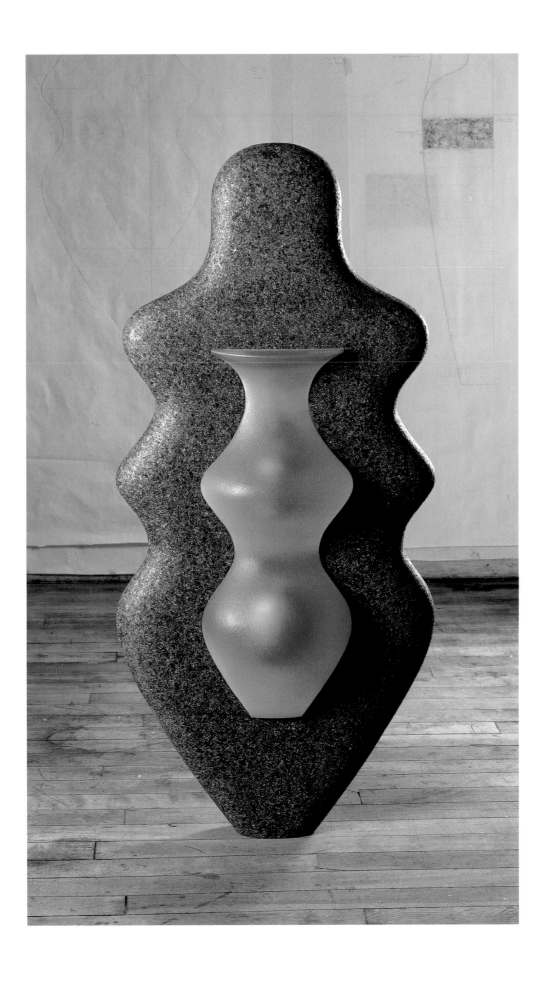

PLATE 38

Bottle Bench, 1996
Cast low expansion glass, brass, patina, and aluminum
$32\frac{1}{2}$ x 54 x $14\frac{1}{2}$ inches
Collection of the artist
cat. 38

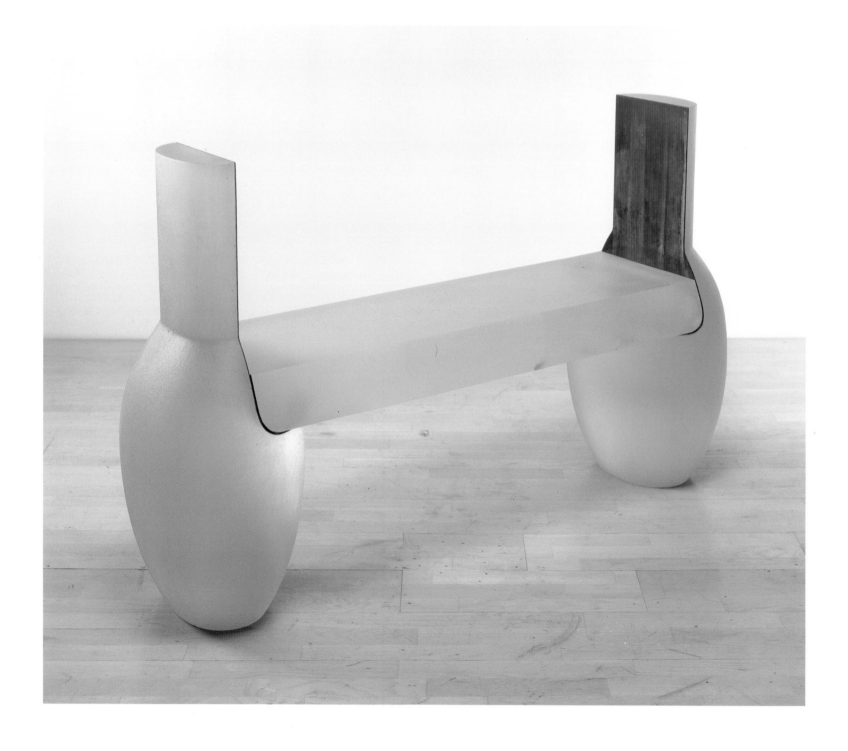

PLATE 39

Model with Column and Bench Maquettes for
Caryatid Columns and Benches, 1997
Mixed media
8 $\frac{1}{4}$ x 36 x 16 inches
Collection of the Hunter Museum of American Art
Chattanooga, Tennessee
Museum commission
cat. 39

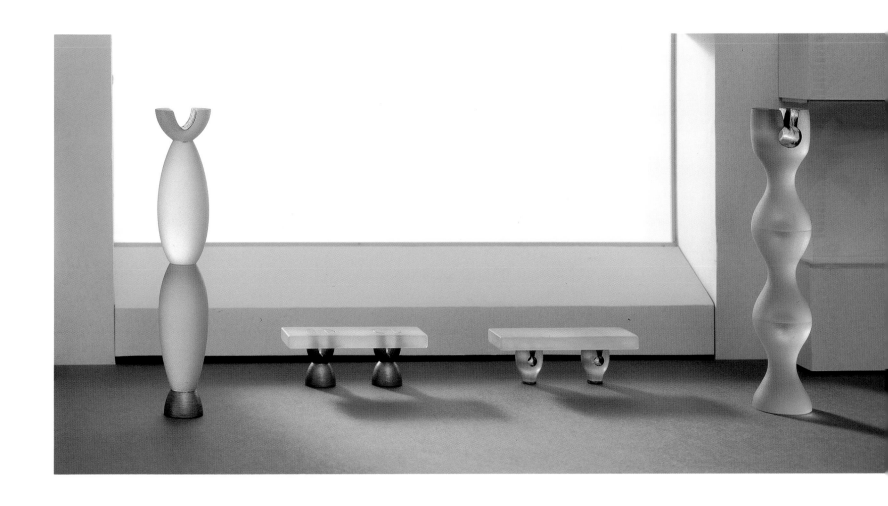

PLATE 40

Model for BankBoston Plaza, *Providence, Rhode Island*, 1997
Mixed media
16 ³/₄ x 42 ¹/₂ x 22 ¹/₂ inches
Collection of the artist
cat. 40

PLATE 41

Work on Paper for Wrapped Form 17, 1998

Mixed media on paper

77 x 35 inches (framed)

Collection of the artist

cat. 43

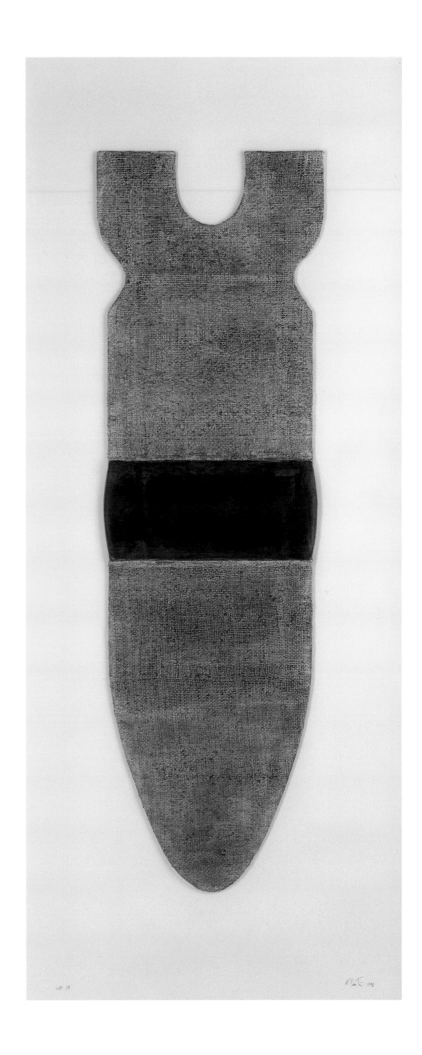

Working Drawing for Wrapped Form 16, 1998
Graphite on paper
98 x 38 inches (framed)
Collection of the artist
cat. 42

PLATE 43

Work on Paper for Wrapped Form 16, 1998
Mixed media on paper
73$\frac{1}{2}$ x 34$\frac{1}{2}$ inches (framed)
Collection of the artist
cat. 41

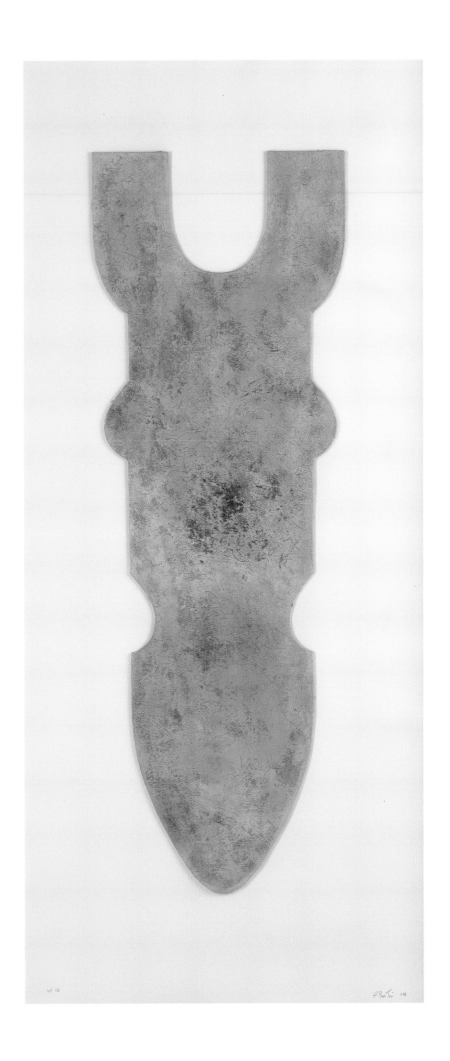

PLATE 44

Large Basin, 1999
Cast glass and iron oxide
$33^{3}/_{8}$ x $61^{1}/_{2}$ x 13 inches
Collection of the artist
cat. 44

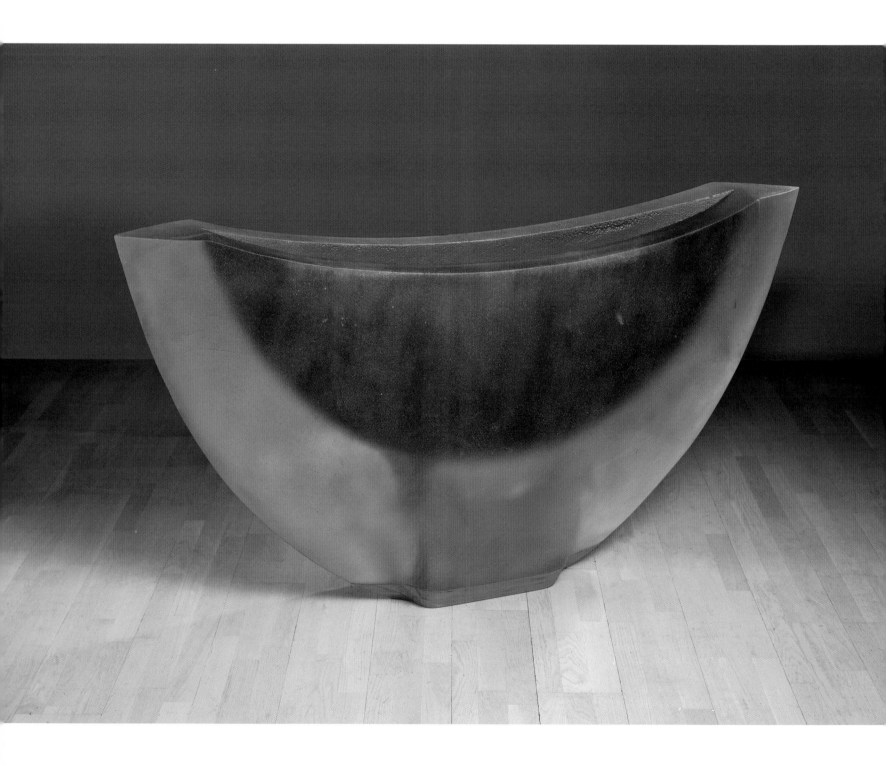

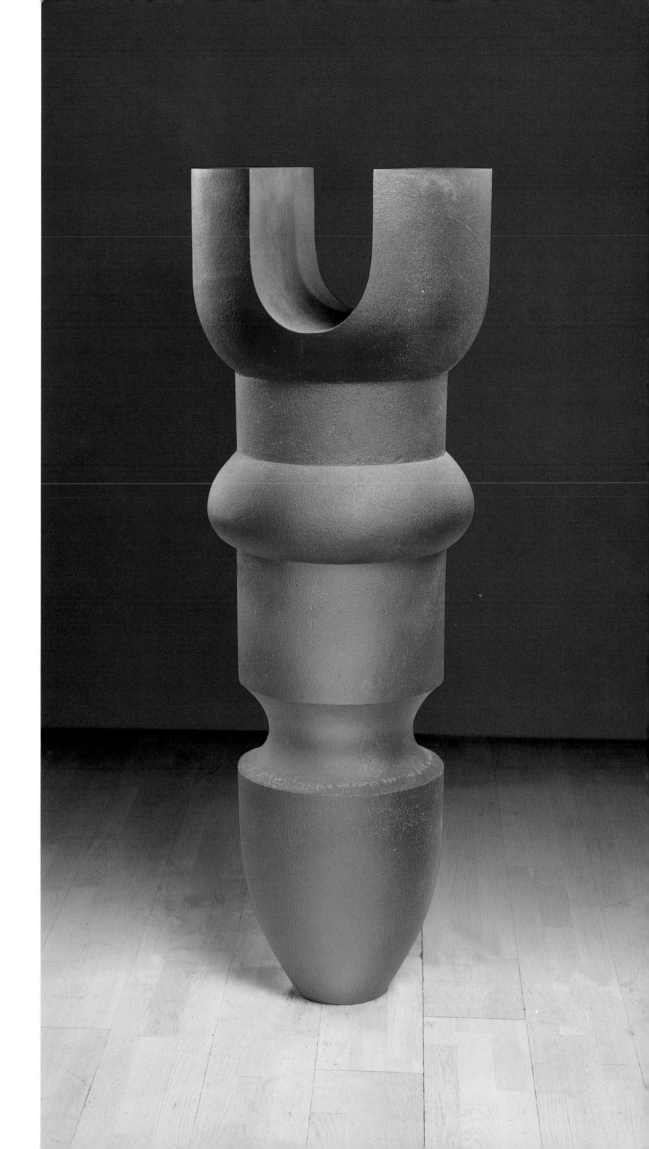

CATALOGUE OF THE EXHIBITION

1

Untitled #2, 1983
Mixed media on paper
$61^{1}/_{8}$ x $31^{1}/_{4}$ inches (framed)
Collection of the artist
plate 1

2

Cast Form 43, 1984
Cast glass, copper, and patina
25 x 12 x 6 inches
Collection of Stanley and Merle Goldstein
plate 4

3

Column 19, 1984
Cast glass, copper, and patina
$80^{1}/_{2}$ x 22 x 22 inches
Collection of Robert and Vera Loeffler
plate 2

4

Structure #13, 1984
Cast glass, copper, and patina
$39^{1}/_{2}$ x 14 x 8 inches
Collection of the Margulies family
plate 3

5

Structure 24, 1984
Cast glass, copper, and patina
$41^{1}/_{2}$ x $12^{3}/_{4}$ x $10^{1}/_{4}$ inches
Collection of Stephen and Mitzi Schoninger
plate 5

6

Untitled #15, 1985
Mixed media on paper
$22^{3}/_{4}$ x 43 inches (framed)
Collection of Dr. and Mrs. Joseph A. Chazan
plate 6

7

Cast Form 65, 1986
Cast glass, copper leaf, gold leaf, and
pigmented waxes
$28^{1}/_{2}$ x $9^{3}/_{4}$ x $4^{1}/_{4}$ inches
Collection of the artist
plate 7

8

Column 36, 1986 (remade 1998)
Cast glass, copper, and patina
97 x $32^{1}/_{2}$ x $14^{1}/_{4}$ inches
Collection of the artist
plate 8

9

Fourth Figure, 1986
Cast glass, brass, gold leaf, and
pigmented waxes
$72^{1}/_{2}$ x $29^{3}/_{4}$ x $9^{3}/_{4}$ inches
Private collection
plate 9

10

Dedicant 12, 1988
Cast glass, brass, lead, gold leaf,
pigmented wax,copper leaf, and patina
$49^{1}/_{2}$ x $18^{1}/_{2}$ x $16^{1}/_{2}$ inches
Collection of the Norton Museum of Art
West Palm Beach, Florida
Gift of Mr. and Mrs. Ridgely W. Harrison
plate 10

11

Eleventh Figure, 1988
Cast glass, brass, gold leaf, and
pigmented waxes
$54^{1}/_{2}$ x 15 x 13 inches
Collection of Daniel Greenberg and
Susan Steinhauser
plate 12

12

Section 6, 1988
Cast glass, lead, gold leaf, and
pigmented waxes
$10^{1}/_{2}$ x 32 x 12 inches
Collection of Michael and Virginia Schroth
plate 14

13

Section 7, 1988
Cast glass, lead, gold leaf, and
pigmented waxes
11 x 36 x $10^{1}/_{2}$ inches
Collection of the artist
plate 11

14

Untitled No. 28, 1988
Mixed media on paper
48 x 19 inches (framed)
Collection of
Dr. and Mrs. Joseph A. Chazan
plate 13

15

First Flask, 1989
Cast glass, brass, lead, and patina
71 x 24 x 12 inches
Collection of Gloria Dobbs
plate 17

16

Second Vase, 1989
Cast glass, gold leaf, and bronze powder
$71^{1}/_{2}$ x 23 x 23 inches
Collection of the
Indianapolis Museum of Art
Gift of Marilyn and Eugene Glick
plate 15

17

13th Figure, 1989
Cast glass, brass, gold leaf, and
pigmented waxes
79 x 18 x $9^{1}/_{2}$ inches
Collection of Jon and Mary Shirley
plate 16

18

Fountain Maquette for
Immanent Circumstance
Norman B. Leventhal Park
Post Office Square, Boston, 1989–92
Mixed media
11 x 9 x 9 inches
Collection of the artist
plate 20

19

Bench 11, 1990
Cast glass, brass, steel, gold leaf, and
pigmented waxes
27 x 52 x 14 inches
Collection of Mallory and Peter
Haffenreffer
plate 18

20

Dedicant 17, 1990
Cast glass, brass, gold leaf, and
pigmented waxes
54 x 14 x 18 1/4 inches
Collection of Helen and David Kangesser
plate 19

21

Working Drawing for Basin 6, 1990
Graphite on paper
79 x 38 inches (framed)
Collection of the artist
plate 21

22

Working Drawing for
Primary Vessel 10, 1990
Graphite on paper
106 x 38 inches (framed)
Collection of the artist
plate 22

23

Basin 3, 1991
Cast glass and lead powder
16 x 36 1/2 x 21 inches
Collection of Maxine and Stuart Frankel
plate 24

24

Basin 11, 1991
Cast glass and red iron oxide
12 3/4 x 29 3/4 x 10 inches
Collection of the artist
plate 25

25

Primary Vessel 5, 1991
Cast glass, brass, steel, and patina
42 1/2 x 35 x 18 3/4 inches
Collection of Charles Cowles
plate 26

26

Primary Vessel 10, 1991
Cast glass and bronze powder
77 x 34 x 34 inches
Collection of the artist
plate 23

27

PV2, 1992
Mixed media on paper
34 x 28 1/4 inches (framed)
Collection of the artist
plate 27

28

Maquette and Drawing for
Ring of Knowledge: Ground, Water,
Fire, Wind, Void, 1993
Commissioned by the Grosvenor Society, Inc.
of Buffalo, New York, in fulfillment of the
gift of James William Kideney and
Isabel Houck Kideney to the
Buffalo and Erie County Public Library
Buffalo, New York
Mixed media
Maquette: five parts
each 1 1/2 x 3 x 1 1/2 inches
Drawing: 24 3/4 x 24 inches
Collection of the artist
plate 28

29

Paired Forms 3, 1993
Cast glass and iron powder
53 1/4 x 32 x 16 1/2 inches
Gift of Dr. and Mrs. Joseph A. Chazan
Collection of the City of Scottsdale—
Scottsdale Museum of Contemporary Art
Arizona
plate 31

30

Work on Paper for Wrapped Form 4, 1993
Mixed media on paper
76 x 36 inches (framed)
Collection of Ric Murray
plate 29

31

Wrapped Form 1, 1993
Cast glass
$54^{1}/_{2}$ x $19^{1}/_{4}$ x $19^{1}/_{4}$ inches
Collection of Francine and Benson Pilloff
plate 30

32

Double Wrapped Form, 1994
Cast glass, lead, and patina
57 x $18^{1}/_{2}$ x $18^{1}/_{2}$ inches
Collection of the artist
plate 33

33

Work on Paper for
Double Wrapped Form, 1994
Mixed media on paper
77 x 47 inches (framed)
Collection of the artist
plate 32

34

Bearing Figure with Alabastron, 1996
Cast low expansion glass, bronze, patina,
and gold leaf
$75^{1}/_{2}$ x 29 x $16^{1}/_{2}$ inches
Collection of the artist
plate 34

35

Bearing Figure with Aryballos, 1996
Cast glass, steel, and patina
17 x 13 x $5^{1}/_{2}$ inches
Collection of the artist
plates 36a and b

36

Bearing Figure with Collared Vessel, 1996
Cast glass, steel, bronze leaf, and patina
$18^{1}/_{2}$ x 10 x 6 inches
Collection of the artist
plate 35

37

Bearing Figure with Undulant Vessel II, 1996
Cast glass, granite, and silver leaf
54 x 30 x 14 inches
Collection of Bob and Karen Felton
plate 37

38

Bottle Bench, 1996
Cast low expansion glass, brass,
patina, and aluminum
$32^{1}/_{2}$ x 54 x $14^{1}/_{2}$ inches
Collection of the artist
plate 38

39

Model with Column and
Bench Maquettes for
Caryatid Columns and Benches, 1997
Mixed media
$8^{1}/_{4}$ x 36 x 16 inches
Collection of the Hunter Museum
of American Art
Chattanooga, Tennessee
Museum commission
plate 39

40

Model for BankBoston Plaza,
Providence, Rhode Island, 1997
Mixed media
$16^{3}/_{4}$ x $42^{1}/_{2}$ x $22^{1}/_{2}$ inches
Collection of the artist
plate 40

4 1

Work on Paper for
Wrapped Form 16, 1998
Mixed media on paper
$73^{1/2}$ x $34^{1/2}$ inches (framed)
Collection of the artist
plate 43

4 2

Working Drawing for
Wrapped Form 16, 1998
Graphite on paper
98 x 38 inches (framed)
Collection of the artist
plate 42

4 3

Work on Paper for
Wrapped Form 17, 1998
Mixed media on paper
77 x 35 inches (framed)
Collection of the artist
plate 41

4 4

Large Basin, 1999
Cast glass and iron oxide
$33^{3/8}$ x $61^{1/2}$ x 13 inches
Collection of the artist
plate 44

4 5

Wrapped Form 16, 1999
Cast glass, lead, and patina
$52^{1/2}$ x $18^{1/2}$ x $17^{1/8}$ inches
Collection of the artist
plate 45

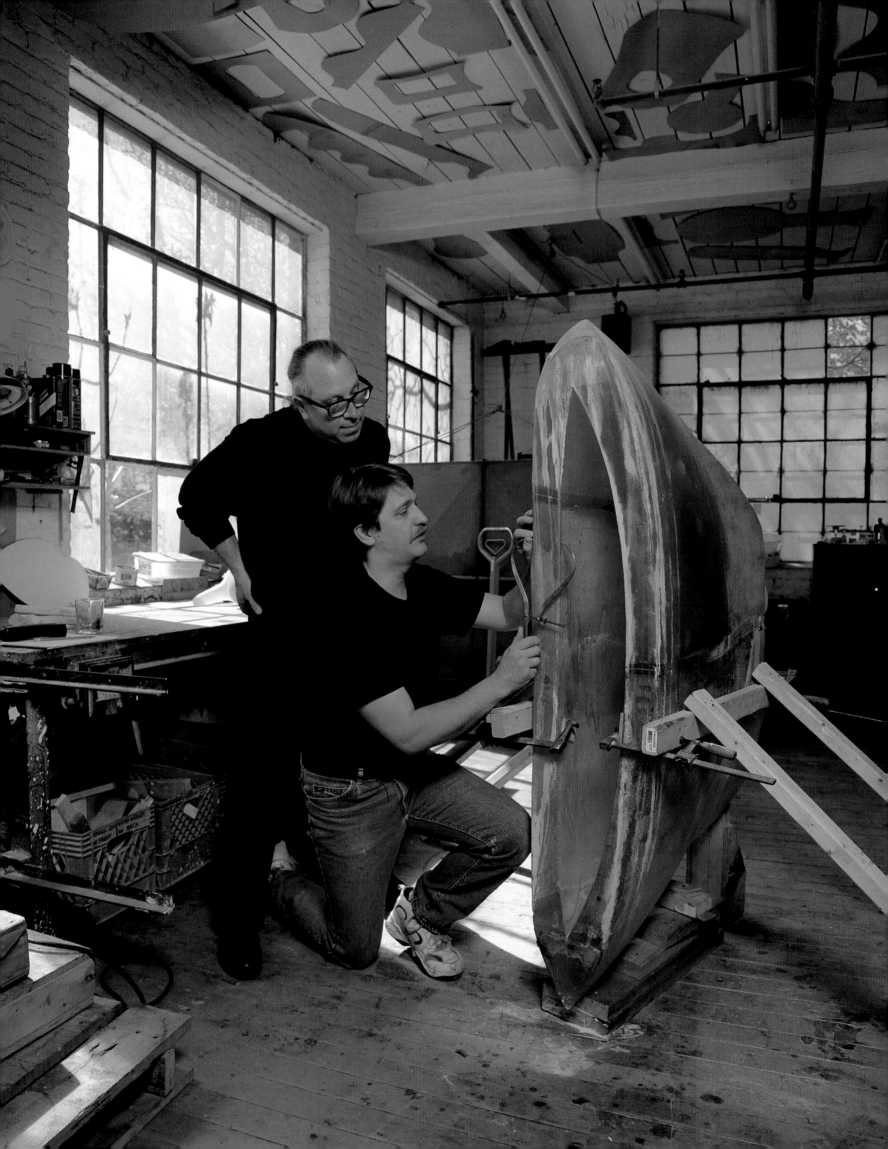

DOCUMENTATION

Gay Ben Tré

HOWARD BEN TRÉ

Born in Brooklyn, New York, 1949

Resides in Providence, Rhode Island and Vinalhaven, Maine

EDUCATION

Missouri Valley College, Marshall, 1967–68

Brooklyn College, New York, 1968–69

Portland State University, Oregon, BSA 1978

Rhode Island School of Design, Providence, MFA 1980

SITED PUBLIC PROJECTS

Artery Plaza, Bethesda, Maryland

Buffalo and Erie County Public Library, Buffalo, New York

Crescent Court, Dallas

Duke University Medical Center, Durham, North Carolina

Hasbro Children's Hospital, Providence, Rhode Island

BankBoston Plaza, Providence, Rhode Island

Hunter Museum of American Art, Chattanooga, Tennessee

IBM Corporation, Gaithersburg, Maryland

Piedmont Park, Atlanta

Norman B. Leventhal Park, Post Office Square, Boston

Rhode Island Convention Center, Providence

Seattle Art Museum

The Toledo Museum of Art, Ohio

Warrington Town Center, England

Howard Ben Tré and Eric Portrais
working in Lafayette Street studio
Pawtucket, Rhode Island, 1999

Albright-Knox Art Gallery, Buffalo, New York

American Craft Museum, New York

Arco Corporate Art Collection, Los Angeles

AT&T Corporate Collection, Chicago

BankBoston Art Collection, Boston

Brooklyn Museum of Art, New York

Brown University, David Winton Bell Gallery, Providence, Rhode Island

Centro Cultural/Arte Contemporáneo, Mexico City

Chase Manhattan Bank Art Collection, New York

The Chrysler Museum, Norfolk, Virginia

The Cleveland Museum of Art

The Corning Museum of Glass, New York

Corporate Art Collection, The Coca-Cola Company, Atlanta

The Detroit Institute of Arts

Duke University Medical Center, Durham, North Carolina

Federal Reserve Board, Washington

Goldman Sachs, New York

High Museum of Art, Atlanta

Hirshhorn Museum and Sculpture Garden, Smithsonian Institution, Washington

Hokkaido Museum of Modern Art, Sapporo, Japan

Hunter Museum of American Art, Chattanooga, Tennessee

Huntington Museum of Art, West Virginia

Indianapolis Museum of Art

J. B. Speed Art Museum, Louisville

Kalamazoo Institute of Arts, Michigan

Koganezaki Park Museum, Shizuoka, Japan

The Leigh Yawkey Woodson Art Museum, Wausau, Wisconsin

Los Angeles County Museum of Art

Merrill Lynch & Co., Inc., New York

The Metropolitan Museum of Art, New York

Milwaukee Art Museum, Wisconsin

Musée d'Art Moderne et d'Art Contemporain, Nice, France

Musée des Arts Décoratifs, Lausanne, Switzerland

Museum of Art, Rhode Island School of Design, Providence

Museum of Fine Arts, Boston

Museum of Fine Arts, Houston

National Museum of American History, Smithsonian Institution, Washington

The National Museum of Modern Art, Kyoto

Newport Art Museum, Rhode Island

Pacific Enterprises, Los Angeles

Palm Springs Desert Museum, California

Pepsico of California

City of Philadelphia

Philadelphia Museum of Art

Phillip Morris Management Corporation, New York

The Phillips Collection, Washington

Phoenix Art Museum

Prudential Insurance Company of America, New York

Reader's Digest Association, Pleasantville, New York

Renwick Gallery of the National Museum of American Art, Smithsonian Institution, Washington

Rockefeller Management Corporation, New York

Rutgers University, The Jane Voorhees Zimmerli Art Museum, New Brunswick, New Jersey

The Saint Louis Art Museum

The San Francisco Arts Commission

Scottsdale Museum of Contemporary Art

Seattle Art Museum

Southwestern Bell Corporation, Houston

Tokio Marine Management, New York

The Toledo Museum of Art, Ohio

SELECTED GRANTS AND AWARDS

Rhode Island State Council on the Arts Fellowship, 1979, 1984, 1990

National Endowment for the Arts Fellowship, 1980, 1984, 1990

Change, Inc. Grant, 1982

Rakow Commission, The Corning Museum of Glass, 1987

Boston Society of Architects, Art & Architecture Collaboration Award, 1993

First Annual Pell Award for Excellence in the Arts, 1997

UrbanGlass, Innovative Use of Glass in Sculpture Award, 1997

Providence Preservation Society Award for Urban Design, 1998

SELECTED EXHIBITIONS

Solo Exhibitions

1979

University of Rhode Island Fine Arts Center Galleries, Kingston, "Howard Ben Tré: Solo"

1980

Hadler/Rodriguez Galleries, New York, "Howard Ben Tré: Recent Sculpture"

1981

Foster/White Gallery, Seattle, "Howard Ben Tré: Sculpture"

Habatat Galleries, Lathrup Village, Michigan, "Howard Ben Tré"

Hadler/Rodriguez Galleries, Houston, "Howard Ben Tré" (exh. cat.)

1982

Hadler/Rodriguez Galleries, New York, "Howard Ben Tré: Columns" (exh. brochure)

1983

Clark Gallery, Lincoln, Massachusetts, "Howard Ben Tré: Recent Work"

Foster/White Gallery, Seattle, "Howard Ben Tré"

Habatat Galleries, Lathrup Village, Michigan, "Howard Ben Tré: Sculpture and Photographs" (exh. cat.)

Hadler/Rodriguez Galleries, Houston, "Howard Ben Tré"

1984

Habatat Galleries, Miami, "Howard Ben Tré: Recent Sculpture and Works on Paper"

1985

Charles Cowles Gallery, New York, "Howard Ben Tré" (exh. cat.)

Hadler/Rodriguez Galleries, Houston, "Howard Ben Tré"

Habatat Galleries, Lathrup Village, Michigan, "Howard Ben Tré"

1986

Charles Cowles Gallery, New York, "Howard Ben Tré" (exh. brochure)

John Berggruen Gallery, San Francisco, "Howard Ben Tré: Recent Sculpture"

1987

Fay Gold Gallery, Atlanta, "Howard Ben Tré"

1988

Charles Cowles Gallery, New York, "Howard Ben Tré: Figures" (exh. cat.)

1989

Charles Cowles Gallery, New York, "Howard Ben Tré"

Dorothy Goldeen Gallery, Santa Monica, California, "Howard Ben Tré: New Work"

The Phillips Collection, Washington, "Contemporary Sculpture: Howard Ben Tré" (exh. cat.) (traveled to Carnegie-Mellon Art Gallery, Pittsburgh; Laumeier Sculpture Park & Museum, St. Louis; DeCordova Museum and Sculpture Park, Lincoln, Massachusetts)

1991

Charles Cowles Gallery, New York, "Howard Ben Tré: Vessels of Light" (exh. cat.)

Clark Gallery, Lincoln, Massachusetts, "Howard Ben Tré: Sculpture"

1992

Dorothy Goldeen Gallery, Santa Monica, California, "Howard Ben Tré: New Work"

The Toledo Museum of Art, Ohio, "Crossing the Boundaries: The Sculpture of Howard Ben Tré"

1993

Brown University, David Winton Bell Gallery, Providence, Rhode Island, "Howard Ben Tré: New Work" (exh. cat.) (traveled to Norton Museum of Art, West Palm Beach, Florida)

Charles Cowles Gallery, New York, "Howard Ben Tré: Wrapped and Paired Forms" (exh. brochure)

1994

Davis/McClain Gallery, Houston, "Howard Ben Tré: Recent Sculpture"

University of Rhode Island, Fine Arts Center Galleries, Kingston, "Howard Ben Tré: Basins and Fountains" (exh. cat.)

Musée d'Art Moderne et d'Art Contemporain, Nice, France, "Sculptures de Verre" (exh. cat.)

1995

University of Richmond, The Marsh Art Gallery, Virginia with the Cleveland Center for Contemporary Art, "Howard Ben Tré: Recent Sculpture" (exh. cat.) (traveled to Newport Art Museum, Rhode Island)

1996

Charles Cowles Gallery, New York, "Indoor/Outdoor: New Sculpture" (exh. brochure)

1998

Hunter Museum of American Art, Chattanooga, Tennessee, "Howard Ben Tré: Caryatids and New Works on Paper"

Group Exhibitions

1978

The Leigh Yawkey Woodson Art Museum, Wausau, Wisconsin, "Americans in Glass" (traveled as "50 Americans")

1979

The Corning Museum of Glass, New York, "New Glass: A Worldwide Survey" (exh. cat.) (traveled to The Metropolitan Museum of Art, New York; Renwick Gallery of the National Museum of American Art, Smithsonian Institution, Washington; The Toledo Museum of Art, Ohio; The Fine Arts Museum of San Francisco; Victoria and Albert Museum, London; Musée des Arts Décoratifs, Paris; Seibu Museum of Art, Tokyo)

University of Washington, Henry Art Gallery, Seattle, "The Pilchuck Show"

1980

Galerie Skandinaviske Mobler, Frankfurt, "Ten American Artists"

Museum of Art, Rhode Island School of Design, Providence, "A Case for Boxes"

1981

Bowling Green State University, Ohio, "Emergence" (exh. cat.)

Bundesgartenschau and Orangerie, Kassel, Germany, "Glaskunst '81"

DeCordova Museum and Sculpture Park, Lincoln, Massachusetts, "Glass Routes" (exh. cat.)

Huntington Museum of Art, West Virginia, "New American Glass: Focus West Virginia" (exh. cat.)

The National Museum of Modern Art, Kyoto and The National Museum of Modern Art, Tokyo, "Contemporary Glass—Australia, Canada, U.S.A. & Japan" (exh. cat.)

1982

Art Gallery of Western Australia and Australian Consolidated Industries Ltd., Perth, "International Directions in Glass Art" (exh. cat.)

Cooper-Hewitt National Museum of Design, Smithsonian Institution, New York, "Columns, Ornament, and Structure"

The Detroit Institute of Arts, "Contemporary Art in Detroit Collections"

Hokkaido Museum of Modern Art and Asahi Shimbun, Sapporo, Japan, "World Glass Now '82" (exh. cat.)

Jesse Besser Museum and Habatat Galleries, Alpena, Michigan, "Glass Sculpture: 4 Artists, 4 Views" (exh. cat.)

1983

Art in Embassies Program, US Embassy, Prague, "Contemporary American Glass Sculpture" (exh. cat.)

The Columbus College of Art and Design, Ohio, "The Fine Art of Contemporary American Glass" (exh. cat.)

Fine Arts Center of Tempe, Arizona, "Selected Works in Glass"

Newport Art Museum, Rhode Island, "Ben Tré — Chihuly: Sculpture and Works on Paper" (exh. brochure)

1984

The Leigh Yawkey Woodson Art Museum, Wausau, Wisconsin, "Americans in Glass" (exh. cat.) (traveled throughout Europe)

The Saint Louis Art Museum, "Hot Stuff"

1985

The Detroit Institute of Arts, "Detroit Collects"

Ella Sharp Museum, Jackson, Michigan and Habatat Galleries, Farmington Hills, Michigan, "Glass: State of the Art" (exh. cat.) (traveled to Grand Rapids Art Museum, Michigan; Midland Center for the Arts, Michigan)

Hokkaido Museum of Modern Art and Asahi Shimbun, Sapporo, Japan, "World Glass Now '85" (exh. cat.)

Rhode Island School of Design, Providence, "44 Alumni" (exh. brochure)

1986

American Craft Museum, New York, "Craft Today: Poetry of the Physical" (exh. cat.) (traveled to Denver Art Museum; Laguna Art Museum, Laguna Beach, California; Milwaukee Art Museum, Wisconsin; J. B. Speed Art Museum, Louisville; Virginia Museum of Fine Arts, Richmond)

Brandeis University, Rose Art Museum, Waltham, Massachusetts, "Sculptural Objects and Installations" (exh. cat.)

California State University, Fullerton, Visual Arts Center, "Cast Glass Sculpture" (exh. cat.)

Contemporary Arts Center, Cincinnati, Ohio, "Transparent Motives: Glass on a Large Scale" (exh. cat.) (traveled to Fort Wayne Museum of Art, Indiana; Owens-Illinois Art Center, Toledo, Ohio; San Jose Museum of Art, California)

The Oakland Museum, California, "Contemporary American and European Glass from the Saxe Collection" (exh. cat.)

Arts Festival of Atlanta, Piedmont Park, "Thirty-Third Arts Festival of Atlanta" (exh. cat.)

The Saint Louis Art Museum, "Art of the '80s"

1987

Arizona State University, University Art Museum, Tempe, "3 + 3 x 7: Sculpture in Glass and Works on Paper" (exh. cat.)

Charles Cowles Gallery, New York, "The Heroic Sublime"

The Corning Museum of Glass, New York, "Thirty Years of New Glass, 1957-1987"

DeCordova Museum and Sculpture Park, Lincoln, Massachusetts and Brown University, David Winton Bell Gallery, Providence, Rhode Island, "New England Now: Contemporary Art from Six States" (exh. cat.) (traveled to Currier Gallery of Art, Manchester, New Hampshire; Bowdoin College Museum of Art, Brunswick, Maine; The New Britain

Museum of American Art, Connecticut; University of Vermont, Robert Hull Fleming Museum, Burlington)

La Jolla Museum of Contemporary Art, California, "Faux Arts: Surface Illusions and Simulated Materials in Recent Art" (exh. cat.)

Tampa Museum of Art, Florida, "Director's Choice"

University of Michigan-Dearborn, "Contemporary Glass from the Sosin Collection" (exh. cat.)

1988

Art Awareness Gallery, Lexington, New York, "Civilized Life" (exh. brochure)

The Hudson River Museum of Westchester, Yonkers, New York, "Columnar" (exh. cat.)

The Philbrook Museum of Art, Tulsa, "The Eloquent Object" (exh. cat.) (traveled to Museum of Fine Arts, Boston; Chicago Public Library Cultural Center; Virginia Museum of Fine Arts, Richmond; and other sites)

Snug Harbor Cultural Center, Newhouse Gallery, Staten Island, New York, "Seeing Glass"

1989

Hirshhorn Museum and Sculpture Garden, Smithsonian Institution, Washington, "Recent Acquisitions, 1986–88"

1990

Memphis Brooks Museum of Art, Memphis, Tennessee, "Glass Today: Memphis Collects Exhibition"

1991

The Detroit Institute of Arts, "Studio Glass: Selections from the David Jacob Chodorkoff Collection"

Espace Duchamp-Villon, Centre Saint-Sever, Rouen, France, "Exposition Internationale de Verre Contemporain" (exh. cat.)

Hokkaido Museum of Modern Art, Sapporo, Japan, "World Glass Now '91" (exh. cat.) (traveled throughout Japan)

1992

Art Gallery of Western Australia, Perth, "Design Visions" (exh. cat.)

Centro de Arte Vitro, Monterrey, Mexico with Museo de Arte Contemporáneo de Monterrey and Museo Rufino Tamayo, Mexico City, "Cristalomancia, arte contemporaneo en vidrio/contemporary art in glass" (exh. cat.)

The Morris Museum, Morristown, New Jersey, "Glass from Ancient Craft to Contemporary Art: 1962–1992 and Beyond" (exh. cat.) (traveled to Fine Arts Museum of the South, Mobile, Alabama; The Philbrook Museum of Art, Tulsa; University of Oklahoma, Fred Jones Jr. Museum of Art, Norman; Scottsdale Center for the Arts, Arizona; Art Museum of South Texas, Corpus Christi)

Renwick Gallery of the National Museum of American Art, Smithsonian Institution, Washington, "Works on Paper: The Craft Artist as Draftsman"

Whatcom Museum of History and Art, Bellingham, Washington, "Clearly Art, Pilchuck's Glass Legacy" (exh. cat.) (traveled)

1993

J. B. Speed Art Museum, Louisville, "The Art of Contemporary Glass"

Milwaukee Art Museum, Wisconsin, "Tiffany to Ben Tré: A Century of Glass" (exh. cat.)

The Toledo Museum of Art, Ohio, "Contemporary Crafts and the Saxe Collection" (exh. cat.)

Turbulence, New York, "Art and Application" (exh. cat.)

1995

Palo Alto Cultural Center, California, "Concept in Form: Artists' Sketchbooks and Maquettes" (exh. brochure)

The Toledo Museum of Art, Ohio, "Toledo Treasures" (exh. cat.)

1996

The Metropolitan Museum of Art, New York, "Studio Glass in the Metropolitan Museum of Art" (exh. cat.)

Seattle Art Museum, "Minimalism"

1997

The Cleveland Museum of Art, "Glass Today" (exh. cat.)

Indianapolis Museum of Art, "Masters of Contemporary Glass: Selections from the Glick Collection" (exh. cat.)

Museum of Fine Arts, Boston, "Glass Today by American Studio Artists" (exh. cat.)

International Contemporary Art Festival, Tokyo, "The 5th International Contemporary Art Festival '97" (exh. cat.)

Tulane University, Newcomb Art Gallery, New Orleans, "Trial by Fire: Glass as a Sculptural Medium" (exh. cat.)

1998

Charles Cowles Gallery, New York, "The Winter Show"

Charles Cowles Gallery, New York, "Works on Paper"

The Detroit Institute of Arts, "A Passion for Glass: The Aviva and Jack A. Robinson Studio Glass Collection" (exh. cat.)

Gallery Shiraishi, Tokyo, "World Artist Tour" (exh. brochure) (traveled)

Los Angeles County Museum of Art, "Glass"

University of California, San Diego, University Art Gallery, "VisAlchemical"

1999

Purchase College/State University of New York, Neuberger Museum of Art, Purchase, New York, "Contemporary Classicism" (exh. cat.)

SELECTED BIBLIOGRAPHY

Gay Ben Tré

Alexander, Chris. "Howard Ben Tré." *Art Express* 2 (1982): 71.

American Craft Museum, New York. *Craft Today: Poetry of the Physical*. Essays by Edward Lucie-Smith and Paul J. Smith. New York: 1986.

"Americans in Glass." *Kunst + Handwerk* 5 (1984): 284–85.

Arizona State University, University Art Museum, Tempe. 3 + 3 x 7: *Sculpture in Glass and Works on Paper*. Essay by Lucinda H. Gedeon. Tempe: 1987.

Arsenale Editrice Venice. *Venezia Aperto Vetro International New Glass*. Essay by Dan Klein. Venice: 1996.

Art in Embassies Program, US Embassy, Prague. *Contemporary American Glass Sculpture*. Washington: 1983.

Art Gallery of Western Australia, Perth. *Design Visions*. Edited by Robert Bell. Perth: 1992.

Art Gallery of Western Australia and Australian Consolidated Industries Ltd., Perth, Australia. *International Directions in Glass Art*. Perth: 1982.

"Artery Plaza: The Artery Organization." *International Sculpture*, January/February 1987: 30–33.

Arts Festival of Atlanta, Piedmont Park. *Thirty-Third Arts Festival of Atlanta*. Essay by Ronald J. Onorato. Atlanta: 1986.

Baker, Kenneth. "Howard Ben Tré." *Arts Magazine* 57 (September 1982): 8.

Bates, Lincoln. "Architecture for Art's Sake." *Southern Homes* 5 (November/December 1987): 78–79.

Ben Tré, Howard. "Symposium International du Verre en France." *Glass Art Society Journal*, 1982–83: 54.

Bowling Green State University, Ohio. *Emergence*. Essay by William Warmus. Bowling Green: 1981.

Brandeis University, Rose Art Museum, Waltham, Massachusetts. *Sculptural Objects and Installations*. Waltham: 1986.

Brenson, Michael. "A Fall Art Scene That's Bristling with Energy." *The New York Times*, November 7, 1986: C26.

Brewster, Todd. "Avant-Glass: New Techniques Alter an Ancient Art." *Life Magazine* 5 (February 1982): 78–82.

Brown University, David Winton Bell Gallery, Providence, Rhode Island. *Howard Ben Tré: New Work*. Interview by Diana Johnson and essay by Donald B. Kuspit. Providence: 1993.

Brussat, David. "Beauty Sculpted from Utiliity." *The Providence Journal*, July 16, 1998: B7.

Bullard, CeCe. "Alterations of Light and Form," *Richmond Times Dispatch*, January 27, 1996: B7.

Caldwell, Gail. "Tré Bien." *The Boston Phoenix*, May 3, 1983: B1.

California State University, Fullerton, Visual Arts Center. *Cast Glass Sculpture*. Essay by Donald B. Kuspit. Fullerton: 1986.

Campbell, Robert. "Post Office Square: The Perfect Park." *The Boston Globe*, July 24, 1992: 41.

Carlock, Marty. *A Guide to Public Art in Greater Boston*. Boston: The Harvard Common Press, 1993.

Castellucci, John. "Thousands Take a Peak at What Hospital Has to Offer." *Providence Journal*, January 23, 1994: B-1.

Cenni, René. "L'Age du Silicum," *Nice Matin*, April 26, 1994: 1.

Centro de Arte Vitro, Monterrey, Mexico, Museo de Arte Contemporaneo de Monterrey and Museo Rufino Tamayo, Mexico City. *Cristalomancia, arte contemporáneo en vidrio/contemporary art in glass*. Text by Miguel Angel Fernández and Susana Patiño González. Monterrey: 1992.

Chambers, Karen S. "The Difficulty of Simplicity." *New Work* 23/24 (Summer/Fall 1985): 26–27.

————. "Howard Ben Tré." *New Work* 23/24 (Summer/Fall 1985): 40.

————. Howard Ben Tré, An Artist in Time." *New Work* 15/16 (Summer/Fall 1983): 4–9.

————. "When Glass Is Not a Glass...Vitreous Sculpture." *American Style*, Spring 1997: 30–39.

Charles Cowles Gallery, New York. *Howard Ben Tré*. Essay by John Perreault. New York: 1985.

Charles Cowles Gallery, New York. *Howard Ben Tré*. Essay by Linda L. Johnson. New York: 1988.

Charles Cowles Gallery, New York. *Howard Ben Tré: Vessels of Light*. Essay by Judd Tully. New York: 1991.

The Cleveland Museum of Art. *Glass Today*. Essay by Henry H. Hawley. Cleveland: 1997.

Colby, Joy Hakanson. "Master Glass Sculptor Ben Tré." *The Detroit News*, June 26, 1992: 11D.

The Columbus College of Art and Design, Ohio. *The Fine Art of Contemporary American Glass*. Text by Paul V. Gardner and C. Edward Wall. Columbus: 1983.

"Contemporary American Crafts." *Philadelphia Museum of Art Bulletin* 87 (Fall 1991): 42–46.

Contemporary Arts Center, Cincinnati, Ohio. *Transparent Motives: Glass on a Large Scale*. Text by Karen S. Chambers. Cincinnati: 1986.

The Corning Museum of Glass, New York. *New Glass, A Worldwide Survey*. Corning: 1979.

The Corning Museum of Glass, New York. *New Glass Review* 1 (1980): 4; 2 (1981): 2; 3 (1982): 7; 4 (1983): 7; 7 (1986): 133.

Daniel, Missy. "Exploring an Affinity with Glass." *The Boston Globe*, December 29, 1989: 43, 45.

Danto, Arthur C. "Embodied Soul." *House & Garden* 167 (July 1998): 52, 54.

D'Arnoux, Alexandra. "A Passion for Art." *Maison & Jardin* 397 (1993): 58.

Davis, Paul. "Designs on the Economic Landscape." *The Providence Journal*, July 31, 1994: A-1.

DeCordova Museum and Sculpture Park, Lincoln, Massachusetts. *Glass Routes*. Text by Sherry Lang. Lincoln: 1981.

DeCordova Museum and Sculpture Park, Lincoln, Massachusetts and Brown University, David Winton Bell Gallery, Providence, Rhode Island, et al. *New England Now: Contemporary Art From Six States*. Lincoln: 1987.

Degener, Patricia. "Glass Sculptures: Industrial, Elegant." *Saint Louis Post-Dispatch*, June 24,1990: 4C.

The Detroit Institute of Arts. "*A Passion for Glass: The Aviva and Jack A. Robinson Studio Glass Collection*. Text by Bonita Fike. Detroit: 1998.

Donohue, Marlena. "The Galleries, Santa Monica." *Los Angeles Times*, April 14, 1989: VI, 18.

Ella Sharp Museum, Jackson, Michigan and Habatat Galleries, Farmington Hills, Michigan. *Glass: State of the Art*. Text by Ferdinand Hampson and Marsha Miro. Jackson: 1985.

Ernould-Gandouet, Marielle. "Howard Ben Tré." *L'Oeil*, May 1994: 14.

Espace Duchamp-Villon, Centre Saint-Sever, Rouen, France. *Exposition Internationale de Verre Contemporain*. Essay by Catherine Vaudour. Rouen: 1991.

Foley, Suzanne. "The Measure of Success." *American Craft* 44 (October/November 1984): 10–15.

Frantz, Suzanne. *Contemporary Glass. A World Survey from the Corning Museum of Glass*. New York: Harry N. Abrams, Inc., 1989.

Gibson, Eric. "Powerful Glass Sculpture Populates the Phillips." *The Washington Times*, December 19, 1989: E3.

Gimelson, Deborah. "Los Angeles Redux." *Art and Auction*, March 1988: 54.

"Glass Master." *Bostonia*, May/June 1990: 67.

Glueck, Grace. "Craft's Increasing Domain." *The New York Times*, October 23, 1986: C10.

———. "Howard Ben Tré." *The New York Times*, April 12, 1985: C20.

———. "In Glass, Darkly and Kissed by Light." *The New York Times*, August 29, 1997: 1, 25.

Grant, Daniel. "Study of Contrasts in Ben Tré's Textures, Forms." *The Boston Herald*, November 23, 1990.

Habatat Galleries, Farmington Hills, Michigan. *Howard Ben Tré: Basins*. Essay by Dan Klein. Farmington Hills: 1992.

Habatat Galleries, Lathrup Village, Michigan. *Howard Ben Tré*. Essay by Ronald J. Onorato. Lathrup Village: 1983.

Hadler/Rodriguez Galleries, Houston. *Howard Ben Tré*. Essay by Ronald J. Onorato. Houston: 1981.

Hadler/Rodriguez Galleries, Houston. *Howard Ben Tré*. Essay by Ronald J. Onorato. Houston: 1983.

Henry, Gerrit. "Howard Ben Tré at Charles Cowles." *Art News*, March 1997: 110–111.

Hokkaido Museum of Modern Art, Sapporo, Japan. *100 Selected Works from the Collection of Hokkaido Museum of Modern Art*. Sapporo: 1997.

Hokkaido Museum of Modern Art and Asahi Shimbun, Sapporo, Japan. *World Glass Now '82*. Sapporo: 1982.

Hokkaido Museum of Modern Art and Asahi Shimbun, Sapporo, Japan. *World Glass Now '85*. Sapporo: 1985.

Hokkaido Museum of Modern Art, Sapporo, Japan. *World Glass Now '91*. Sapporo: 1991: 162–67, 260.

Hollister, Paul. "Howard Ben Tré's Cast Glass: Memories of the Mechanical Age." *Neues Glas* 3 (1982): 127–33.

———. "Howard Ben Tré's Sculptures in Glass." *The New York Times*, April 1, 1982: C18.

The Hudson River Museum of Westchester, Yonkers, New York. *Columnar*. Essay by Janice C. Oresman. Yonkers: 1988.

Hunter-Stiebel, Penelope. "Contemporary Art Glass: An Old Medium Gets a New Look." *ARTnews* 80 (Summer 1981): 130–35.

Huntington Museum of Art, West Virginia. *New American Glass: Focus West Virginia*. Huntington: 1981.

Indianapolis Museum of Art. *Masters of Contemporary Glass: Selections from the Glick Collection*. Essay by Martha Drexler Lynn with Barry Shifman. Indianapolis: 1997.

International Contemporary Art Festival, Tokyo. *The 5th International Contemporary Art Festival '97 Tokyo*. Tokyo: 1997.

Jepson, Barbara. "This Sculptor's World Is Made of Glass." *The Wall Street Journal*, November 9, 1983: 28.

Jesse Besser Museum and Habatat Galleries, Alpena, Michigan. *Glass Sculpture: 4 Artists— 4 Views*. Alpena: 1982.

Kangas, Matthew. "Engendering Ben Tré." *Glass* 40 (Spring/Summer 1990): 20–27.

Klein, Dan. *Glass: a Contemporary Art*. New York: Rizzoli, 1989.

Koplos, Janet. "Howard Ben Tré at Charles Cowles." *Art in America* 79 (December 1991): 112–113.

Kuspit, Donald B. "Howard Ben Tré at Charles Cowles," *ArtForum* 35, 7 (March 1997): 91.

La Jolla Museum of Contemporary Art, California. *Faux Arts: Surface Illusions and Simulated Materials in Recent Art*. Text by Ronald J. Onorato. La Jolla: 1987.

Laumeier Sculpture Park, St. Louis. *Laumeier Sculpture Park Second Decade 1987–1996*. Essays by Beej Nierengarten-Smith and George McCue. St. Louis: 1998.

The Leigh Yawkey Woodson Art Museum, Wausau, Wisconsin. *Americans in Glass*. Wausau: 1978.

The Leigh Yawkey Woodson Art Museum, Wausau, Wisconsin. *Americans in Glass*. Text by David J. Wagner and David R. Huchthausen. Wausau: 1984.

Leimbach, Dulcie. "Currents." *The New York Times*, October 27, 1994: C-3.

"A Look at the Future of Glass as Art." *Glass Art Society Journal*, 1982-83: 57–61.

Lösken, Manfred. "Feuerzauber." *Kunst + Handwerk* 23 (November 1980).

Love, Nancy. "A Touch of Glass." *Art and Auction* 8 (1985): 42.

Lucie-Smith, Edward. *Sculpture Since 1945*. London: Phaidon Press and New York: Universe Books, 1987.

Mason, Marilynne S. "Glass, Once a Craft, Rates as an Art Form." *The Christian Science Monitor*, April 20, 1993: 12.

Meitner, Richard. "The Glass Bead Game." *Neues Glas* 2 (1982): 68–76.

The Metropolitan Museum of Art, New York. *Studio Glass in the Metropolitan Museum of Art*. Essay by Jane Adlin. New York: 1996.

Michelson, Maureen. "Profile: Howard Ben Tré." *Glass Studio* 10 (January 1980): 56–59.

Miller, Alexis Magner. "Howard Ben Tré: Columns of Frozen Light." *The Providence Sunday Journal Magazine*, March 22, 1987: 18–19.

Milwaukee Art Museum, Wisconsin. *Tiffany to Ben Tré: A Century of Glass.* Text by Joan Barnett and Audrey Mann. Milwaukee: 1993.

Miro, Marsha. "Glass Master Envisions Prehistoric Tools with a Contemporary Cast." *Detroit Free Press*, July 19, 1992: 5Q.

Monod, Véronique. "Le Verre." *L'Atelier* 25 (February 1978): 15–18.

Morgenroth, Lynda. "Post Office Square Fountain Is Abstract Study." *The Boston Sunday Globe*, August 22, 1993: City 7.

———. "City of Fountains." *The Boston Globe*, September 10, 1992: Calendar, pp. 8–9.

The Morris Museum, Morristown, New Jersey. *Glass from Ancient Craft to Contemporary Art: 1962–1992 and Beyond.* Essay by Karen S. Chambers. Morristown: 1992.

Muchnic, Suzanne. "Glass Society Shows Its Mettle." *Los Angeles Times*, April 17, 1986.

Musée d'Art Moderne et d'Art Contemporain, Nice, France. *Sculptures de Verre.* Text by P. Chaigneau and D. Johnson. Nice: 1994.

Museum of Fine Arts, Boston. Glass *Today by American Studio Artists.* Essays by Jonathan Fairbanks and Pat Warner. Boston: 1997.

Narrett, Eugene. "Howard Ben Tré, Sculpture." *Art New England*, June 1983: 7.

The National Museum of Modern Art, Kyoto and The National Museum of Modern Art, Tokyo. *Contemporary Glass—Australia, Canada, U.S.A. & Japan.* Kyoto and Tokyo: 1981.

Netzer, Sylvia. "Howard Ben Tré." *Glass* 45 (Fall 1991): 48.

Nickisher, Heidi. "Howard Ben Tré." *Artweek* 23 (February 6, 1992): 17–18.

Nicola, Günter. "American and European Glass from the Saxe Collection Exhibition." *Neues Glas* 3 (1987): 214–215.

The Oakland Museum, California. *Contemporary American and European Glass from the Saxe Collection.* Text by Kenneth R. Trapp and William Warmus. Oakland: 1986.

Ono, Seiko, ed. *All About Glass.* Tokyo: The Shinshusha Co., Ltd., 1992.

Onorato, Ronald J. "Howard Ben Tré." *Art New England*, November 1990: 18–19, 32.

———. "Howard Ben Tré." *Arts Magazine* 54 (June 1980): 5.

Pantalone, John. "Master Glass." *Newport This Week*, April 25, 1996: 10.

Pautler, Thomas, ed. *RISD at Work.* Providence, Rhode Island: Rhode Island School of Design, 1985.

Perrault, John. "Glass Struggle," *The Soho News*, December 30, 1980: 22.

The Philbrook Museum of Art, Tulsa. *The Eloquent Object.* Essay by Marcia and Tom Manhart. Tulsa: 1987.

The Phillips Collection, Washington. *Howard Ben Tré.* Essay by Linda L. Johnson. Washington: 1989.

Pincus, Robert L. "Glassworks." *The Union-Tribune*, January 29, 1998: 36.

Purchase College/State University of New York, Neuberger Museum of Art, Purchase, New York. *Contemporary Classicism*. Text by Judy Collischan. Purchase: 1999.

Raimondi, Julie A. "Body & Soul." *Contract Design* 7 (July 1998): 9, 40, cover.

"Recent Acquisitions, A Selection: 1995–96." *The Metropolitan Museum of Art Bulletin*, Fall 1996: 70.

"Recent Acquisitions." *Rhode Island School of Design Museum Notes* 73 (October 1988): 27.

"Review — Howard Ben Tré." *New Work* 27 (Autumn 1986): 16–23.

Roberts-Pullen, Paulette. "Fire and Ice." *Richmond Style Weekly*, February 6, 1996: 36.

Sabar, Ariel. "A Conversation with Howard Ben Tré, Noted Sculptor." *The Providence Journal*, June 30, 1997: C1,3.

Save, Colette. "Le Verre — Howard Ben Tré." *L'Atelier* 69 (1982): 26–27.

Schwan, Gary. "Glass Sculptures' Power Clear." *Palm Beach Post*, January 14, 1994: 13.

Shaw-Eagle, Joanna. "Exhibit celebrates 'The Renwick at 25.'" *The Washington Times*, March 23, 1997: D1,3.

———. "The Fine(?) Art of Developing Bethesda." *New Art Examiner*, November 1986: 40–42.

Silander, Liisa. "In Search of the Perfect Site." *Views*, Summer 1997: 8–13.

Sjostrom, Jan. "Glass Works a Fusion of East, West." *Palm Beach Daily News*, January 8, 1994: 1.

Smith, Chalon. "Exhibits Offer Clues to the 'Mystery' of Glass." *Los Angeles Times*, April 16, 1986: 1, 4.

Smith, Robert L. "Library Prepares to Dedicate Sculpture." *The Buffalo News*, March 11, 1994: C-1.

Sosin, Jean and Hilbert. "Glass Collectors in the USA, Jean & Hilbert Sosin." *Neues Glas* 3 (1986): 204–207.

Spillman, Jane Shadel and Suzanne K. Frantz. *Masterpieces of American Glass*. New York: Crown Publishers, 1990.

Stapen, Nancy. "An Elegant Handsome Hybrid." *The Boston Globe*, December 5, 1990: 75.

Takeda, Atsushi. "Howard Ben Tré, World Artist Tour." *Bijutsu no Mado*, December 1997: 165–67.

Tarchinski, Pamela J. "Howard Ben Tré." *Glass* 45 (1991): 48.

Temin, Christine. "The Public's Art?" *The Boston Sunday Globe*, August 30, 1998: N6.

Tiberi, Liliane. "Sculptures de verre." *La Tribune*, June 6, 1994: 2.

The Toledo Museum of Art, Ohio. *Contemporary Crafts and the Saxe Collection*. Text by Davira Taragin et al. New York: Hudson Hills Press and The Toledo Museum of Art, 1993.

The Toledo Museum of Art, Ohio. *Toledo Treasures*. New York: Hudson Hills Press and The Toledo Museum of Art, 1995.

Tulane University, Newcomb Art Gallery, New Orleans. *Trial by Fire, Glass as a Sculptural Medium*. Essay by Nancy Corwin. New Orleans: 1997.

Turbulence, New York. *Art and Application*. Text by Arthur C. Danto. New York: 1993.

University of Michigan-Dearborn: *Contemporary Glass from the Sosin Collection*. Text by C. Edward Wall and Davira Taragin. Dearborn: 1987.

University of Rhode Island, Fine Arts Center Galleries, Kingston. *Howard Ben Tré: Basins and Fountains*. Essay by Ronald J. Onorato. Kingston: 1994.

University of Richmond, The Marsh Art Gallery, Virginia with the Cleveland Center for Contemporary Art. *Howard Ben Tré: Recent Sculpture*. Essay by Richard Waller. Richmond: 1995.

Van Siclen, Bill. "A Clearly Masterful Exhibit." *The Providence Journal*, September 2, 1994: D-3.

_____. "Abundant Art Serves Dual Purpose." *The Providence Journal*, January 20, 1994: 9.

_____. "The Art of a Working Glass Hero." *The Providence Journal*, November 18, 1990: E5.

_____."Design Breathes New Life into Downtown Bank Plaza." *The Providence Journal*, June 30, 1998: F1, 4.

_____. "Making More of Minimalism." *The Providence Journal*, August 14, 1992: D16.

_____. "Overflowing with Ideas." *The Providence Journal*, June 14, 1992: E1, E4.

_____. "Rhode Island: Incandescent in Glass Talent." *The Providence Journal*, August 3, 1997: E8.

_____. "Shining Stars of Glass." *The Providence Sunday Journal*, August 22, 1993: E1, 4.

Vaudour, Catherine. *L'Art du Verre Contemporain*. Paris: Armand Colin, 1993.

Wall, C. Edward. "Adventures in Glass." *Arizona Arts and Travel*, September/October 1983: 21.

Weber, Bruce. "Works in Progress: Glass Act." *The New York Times Magazine*, March 6, 1988: 110.

Whatcom Museum of History and Art, Bellingham, Washington. *Clearly Art, Pilchuck's Glass Legacy*. Essay by Lloyd E. Herman. Bellingham: 1992.

Whittemore, Katharine. "Post Office Square Fountain." *The Boston Globe Magazine*, September 19, 1993: 8.

Yaklut, Jud. "The Relevance of Glass. 'Transparent Motives: Glass on a Large Scale.'" *Dialogue, An Art Journal* (Columbus, Ohio) 9 (May/June 1986): 26–27.

Zimmer, William. "Hudson River Museum Spotlights the Column." *The New York Times*, August 7, 1988: Westchester Weekly, section 22: 24.

VIDEOS

Adams, Geoff, producer. *Howard Ben Tré: The Work*. Providence, Rhode Island: Pell Awards Committee, 1997.

Adams, Geoff, producer. *The Making of BankBoston Plaza*. Providence, Rhode Island: BankBoston, 1998.

VanVeen, Mark, producer, and Geoff Adams, director. *Ben Tré: Fountains*. Providence, Rhode Island: EastFilms, 1995.

INDEX

Page numbers in italics refer to illustrations

PHOTOGRAPHY

Unless otherwise noted, photographs of works of art reproduced in this publication have been supplied by the artist, with permission from the lenders. All photographs are by Ric Murray, Providence, Rhode Island, with the exception of the following: Courtesy of Anthony d'Offay Gallery, London: Jacob, fig. 7; Gay Ben Tré: Jacob, figs. 3, 8; Sims, fig. 3; Howard Ben Tré: Danto, fig. 13, Jacob, fig. 2; Sims, figs. 4, 9, 10, 21, 22; Rip Gerry (courtesy of Haffenreffer Museum of Anthropology, Brown University, Providence, Rhode Island): Sims, fig. 23; Courtesy of Marian Goodman Gallery, New York: Jacob, fig. 12; Courtesy of Rhona Hoffman Gallery, Chicago: Jacob, fig. 20; Warren Jagger: Danto, fig. 17, Jacob, figs. 27, 29, 32, 34; Seth Joel (courtesy of The Metropolitan Museum of Art, New York): Jacob, fig. 5; Courtesy of S. C. Johnson, Racine, Wisconsin: Jacob, fig. 19; Scott Lapham: Sims, fig. 5; Courtesy of Maya Lin and Gagosian Gallery, New York: Jacob, fig. 23; James Madden: Danto, fig. 3, cat. 39; Courtesy of Museum of Fine Arts, Boston: Jacob, fig. 30; Courtesy of The Museum of Modern Art, New York: Sims, fig 7; Steve Myers: Jacobs, fig 21; Courtesy of PaceWildenstein, New York: Jacob, fig. 13; Courtesy of Betty Seid, Chicago: Jacob, fig. 26; Courtesy of Sheldon Memorial Art Gallery, University of Nebraska-Lincoln: Sims, fig 6; Meidad Suchowolski, Tel Aviv: Jacob, fig. 15; Tim Thayer: Danto, figs. 5, 7 (courtesy of The Toledo Museum of Art), Sims, fig. 25; The Toledo Museum of Art: Sims, fig. 11; Courtesy of John Weber Gallery, New York: Jacob, fig. 22; unknown: Sims, fig. 2.